HISTORIC PHOTOS OF
MISSOURI

TEXT AND CAPTIONS BY ALAN GOFORTH

TURNER

PUBLISHING COMPANY

The classic tales of Mark Twain transformed Hannibal into "America's Hometown." Long before it became a tourist destination, however, it was a working river town, as can be seen in this panorama from the early twentieth century.

HISTORIC PHOTOS OF
MISSOURI

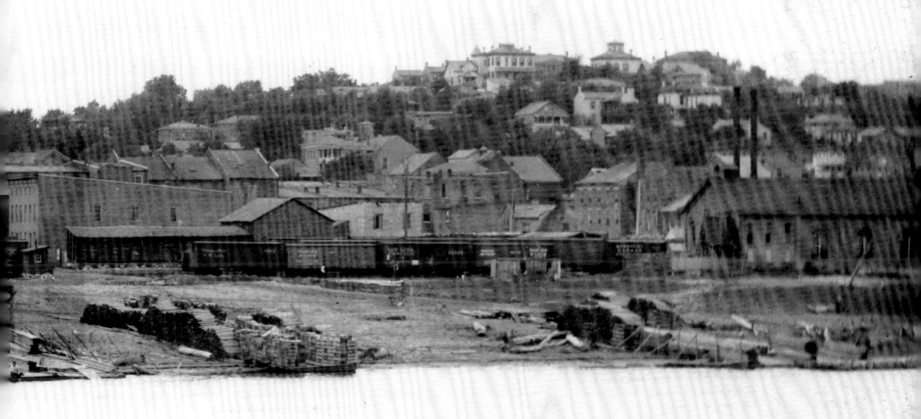

Turner Publishing Company
200 4th Avenue North • Suite 950
Nashville, Tennessee 37219
(615) 255-2665

www.turnerpublishing.com

Historic Photos of Missouri

Copyright © 2010 Turner Publishing Company

Library of Congress Control Number: 2009933003

ISBN: 978-1-59652-509-2

Printed in China

10 11 12 13 14 15 16—0 9 8 7 6 5 4 3 2 1

CONTENTS

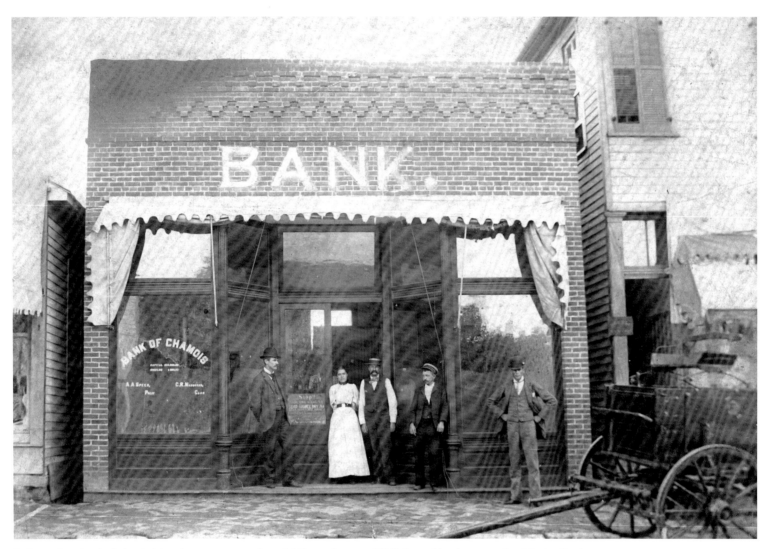

Independent banks helped drive the commerce of small Missouri towns. Well-dressed businesspeople visit the Bank of Chamois, which is west of Hermann.

Acknowledgments

This volume, *Historic Photos of Missouri,* is the result of the cooperation and efforts of many individuals and organizations. It is with great thanks that we acknowledge the valuable contribution of the following for their generous support:

Library of Congress
Missouri State Archives

PREFACE

"I come from a state that raises corn and cotton and cockleburs and Democrats, and frothy eloquence neither convinces nor satisfies me. I am from Missouri. You have got to show me." Ever since Representative Willard Duncan Vandiver made those remarks at a Philadelphia banquet in 1899, Missouri has been known as the Show-Me State. And what better way to understand the fascinating history of the Show-Me State since the mid-1800s than by showing it through nearly 200 archival photographs?

These photos tell the story of great men and women doing great things, such as Charles Lindbergh taking flight, Mickey Mantle swinging a bat, and Harry Truman dedicating a statue. But just as important, the photos pull back the curtain on ordinary people simply living their lives. Neighbor helps neighbor as a flood ravages the community. Women gather at the capitol to celebrate the ratification of a constitutional amendment giving them the right to vote. Farmers take pride in their simple yet well-maintained operations.

Some photographs show the challenging times, such as floods, two world wars, and the Great Depression. Still others reveal Missourians at play, whether at a baseball game, small-town parade, or boating at the Lake of the Ozarks. The photographic journey chronicles a state that grew from small towns to big cities and from steam engines to jets. Through it all, their Show-Me attitude helped them not only to persevere but to pursue their dreams. Many of these photos were taken by professional photographers using the latest technology of their day. Others were shot by amateurs to preserve a moment in time. All of them reveal persons, places, or events that someone believed would be of interest to their own time or to future generations such as ours.

The images are organized into four general eras of state history. The first chapter begins with the steady growth of the state after the Civil War and goes through the 1904 Louisiana Purchase Exposition, or World's Fair, in St. Louis. The second chapter continues the story through the challenges of World War I and the beginning of the Great Depression. Chapter

Three shows how Missourians rebuilt their lives before facing yet another world war, and the fourth chapter continues the story into the postwar era up to the 1970s.

This book is the result of many hours of homework by the researchers and writer. Archivists from around the state generously opened their files to make it possible. Although it would be impossible to include every photograph, the ones used were carefully chosen to present a comprehensive mosaic of Missouri history. With the exception of touching up imperfections that have accrued with the passage of time and cropping where necessary, no changes have been made. The focus and clarity of many images are limited to the technology and the ability of the photographer at the time they were recorded.

We hope that gaining a better understanding of the state's history will help citizens shape an even better future. Whether you have lived in Missouri your whole life or have never set foot in the state, we promise to make good on Vandiver's challenge to show you.

—*Alan Goforth*

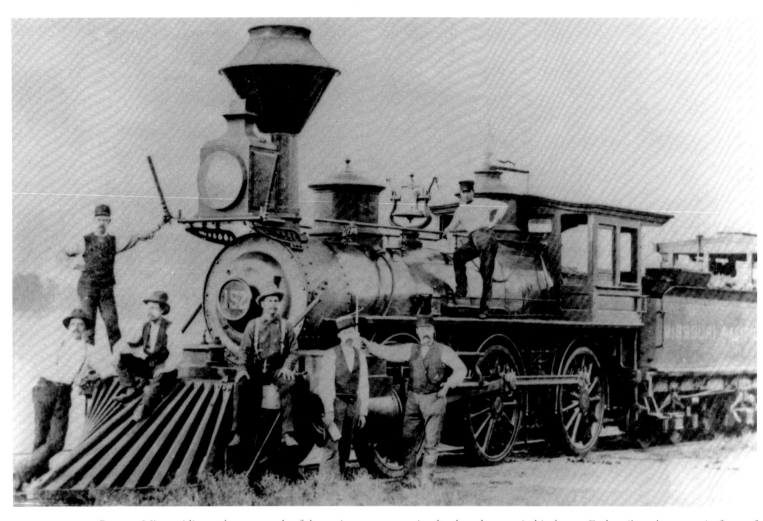

Because Missouri lies at the crossroads of the nation, transportation has long been a vital industry. Early rail workers pose in front of Missouri Pacific engine No. 152 before building up a head of steam for a journey.

DESTINED FOR GREATNESS

(1860s–1904)

Missouri entered the Union in 1821 destined for greatness. Abundant resources, hardworking immigrants, and a central location gave it everything it needed to succeed. What may be more impressive, however, was the ability of the state to remain intact through the social upheaval of the early and mid nineteenth century. Missouri was admitted as a slave state as part of the Missouri Compromise. The infamous Dred Scott Decision of 1857, which had its origins in a St. Louis courthouse, revealed the passionate views on both sides of the debate. Although it has become a cliche, brother really did fight against brother until the Civil War settled the slavery issue once and for all.

Through it all, immigrants continued to arrive, with the state population nearly doubling every year from the 1830s to the 1860s. Many were Irish, Germans, and Italians fleeing famine or oppression at home. Their strong work ethic, combined with that of earlier settlers, helped clear the land, build the railroads, and start the factories that would propel the Missouri economy into the new century. Cities such as St. Louis and Kansas City, as well as countless smaller towns, sprang up along the Mississippi and Missouri rivers. The arrival of the railroads in midcentury gave farmers and factory owners convenient access to national markets.

Colorful figures made lasting marks on the state. Both Robert E. Lee and Ulysses S. Grant worked in St. Louis before leading their armies in the Civil War. Farther north, Mark Twain was gathering material for the stories that would make Hannibal "America's Hometown." And along the Kansas border, Jesse James and his gang were striking fear into the hearts of bankers and railroads.

Missouri not only survived its tumultuous early days but was well positioned to move ahead when the calendar marked the coming of the twentieth century. For Missouri, however, the new century began not in 1900 but four years later, when the 1904 Louisiana Purchase Exposition brought the world to St. Louis.

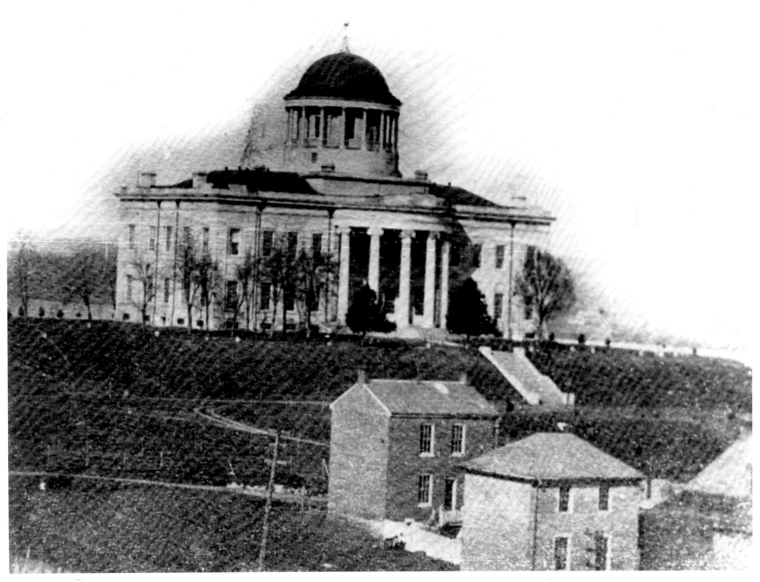

The first Missouri capitol in Jefferson City, seen here in the 1860s, was replaced with the current building after a lightning strike in 1911. "I have no tears to shed over the fact that the building has been destroyed, as it was totally inadequate and not in keeping with the requirements of our great state," Senator William Warner remarked.

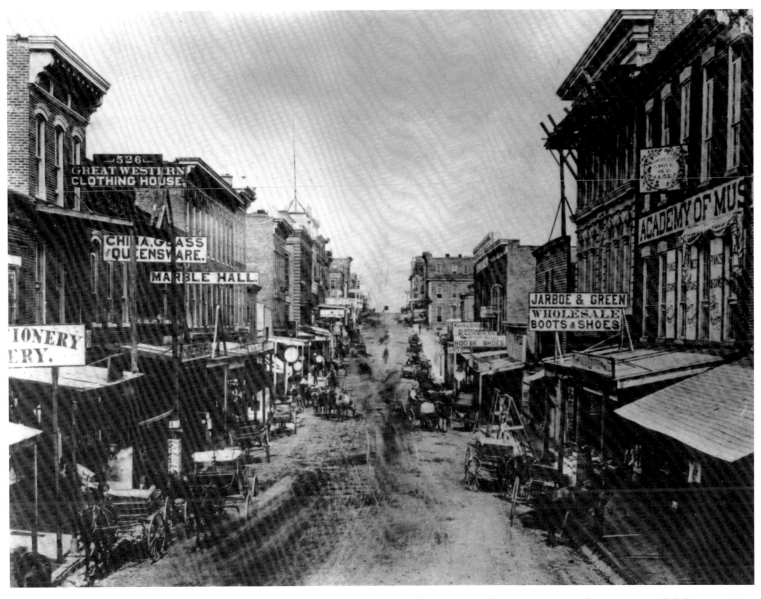

A lack of pavement didn't stop early Missourians from going downtown to shop. Businesses in the 1870s provided the necessities, including clothing and shoes, but also offered some of the finer things of life, such as stationery and music lessons.

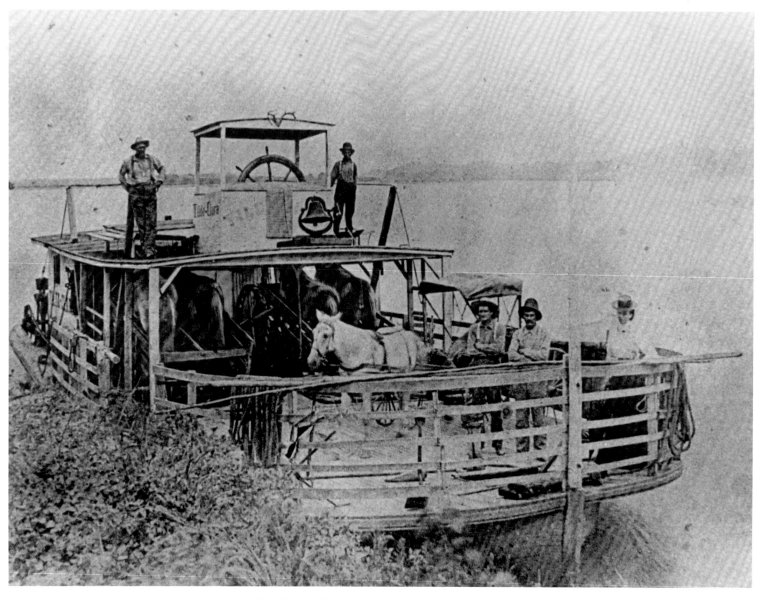

New Haven, originally called Miller's Landing, was founded in 1836 as a riverboat stop on the Missouri River. The later arrival of the Union Pacific Railroad made the town a transportation hub. This ferry used old-fashioned horsepower to transfer people and products across the river.

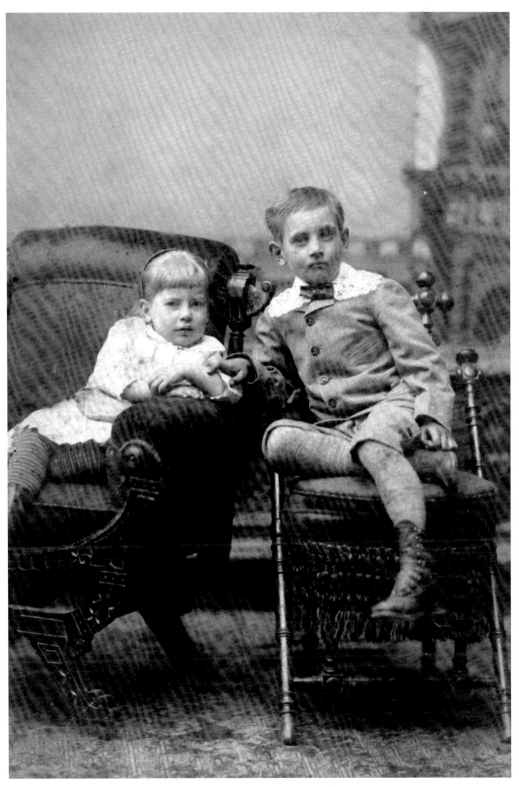

Few names are more famous—or infamous—in Missouri history than Jesse James. Although he was born in Clay County and died in St. Joseph, the outlaw and his gang roamed the nation from Iowa to Texas to West Virginia to Tennessee. This photo of children Mary and Jesse Jr. was made by Taylor Copying Company of St. Louis in 1882, the year Jesse James was shot and killed by Bob Ford. Jesse Jr. would grow up to practice law in Kansas City.

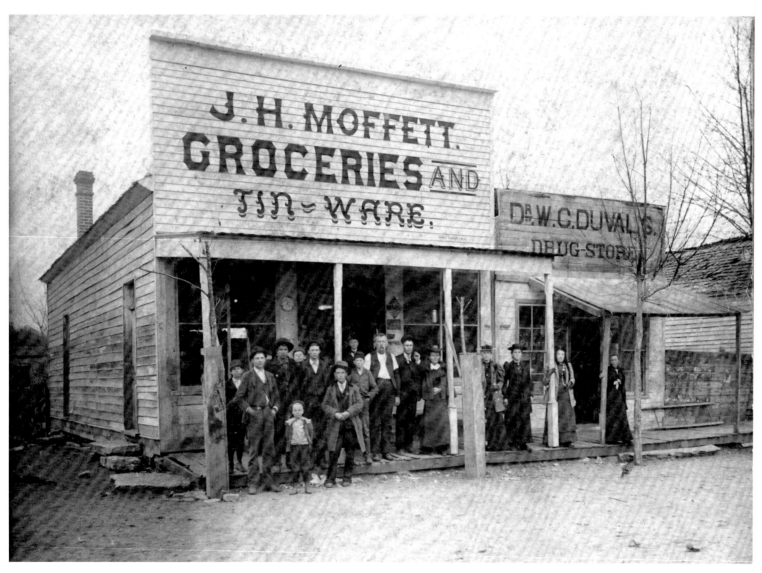

Just as they do today, retailers in the 1800s located where the people were. Townspeople dress up for a trip to J. H. Moffett Groceries and Tin-Ware, and Dr. W. C. Duval's Drug Store.

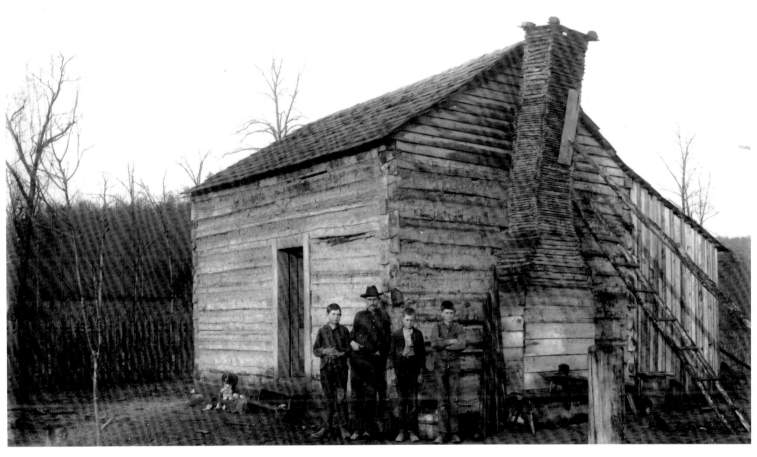

Early settlers were remarkably resourceful in making the most of what Mother Nature provided. Families living in forested parts of the state often built log cabins, such as this rustic example constructed from hand-hewn logs.

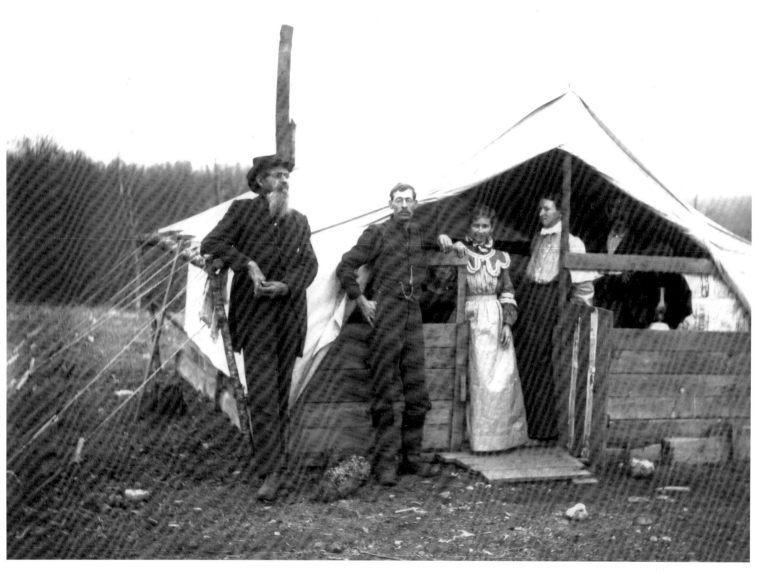

Missouri weather was just as unpredictable in the 1800s as it is today. This family is shown relying on a combination of lumber and canvas for protection from the elements.

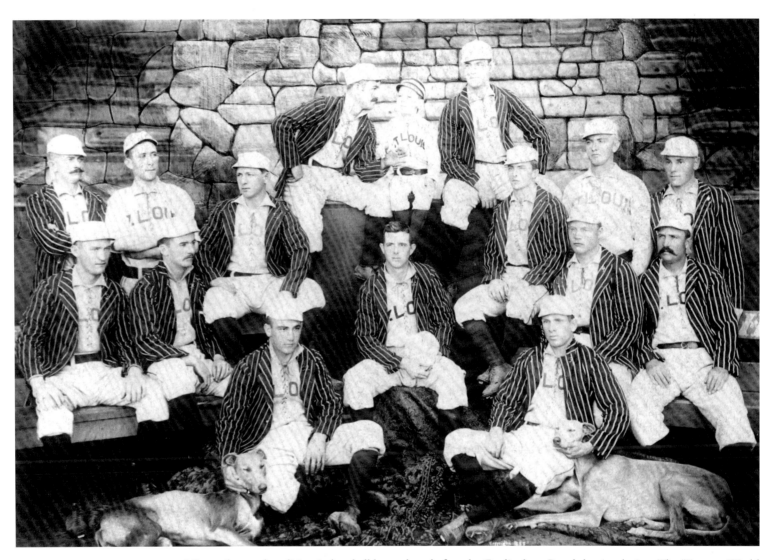

Missouri's proud tradition in baseball began long before the Cardinals or Royals began playing. The "Famous World Beaters," better known as the St. Louis Browns, were champions of the American Association from 1885 to 1888, as well as "world champions" in 1885 and 1887.

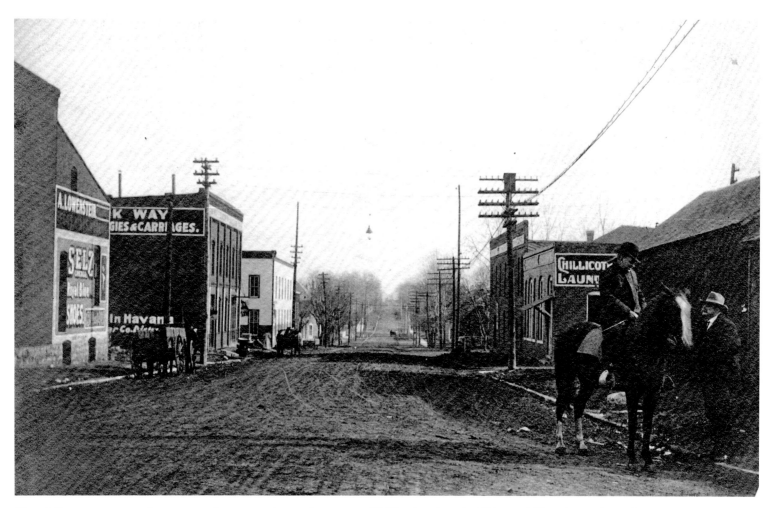

Electric lines were among the many modern conveniences that came to Chillicothe when the Chicago, Milwaukee & St. Paul Railroad was built through the town in 1886. The Chillicothe Laundry, in contrast, no doubt profited off clothing soiled by the mud and dust of the inconvenient, unpaved streets.

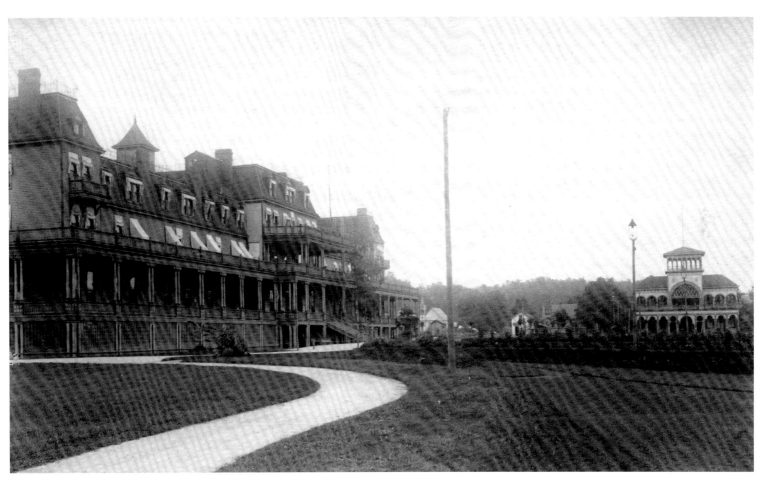

The discovery of healing mineral water in Excelsior Springs in the 1880s turned the sleepy town into a tourist destination. The majestic Elms Hotel attracted guests who wanted to soak in the mineral waters or soak up the sun in the lush gardens. This version of the hotel burned to the ground in 1898 and has been rebuilt twice.

Residents of Westphalia in central Missouri's Osage County greet guests to the Catholic holiday Corpus Christi Day. Immigrants named the town after the Westphalen area of Germany, and many street names were labeled in German as well as English.

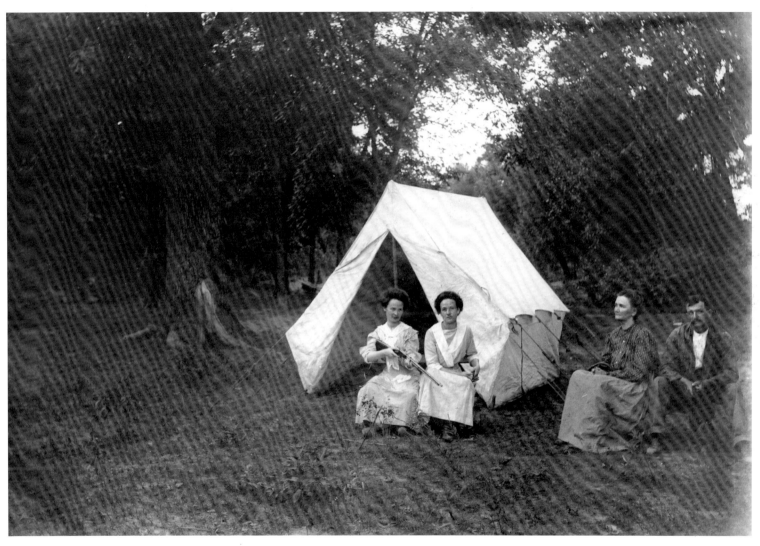

Annie Oakley had nothing on frontier women in Missouri. This woman lifts her gun at a campsite in the 1880s as her companions look on nonchalantly.

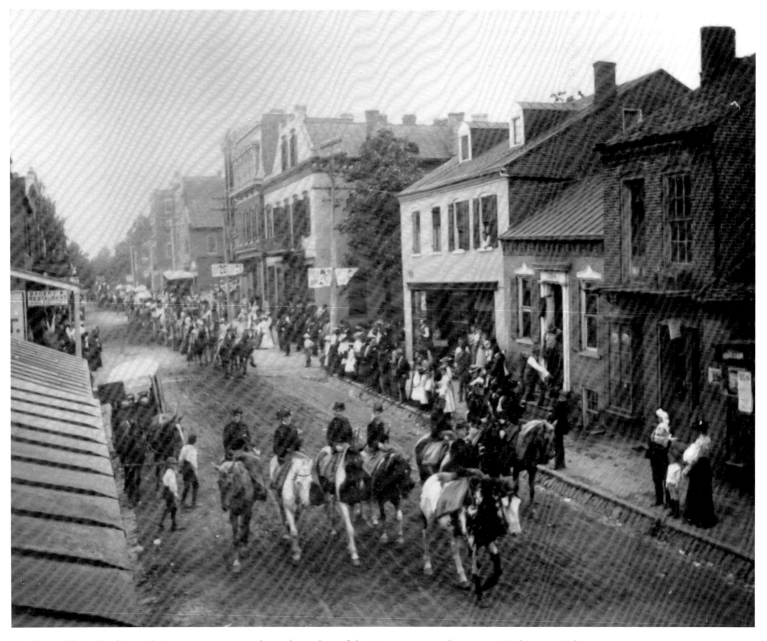

Family and friends of Daniel Boone were among the early settlers of the river town now known as Washington. The town prospered from river trade between St. Louis and towns farther up the Missouri River. Americans of predominantly German lineage celebrate in this 1890 parade.

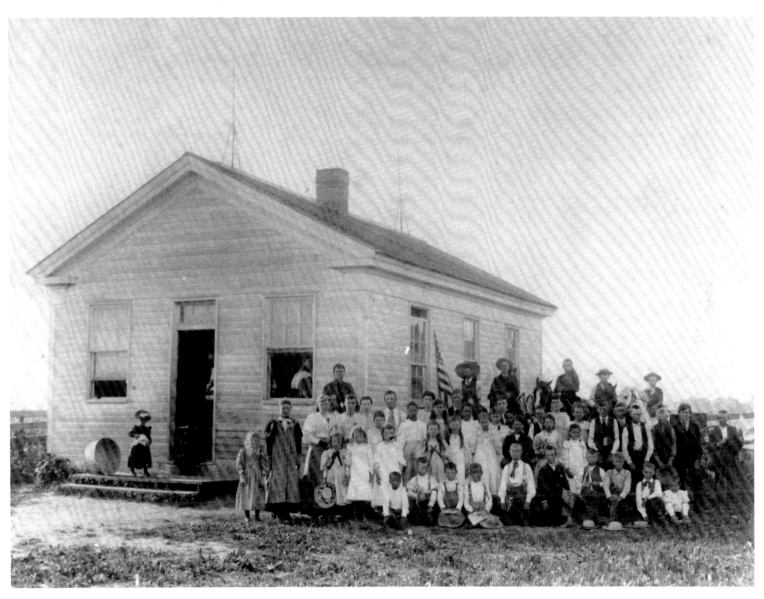

One-room schoolhouses did more than simply instruct children—they were a social hub for many rural communities. Students of all ages, including a few on horseback, gather for this 1891 photograph outside Cooper School in Atchison County in northwest Missouri.

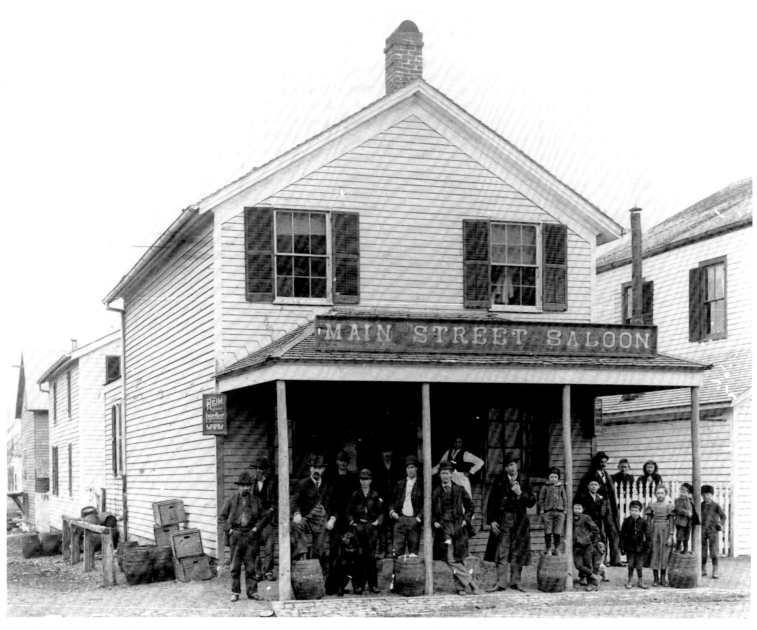

Founded around 1735, the river town of Ste. Genevieve, named for the patron saint of Paris, is the oldest permanent European settlement in the state and one of the oldest colonial settlements west of the Mississippi River. Townspeople greet their friends and neighbors in 1891 at the Main Street Saloon.

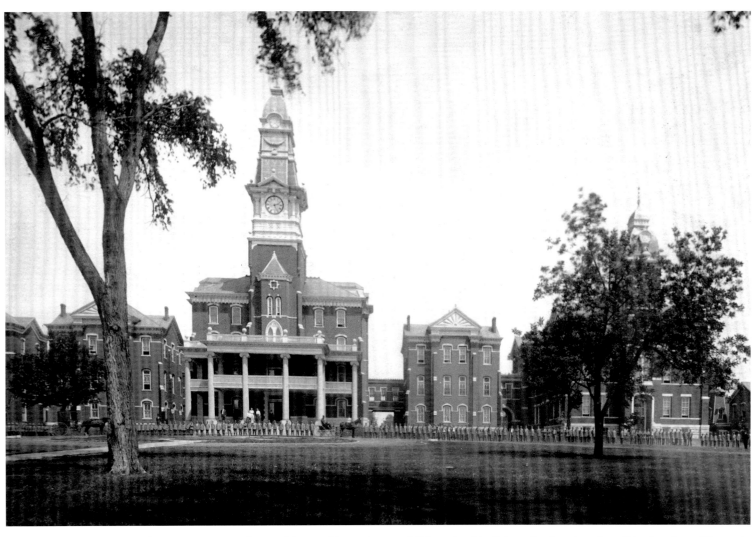

The Missouri General Assembly voted in 1851 to establish a school in Fulton for the education of deaf students. The main building, with its ornate clock tower, dominated the campus when this photograph was taken in the 1890s.

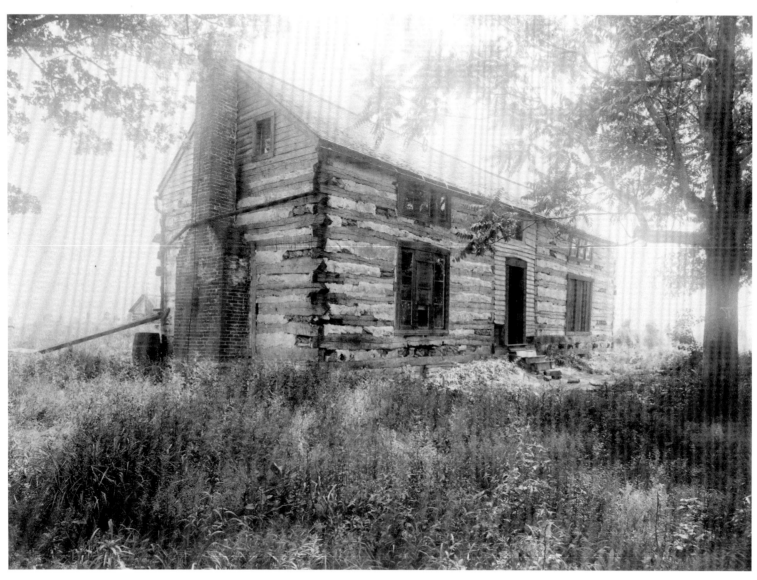

Long before he led the Union forces to victory or became the 18th president of the United States, Ulysses S. Grant tried earning his living off the land by selling firewood cut on his farm south of St. Louis. "Hardscrabble," the log cabin where he and his wife Julia lived, can still be seen today as part of the Grant's Farm tour.

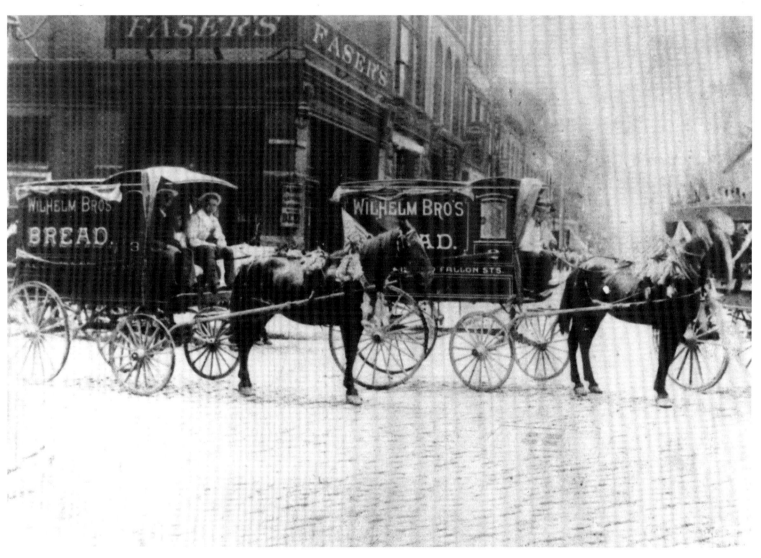

The clop-clop of horses' feet on cobblestone streets was a common sound in the St. Louis of the 1890s. In this image, Wilhelm Brothers Bread employees pause for the photographer before resuming their delivery service among downtown buildings.

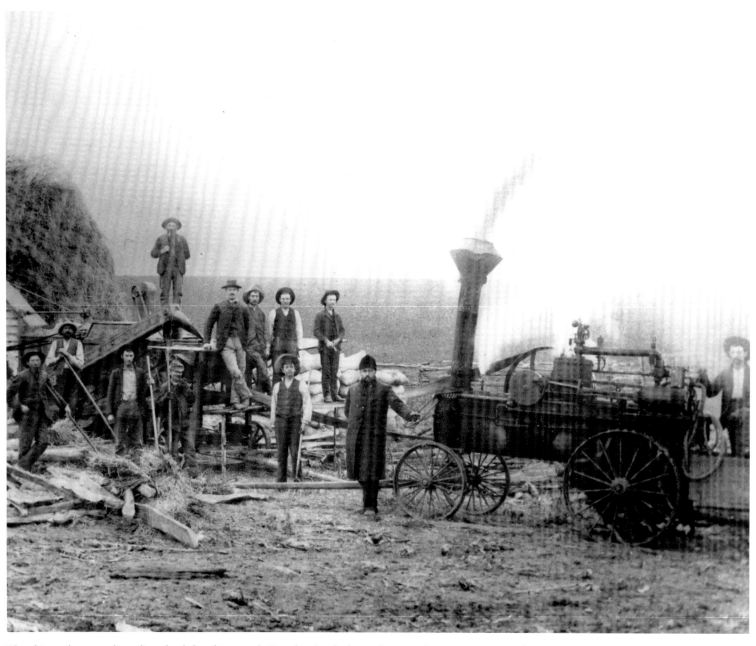

Threshing wheat was hot, dirty, back-breaking work. But despite the heat, this crew from 1893 wears jackets and vests while using a steam engine to thresh near Corder in Lafayette County.

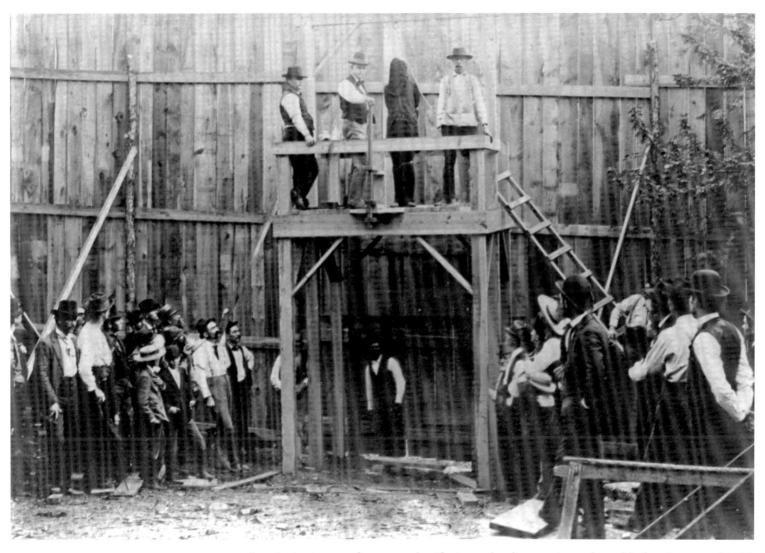

Frontier justice was often sure and swift. A crowd gathers to witness this public hanging around 1896.

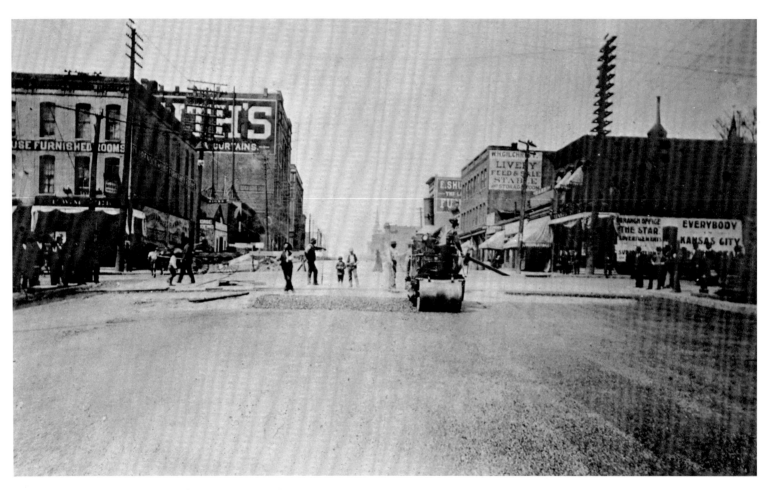

Road repair has long been a part of urban life. An early steamroller paves Grand Boulevard in Kansas City in 1894, in a view that faces north from 12th Street toward where the Sprint Center is located today.

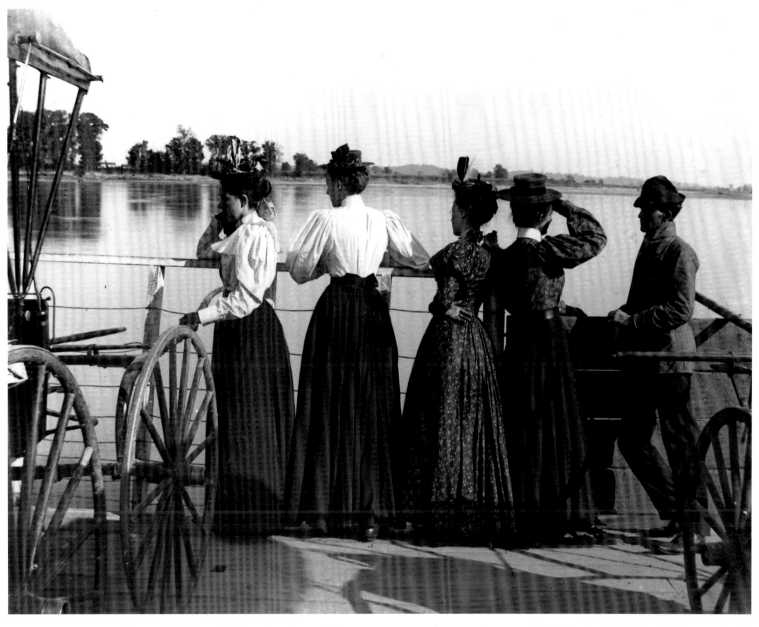

Because the Missouri River slices through the state, numerous ferry crossings were needed in the days before bridges were built. The Maclay family crosses near Rocheport in Boone County in the fall of 1898.

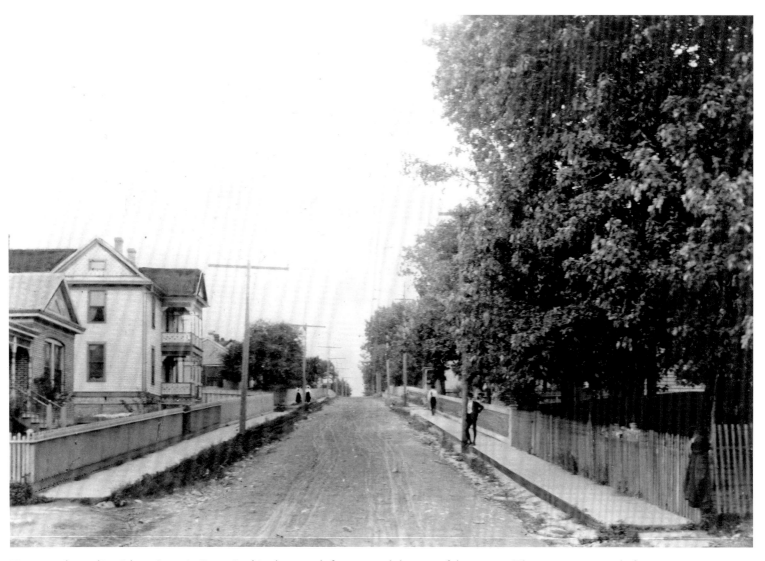

Houses and trees line Adams Street in Festus in this photograph from around the turn of the century. The street was named after W. J. Adams, who founded the town as Limitville in 1878. Legend holds that the name Festus was later selected by opening a Bible at random and landing upon "Porcius Festus," a governor of Judea.

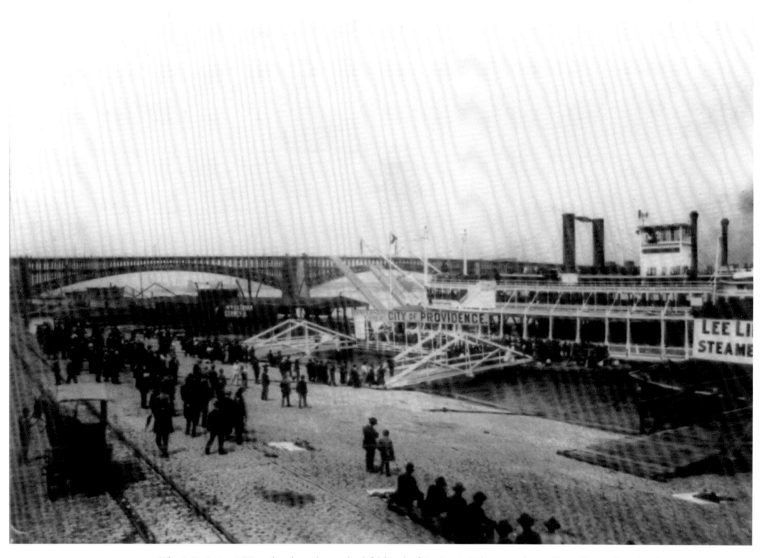

The Mississippi River has long been the lifeblood of St. Louis. The steamboat *City of Providence* loads passengers on the cobblestone wharf in this view from around the turn of the century. In the distance is the Eads Bridge, completed in 1874 to become the longest arch bridge in the world.

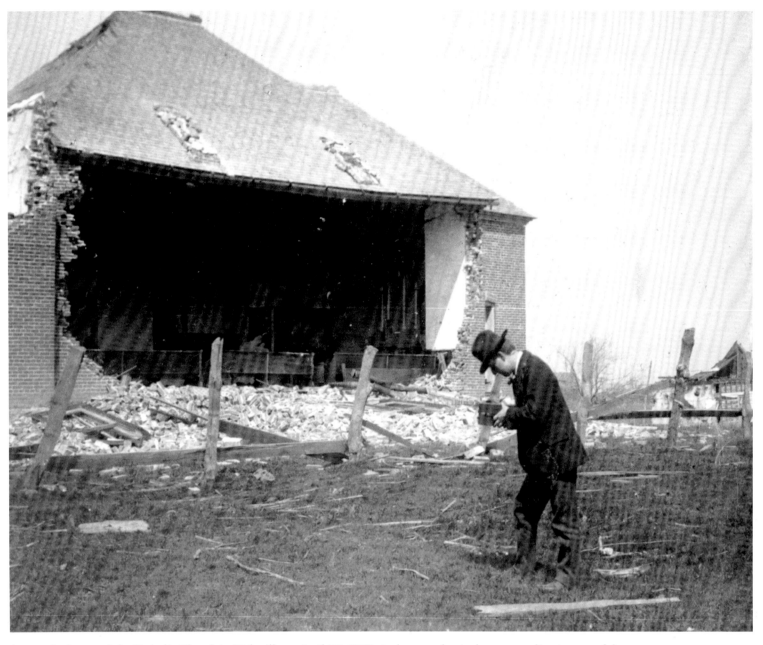

A tornado destroyed the Catholic Church in Kirksville on April 27, 1899. A photographer is shown recording images of the ruins. This image was originally printed as a stereograph, a popular kind of photograph at the turn of the century. Invented by Sir Charles Wheatstone in 1840, the stereograph imparted a three-dimensional effect to photographic imagery when viewed through a stereoscope.

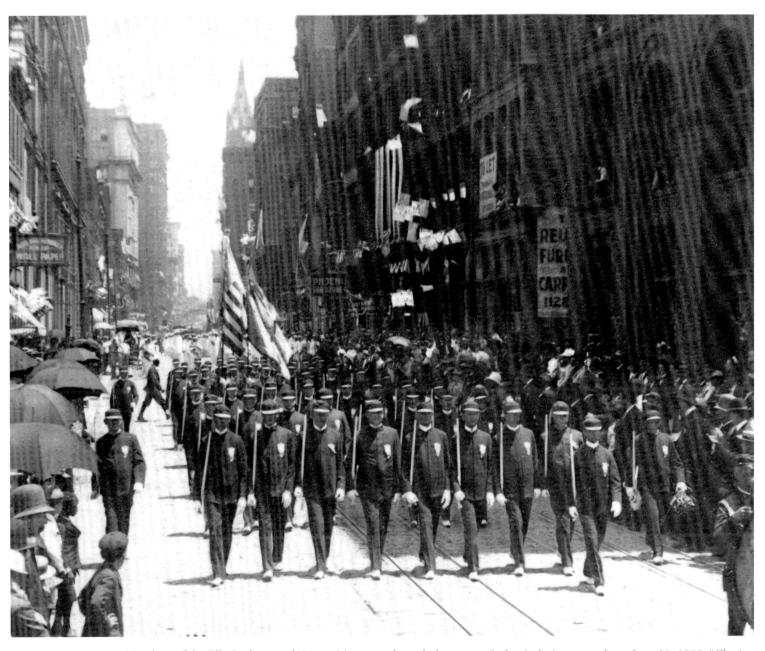

Members of the Elks Lodge march in precision rows through downtown St. Louis during a parade on June 21, 1899. "Charity, Justice, Brotherly Love and Fidelity" was the group's motto. Americans of the era relied on umbrellas, held by parade goers visible at left, to shield themselves from both rain and sun.

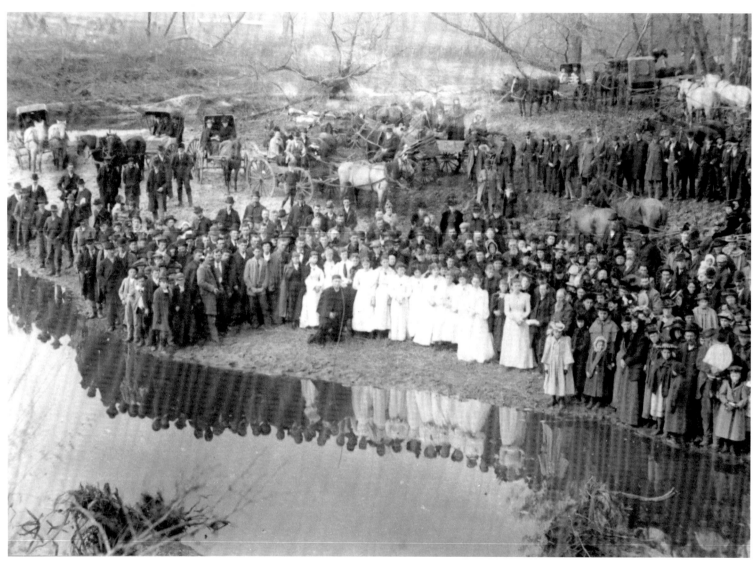

"Shall We Gather at the River?" was more than just the title of a popular hymn. Church members wearing their Sunday finest gather for a baptism service south of Newark in Knox County in 1900.

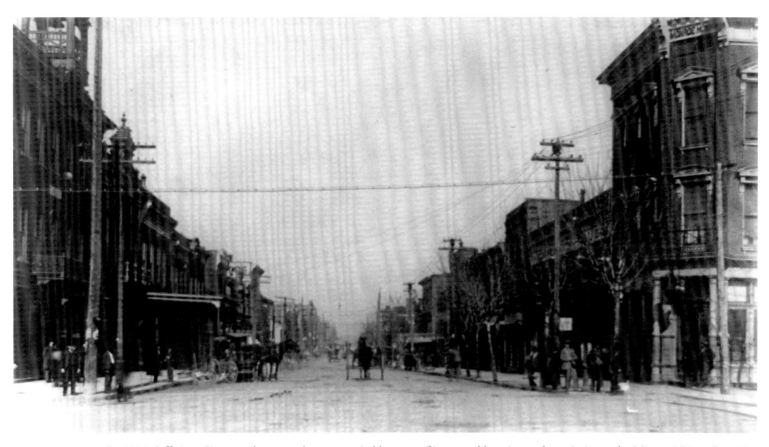

In 1821, Jefferson City was chosen as the state capital because of its central location and proximity to the Missouri River. By 1901, electricity contributed to downtown commerce along High Street and helped connect the capital to the rest of the state.

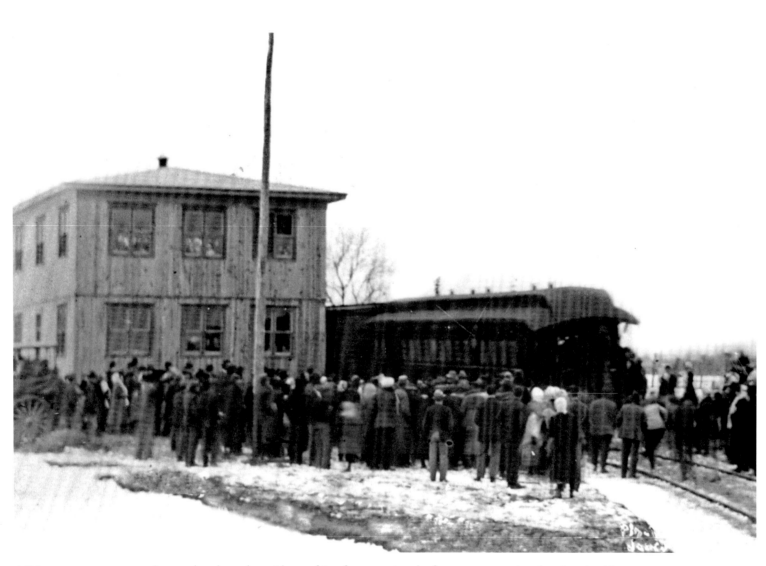

A February snowstorm wasn't enough to keep the residents of Ava from greeting the first passenger train when it arrived in 1901. Ava is the only incorporated town in Douglas County, in the Ozarks region of the south-central part of the state.

The town saloon was a popular gathering place for men of all ages in the early 1900s.

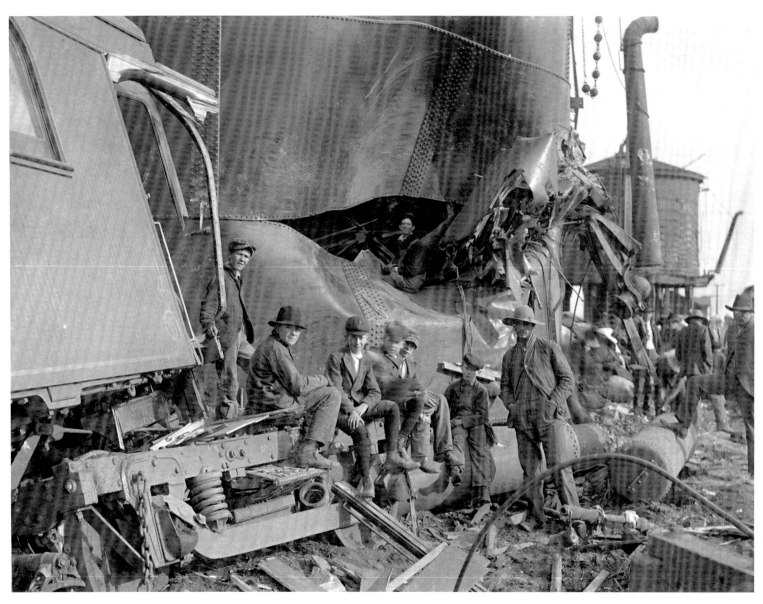

As trains became more popular, wrecks became more common. Local men assess the damage from a Santa Fe Chicago Express accident near Dean Lake in Mercer County in 1903. Water towers like the one visible in the background provided water, essential to steam engine operation. Steam engines burned wood or coal to boil water, which created the steam to power the train.

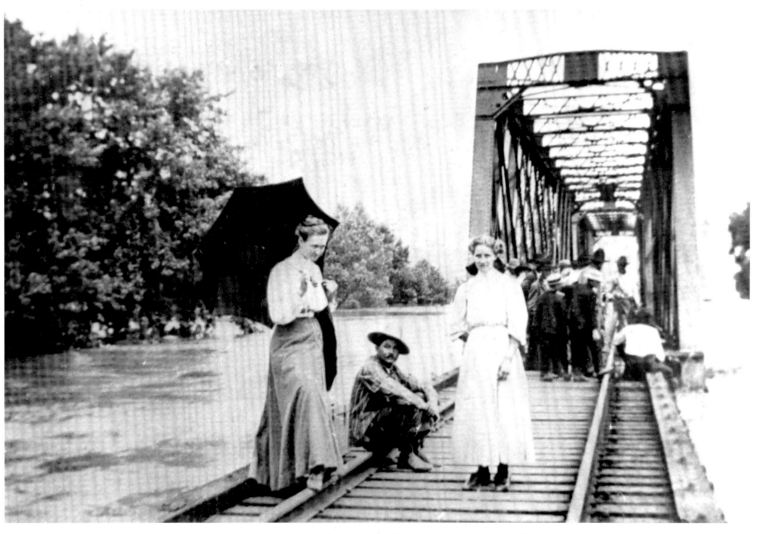

Water in the Grand River rose toward the tracks of this Rock Island Railroad bridge during a flood in the early 1900s. The river begins in Iowa and empties into the Missouri River near Brunswick.

In what could be a scene from an early comedy movie, passengers consider their options while standing on top of a flooded Missouri-Kansas-Texas (KATY) train in 1904. Accustomed to overcoming adversity, Americans a century ago could confront difficult circumstances with poise and a steady pose.

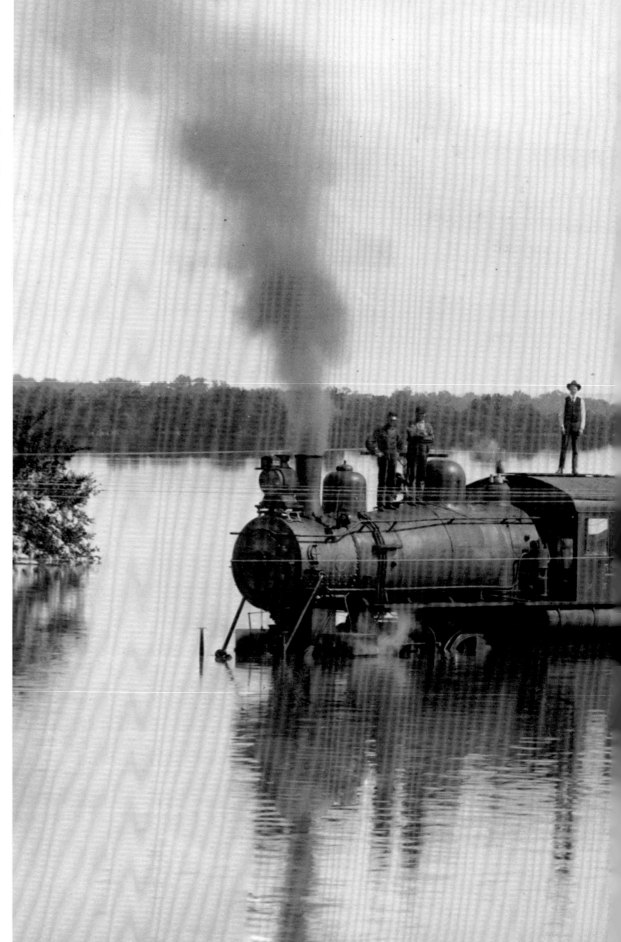

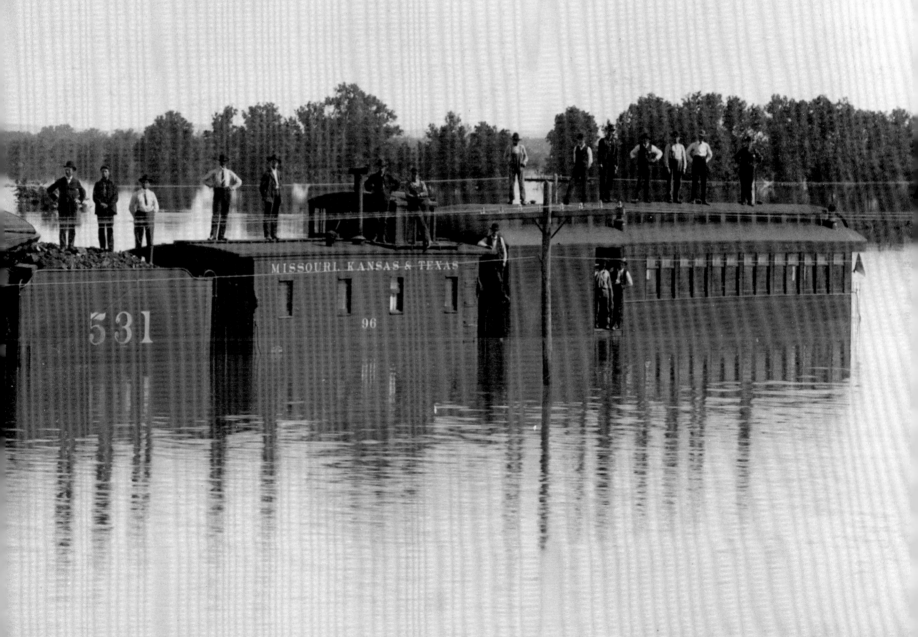

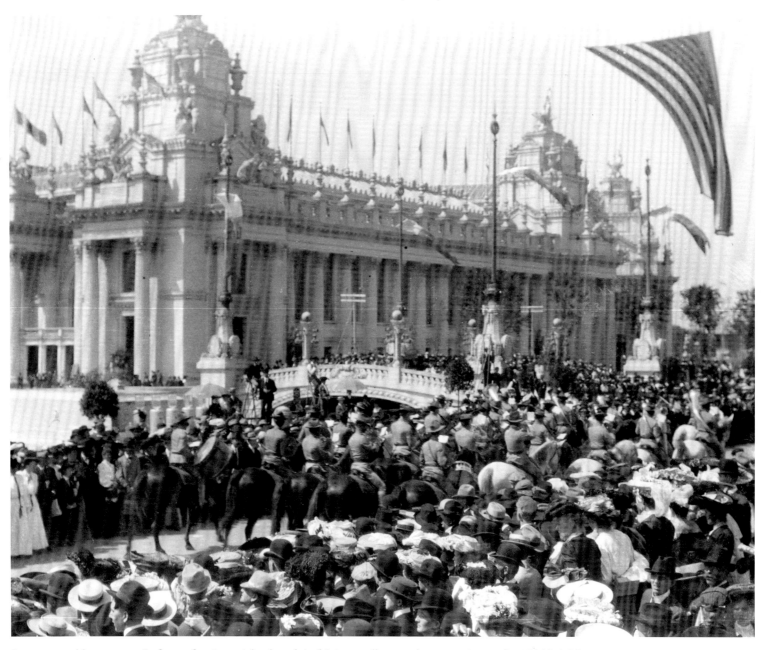

It may resemble a pageant in front of an imperial palace, but this is actually a cavalry procession at the 1904 Louisiana Purchase Exposition, or World's Fair, in St. Louis. More than 60 nations provided exhibits for the fair, which was held on the site of present-day Forest Park and Washington University.

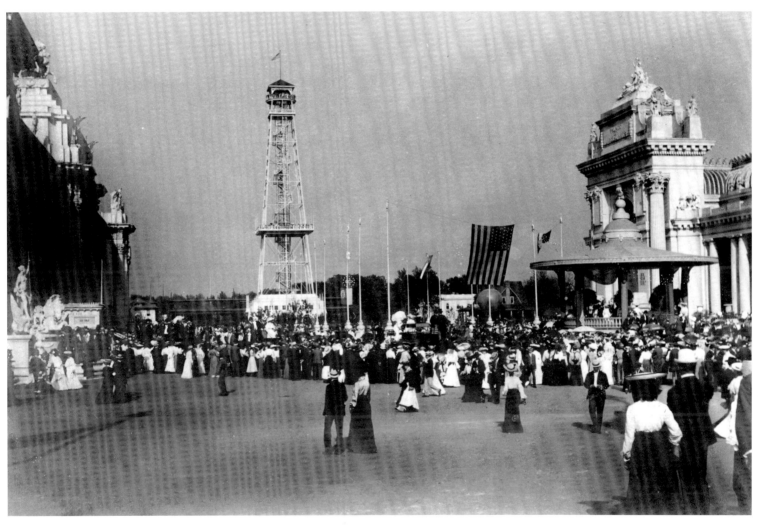

The Palace of Fine Art at the 1904 World's Fair in St. Louis was designed by architect Cass Gilbert and featured a sculpture based on the Baths of Caracalla in Rome. Located in Forest Park, the building remains a center of the city's cultural life, serving as home of the St. Louis Art Museum.

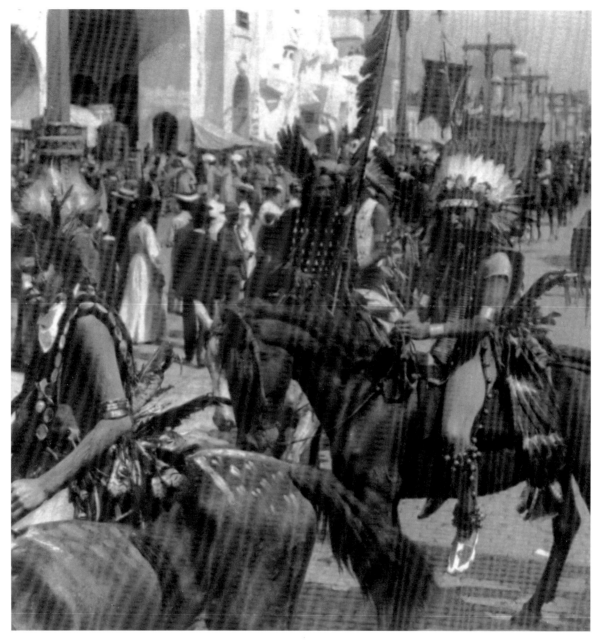

St. Louisans quickly became accustomed to a variety of cultures during the World's Fair of 1904. These representatives of ancient America ride horses through the fairgrounds wearing traditional attire. The first of the modern Olympic games to be held in the United States also took place at the fair.

THROUGH GOOD TIMES AND BAD
IN THE NEW CENTURY

(1905–1929)

As the new century dawned, Missouri boasted three million residents, a burgeoning industrial base, and a can-do spirit. The landmark Eads Bridge, linking St. Louis with Illinois across the Mississippi River to the east, stood as testament to the ability of Missourians to do whatever they set out to accomplish.

The population of Kansas City also surged during the early years of the century. Slowly but surely, it made the transition from a wide-open frontier town to a city grounded on manufacturing, transportation, and the livestock trade. Horses and buggies gave way to automobiles, and phone lines were stretched across the landscape, connecting small towns and rural areas to the cities. Smaller cities such as Springfield, Columbia, and St. Joseph grew into regional commercial hubs. Jefferson City, in the central region of the state, continued its role as state capital.

At the same time they were growing the state economy, Missourians also took time to enjoy themselves. All eyes were on the sky during the early days of aviation. Barnstormers entertained crowds at the Missouri State Fair in Sedalia, and a young Charles Lindbergh was pushing the limits of flight at Lambert Field in St. Louis. Bluegrass and folk music echoed from the hollows of the Ozark Mountains. Jazz began to emerge in the urban areas. Throughout the state, moviegoers packed local theaters to see the latest Hollywood releases.

While Missourians and the nation at large prospered, dark clouds were building on the horizon. Local disasters, such as floods and fires, are forever, but a war was brewing across the Atlantic. In 1917, thousands of Missouri soldiers would leave their families to fight the "War to End All Wars," including a youthful Harry S. Truman. The University of Missouri in Columbia later built Memorial Union to honor the 117 students who lost their lives in service to the nation during World War I. All told, 11,172 Missourians became casualties of the war effort, helping to win victory overseas and secure the status of the United States as a world power.

With the war behind them, families were eager for life to return to normal. For 10 years, Missourians and all Americans enjoyed an era of peacetime prosperity. In October 1929, however, the stock market collapsed, sending the nation into the Great Depression. Once again, Missourians would have to dig deep to show their resiliency.

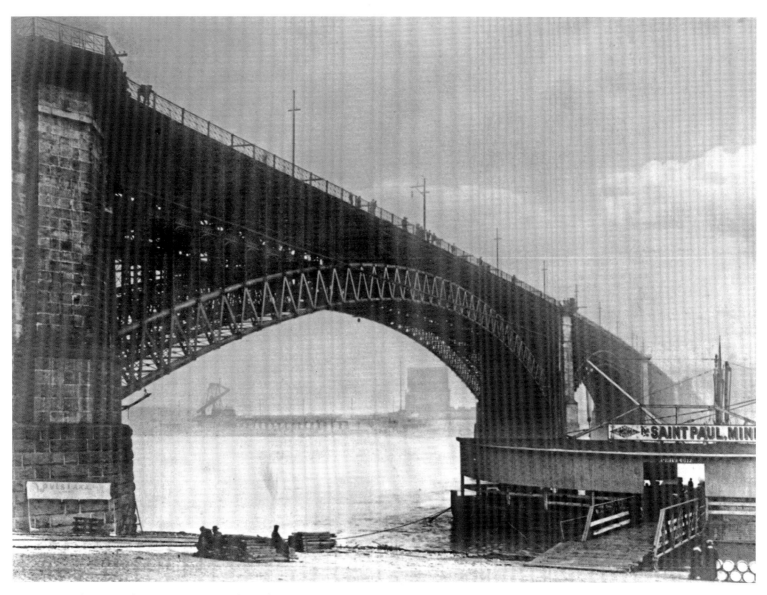

The Eads Bridge spans the Mississippi River for both road and rail traffic between St. Louis and East St. Louis, Illinois. The span, designed by James Eads and built in 1874, at the time was the longest arch bridge in the world and the first bridge to span the great river at its greatest widths. The bridge was featured on a two-cent postage stamp commemorating the Trans-Mississippi Exhibition of 1898. A steamer from St. Paul, Minnesota, is being loaded in this 1905 photograph.

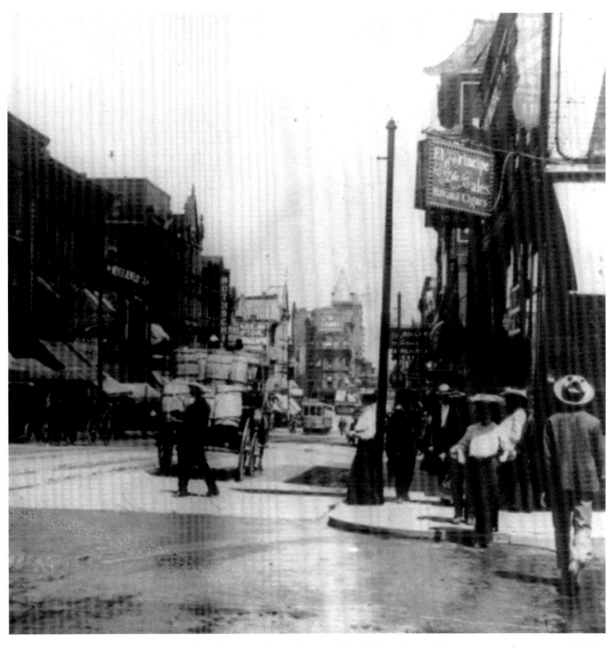

Everything's up-to-date in Kansas City, judging from this street scene from around 1905.

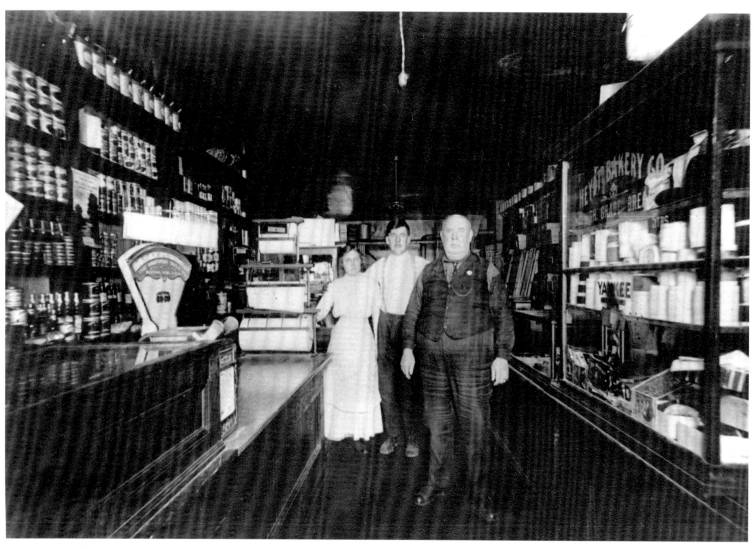

The staff of the William H. James Store in Valley Park offered one-stop shopping early in the century. The St. Louis County community featured one of the first post offices in the area and was also a hub for the Missouri Pacific and St. Louis–San Francisco railroads.

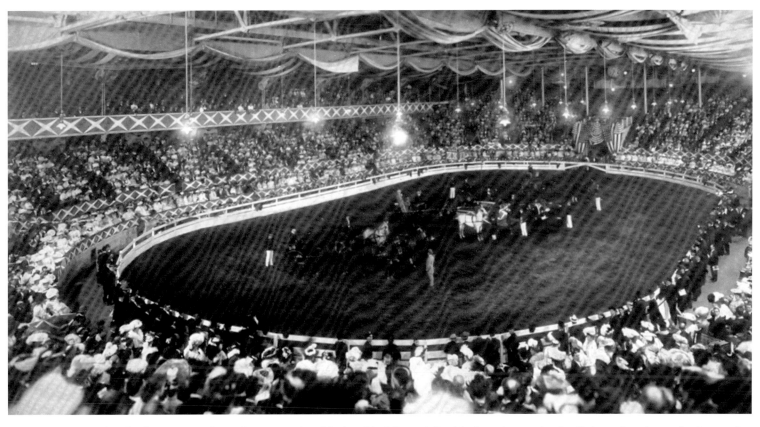

Rural and urban interests have always gone hand-in-hand in Missouri. In this view, thousands of well-dressed equine enthusiasts gather for the Kansas City Horse Show in 1905. The city remains home to the prestigious American Royal livestock show each fall.

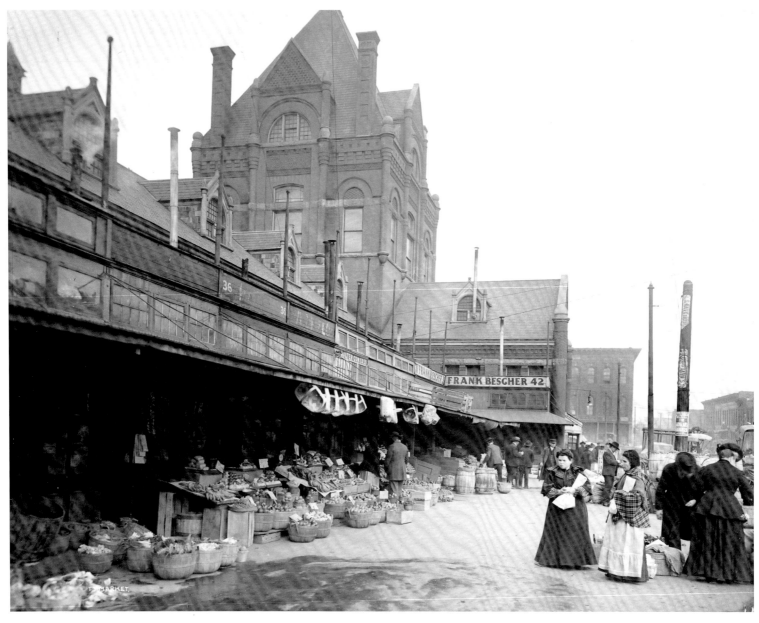

City Market has been bringing country fresh fruits and vegetables to Kansas City residents for well over a century. Women shop for bargains in this photograph from 1906. The market, located between downtown and the Missouri River, continues to thrive today.

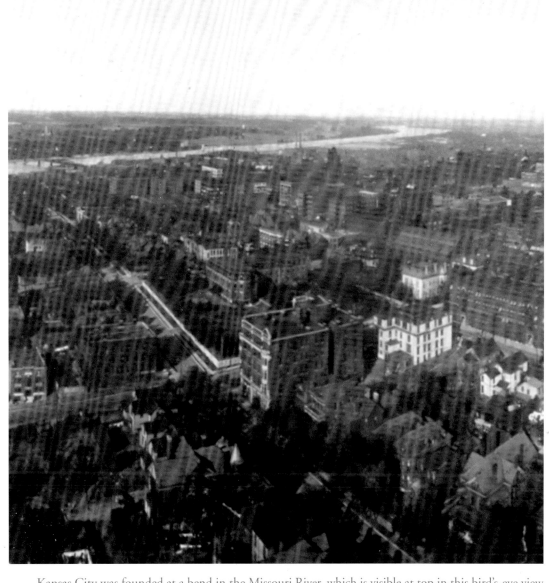

Kansas City was founded at a bend in the Missouri River, which is visible at top in this bird's-eye view from around 1907. The image faces north toward downtown.

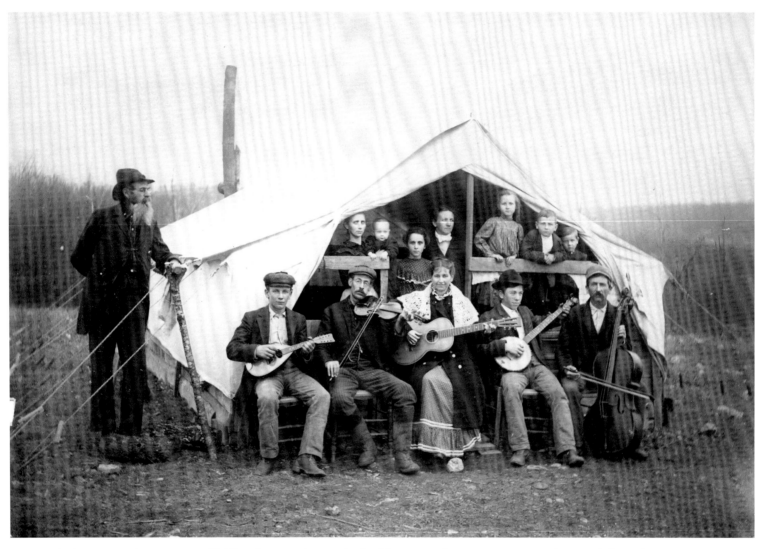

The Ozarks have inspired generations of fiddlers, banjo pickers, and other bluegrass and country musicians. The Stonehill Band makes music near Salem in Dent County in late 1907.

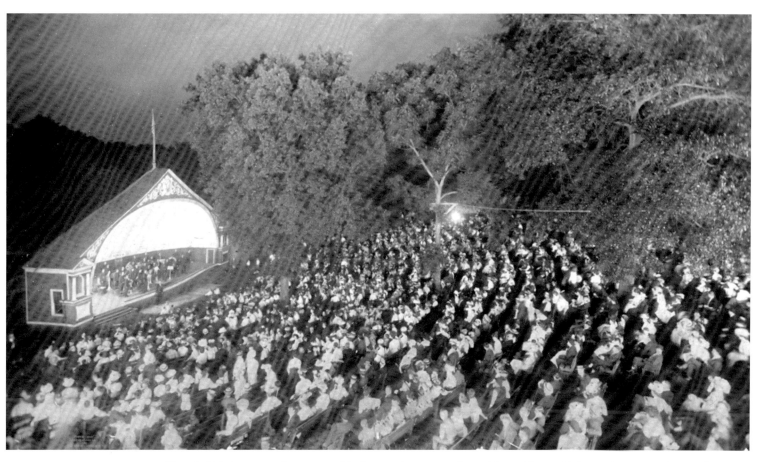

Electric lighting opened a new world of entertainment to city residents. Kansas Citians enjoy an evening performance at Fairmount Park in the early 1900s.

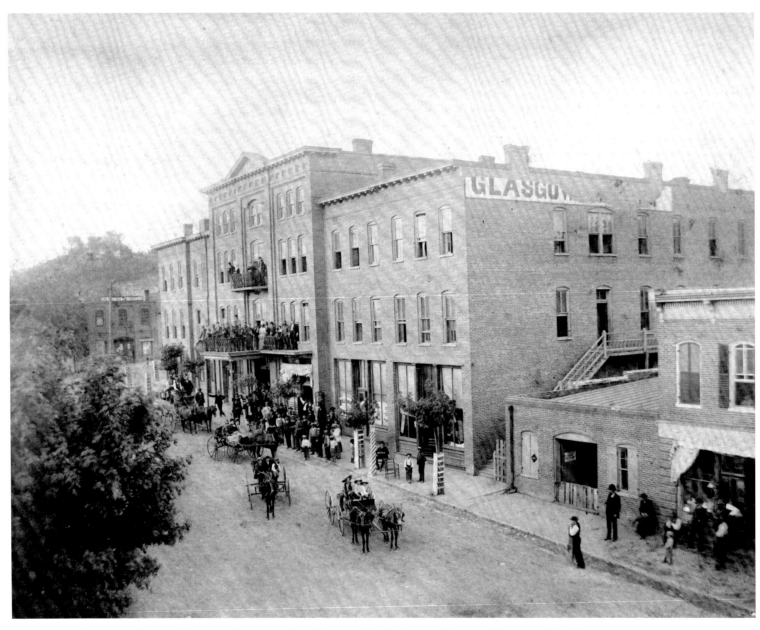

Glasgow, in Chariton and Howard counties, has a proud tradition as a riverboat town. Horse-and-buggy traffic, shown here around 1908 in front of the Price Hotel, was also bustling.

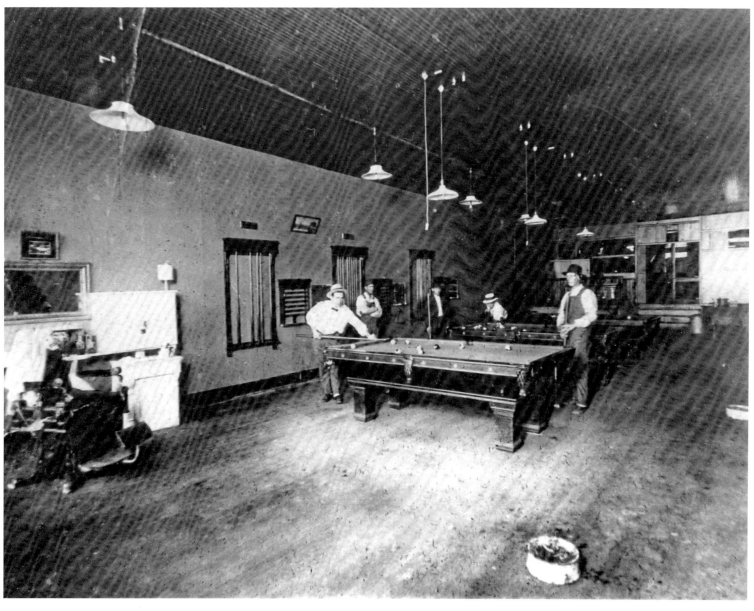

In 1907, men in Blue Springs could unequivocally tell their wives they were going out to "queue" up for a haircut at this combination barbershop and pool hall. The barber's chair is unoccupied at left; the unshorn are patiently waiting their turn for a cut and shave at right.

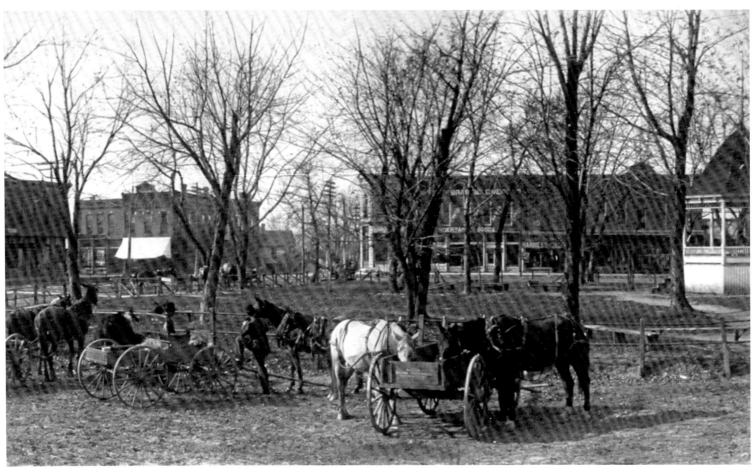

Horses and buggies were still the dominant means of transportation in Unionville around 1908. Visitors tied up their horses around the town square while visiting local businesses. The town is close to the Iowa border in north-central Missouri.

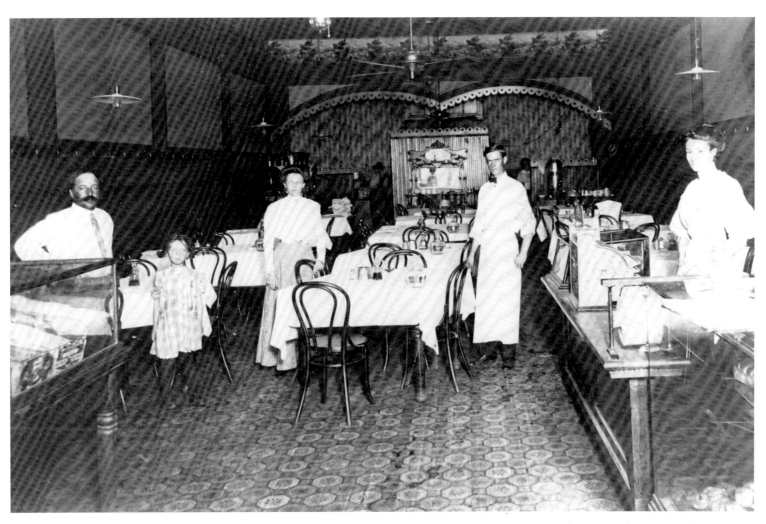

White-tablecloth restaurants are nothing new to the state. Diners at Domino's Café in Springfield early in the twentieth century were greeted by waitresses in dresses and waiters in white shirts and neckties. Ceiling fans helped keep diners cool in the days before air conditioning.

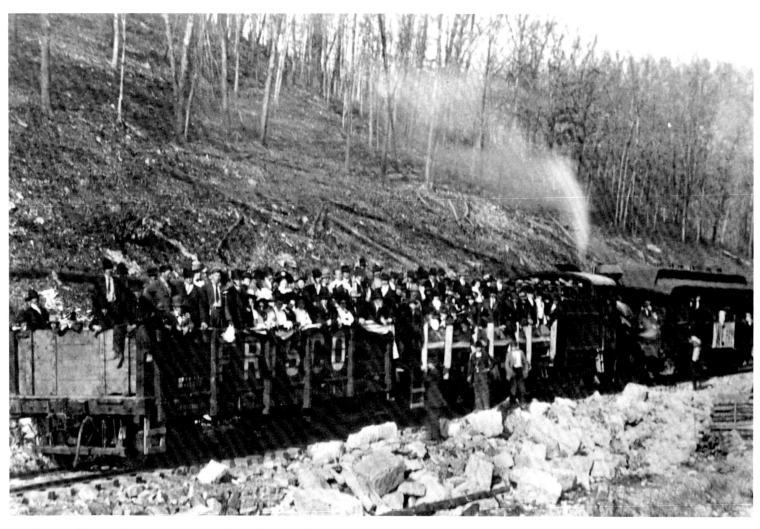

It's "all aboard" as southern Missourians pack the first branch railroad train from Mansfield to Ava in March 1910. Writer Laura Ingalls Wilder and her family had moved to a farm near Mansfield 14 years earlier.

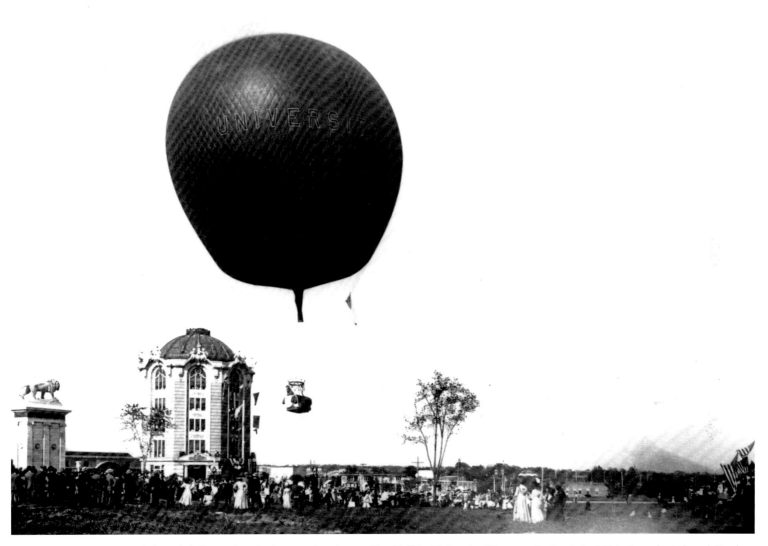

A hot-air balloon dwarfs the crowd and even City Hall in University City near St. Louis in 1910. Founder Edward Gardner Lewis originally built the unusual structure as part of his publishing empire. Lewis hired architect Herbert C. Chivers in 1903 to design the new headquarters, known familiarly as the Woman's Magazine Building.

"Clang-clang-clang went the trolley." Just as in the movie *Meet Me in St. Louis,* streetcars were relied on for traversing the city in the early 1900s.

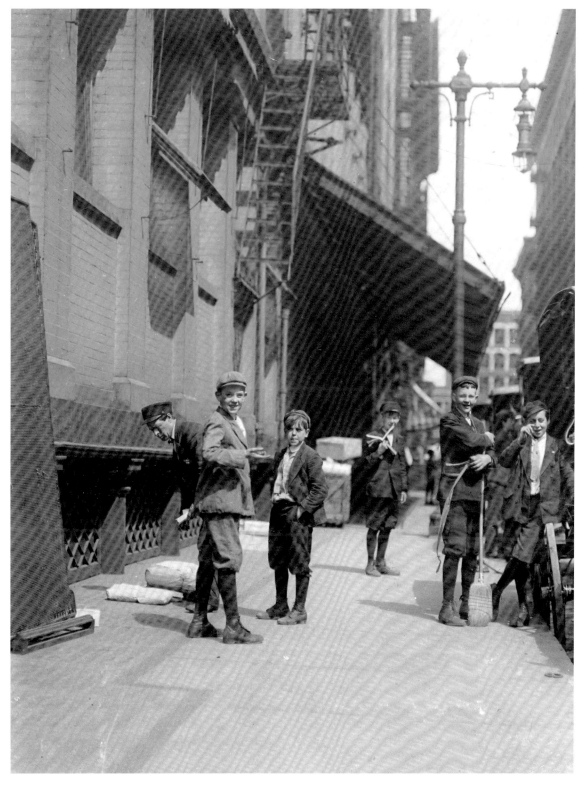

What were the better-dressed kids in St. Louis wearing in 1910? These boys sport knickers and caps as they hang out in front of Nugent's, downtown at Washington Street and Broadway.

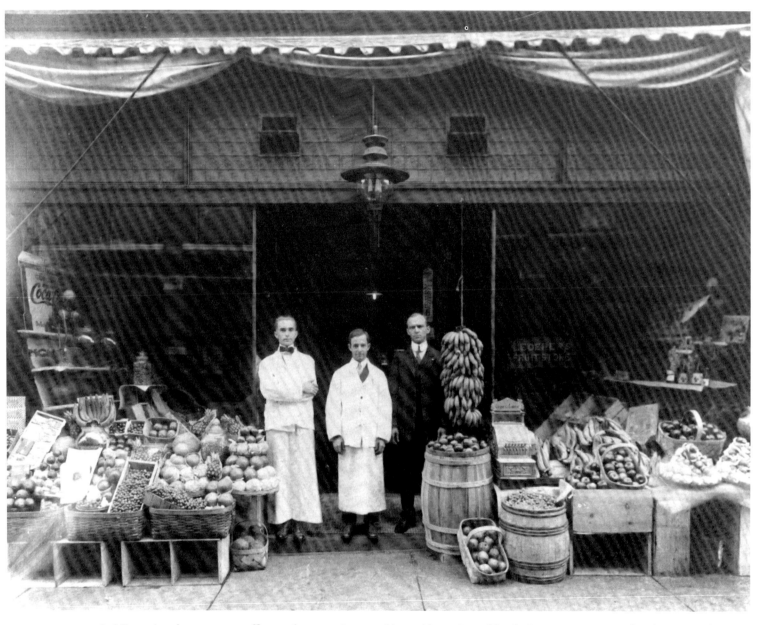

As Missourians became more affluent, they grew interested in a wider variety of foods. Bananas, once considered an exotic fruit, are displayed alongside local produce at Lederer's Fruit Store in Springfield in 1910.

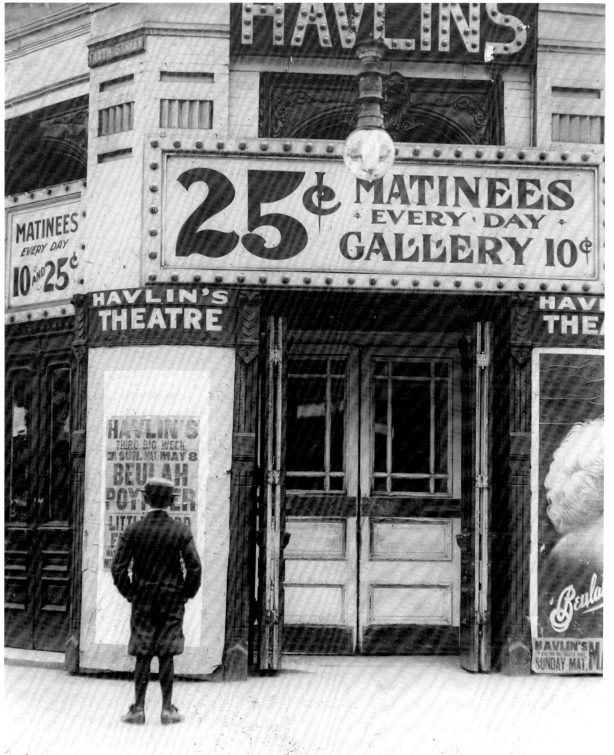

Even in 1910, 25-cent matinees and 10-cent gallery seats must have seemed like a bargain. A St. Louis boy checks out a poster for the latest Beulah Poynter movie at Havlin's Theatre.

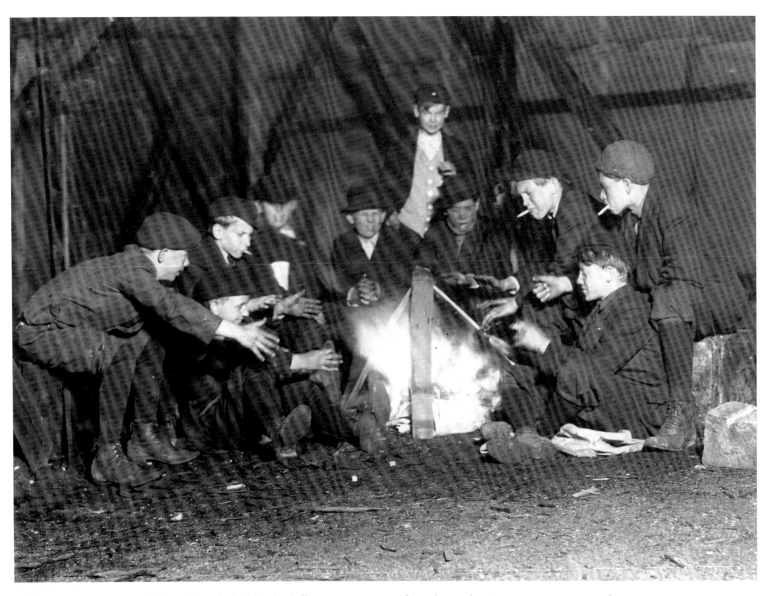

Delivering newspapers at night can be a chilly job. The Jefferson Street Gang of newsboys takes time to warm up around a campfire in a corner lot on Jefferson Street near Olive Street in 1910.

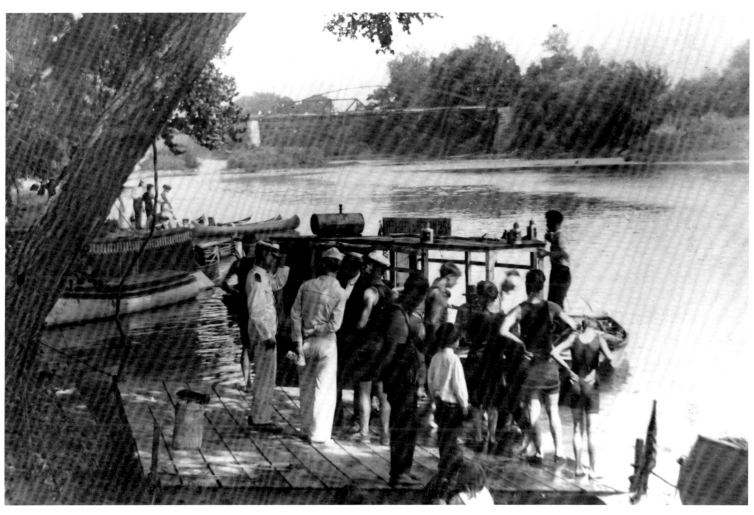

Missouri summers can get pretty steamy, and one of the best ways to cool off is to swim or boat in the river. A group of Valley Park residents enjoys a visit to the Meramec River in 1910. The Meramec flows two hundred miles before emptying into the Mississippi.

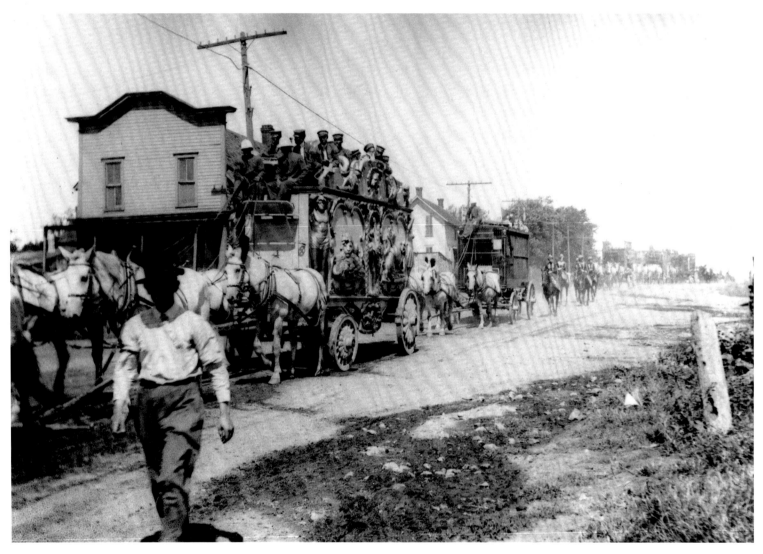

Life could be hard in the early twentieth century, but people still found ways to make merry. In this view from 1910, ornately carved circus wagons parade through Monett, in Barry County near the Arkansas border, to announce the arrival of the circus. Youngsters everywhere eagerly anticipated the coming of the circus each year.

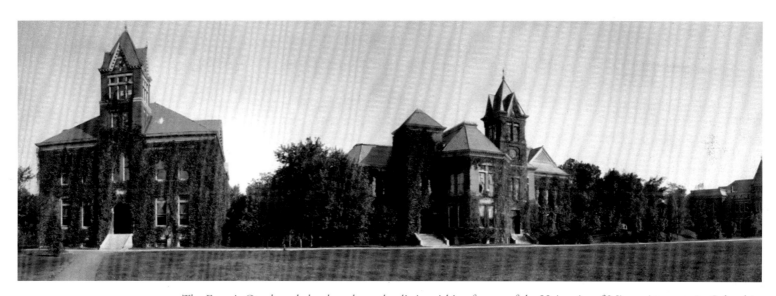

The Francis Quadrangle has long been the distinguishing feature of the University of Missouri campus in Columbia.

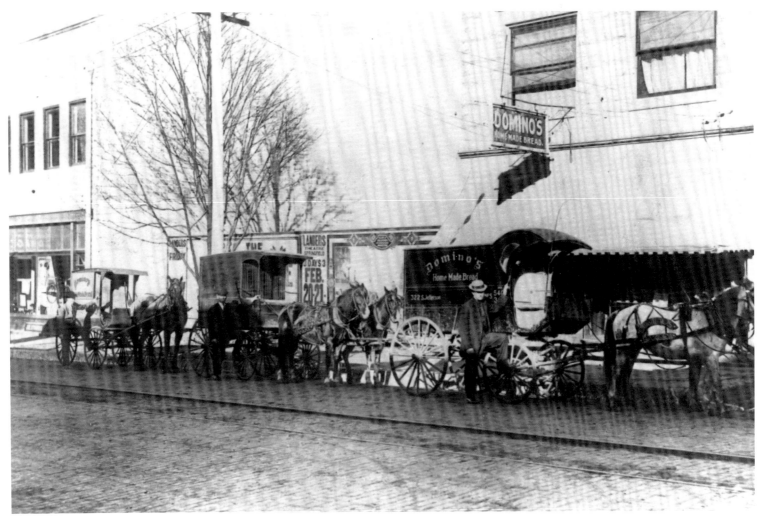

Domino's horse-drawn delivery service prepares to distribute fresh loaves of the company's "Home Made Bread" throughout Springfield.

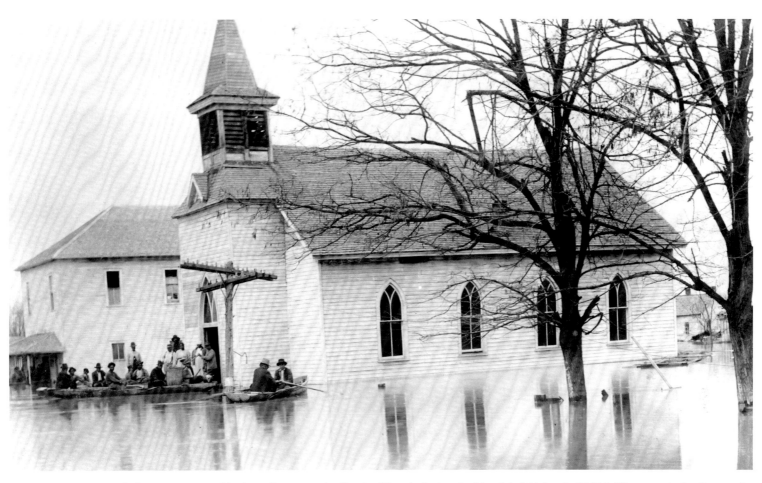

Refugees are rescued by boat from near the Baptist Church during the New Madrid flood of 1912. The town is also famous for the New Madrid earthquakes a century earlier, which were so powerful they caused the Mississippi River to flow backward.

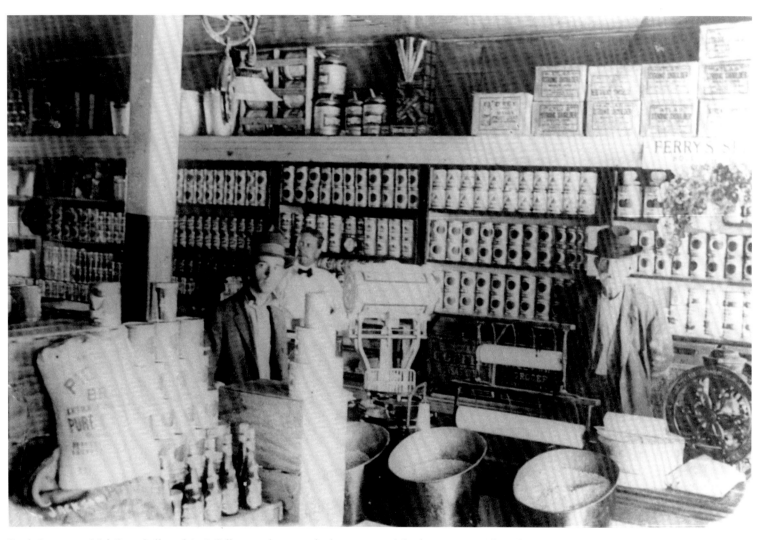

Buck Patterson, Mel Campbell, and A. J. Sellars catch up on the latest news while shopping at Nyhart Store in Bates County in 1913. The well-stocked shelves included everything from canned goods to garden seed.

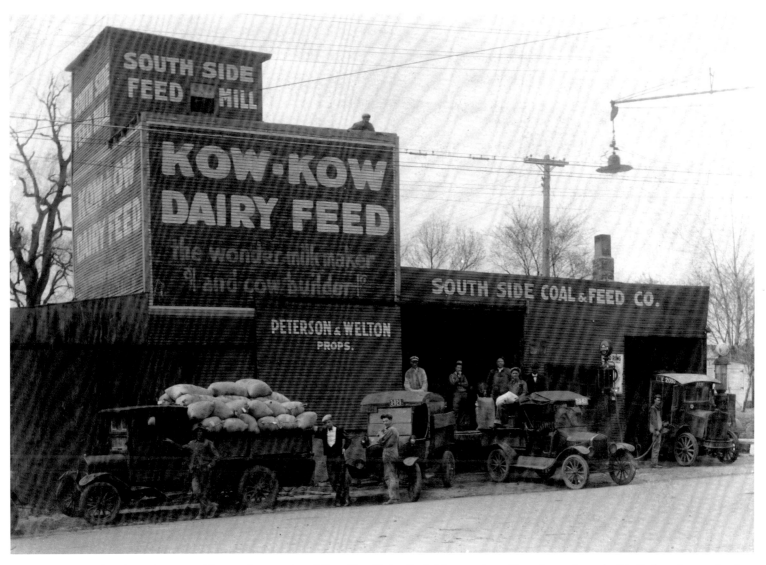

What dairy farmer could resist the promise of Kow-Kow Dairy Feed, "the wonder milk maker and cow builder"? Area farmers load up on the feed at South Side Coal & Feed Company in Independence in 1914.

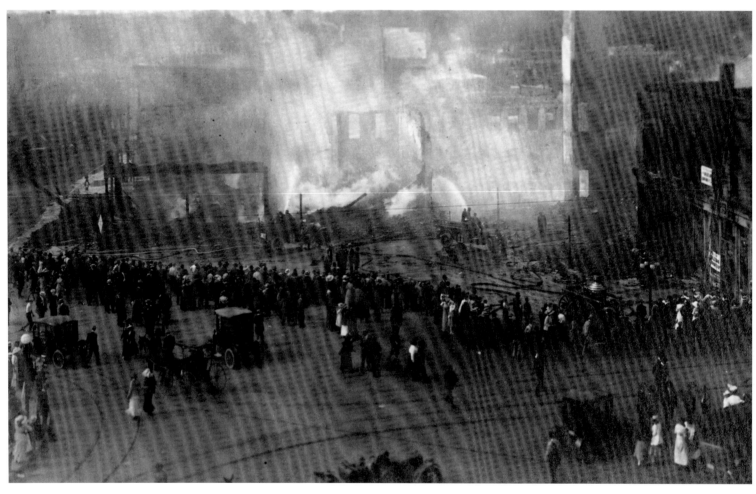

Throngs of onlookers watch fire fighters extinguish the smoldering remnants of a downtown fire in Springfield in 1913.

Several people were killed when the seven-story Missouri Athletic Club building in St. Louis went up in flames in March 1914. The cost of the blaze was estimated to be more than $350,000.

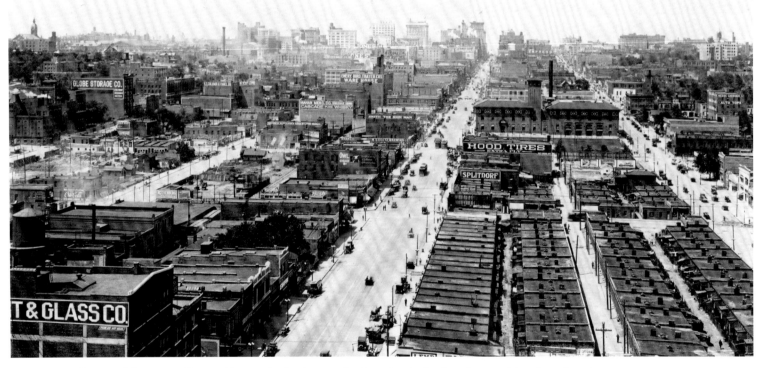

The business district of downtown Kansas City was beginning to take shape in 1915, when the transition from frontier town to the city of today was in full swing. Streetcars and horse-drawn vehicles now shared the thoroughfares with the growing number of automobiles.

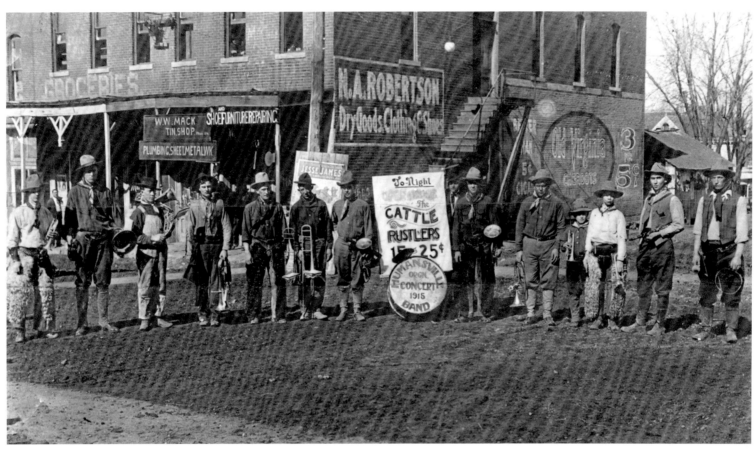

It may resemble the Wild West, but the setting for this concert by local cowboys known as the Humansville Band was Polk County in 1915. The performance was held on the street in front of the N. A. Robertson Dry Goods store.

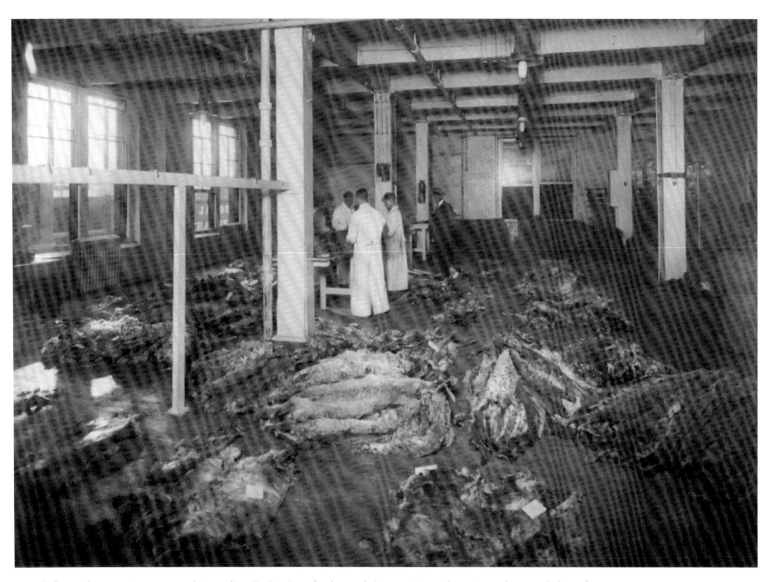

French fur traders were instrumental in settling St. Louis and other early towns. Around 1915, workers grade lynx furs in preparation for the Funsten Public Auction Fur Sale in St. Louis.

Ready! The headline says it all as Missourians got acquainted with newfangled flying machines. Charles Lindbergh would bring worldwide attention to the state in 1927 when he flew his *Spirit of St. Louis* nonstop from New York to Paris.

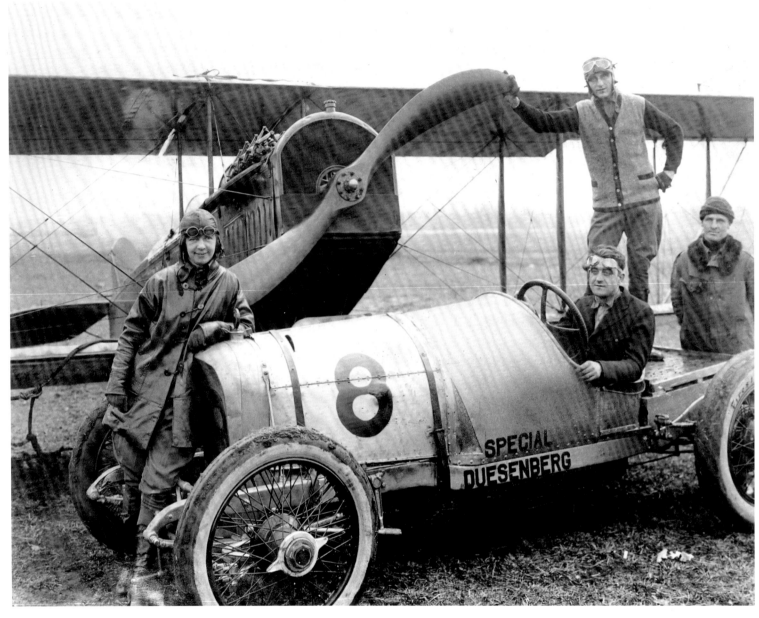

Ruth Law's Flying Circus took to the skies above the Missouri State Fair in 1921. The fair had already earned a reputation for aeronautical exhibitions, with Orville and Wilbur Wright themselves performing in 1910. As a leading barnstormer during the early era of flight, Law would beat the odds, retiring from exhibition flying and living to the age of 83.

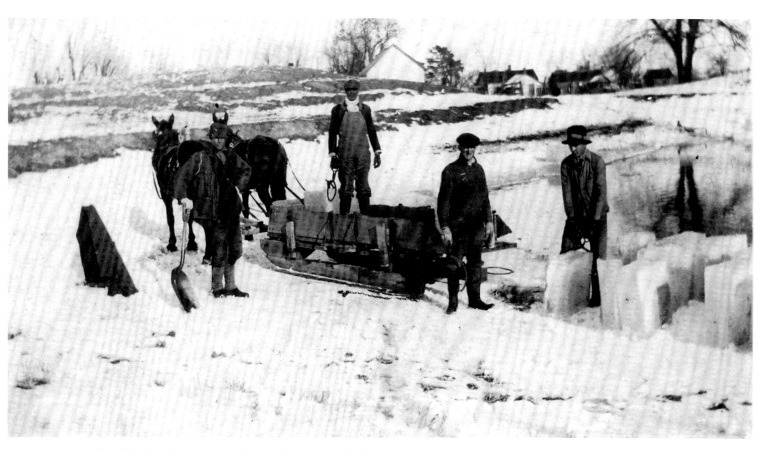

These blocks of ice may have been cold in the dead of winter, but they sure came in handy on a hot July day. Workers near Renick in Randolph County harvest blocks of ice and haul them by sleigh for storage in 1918.

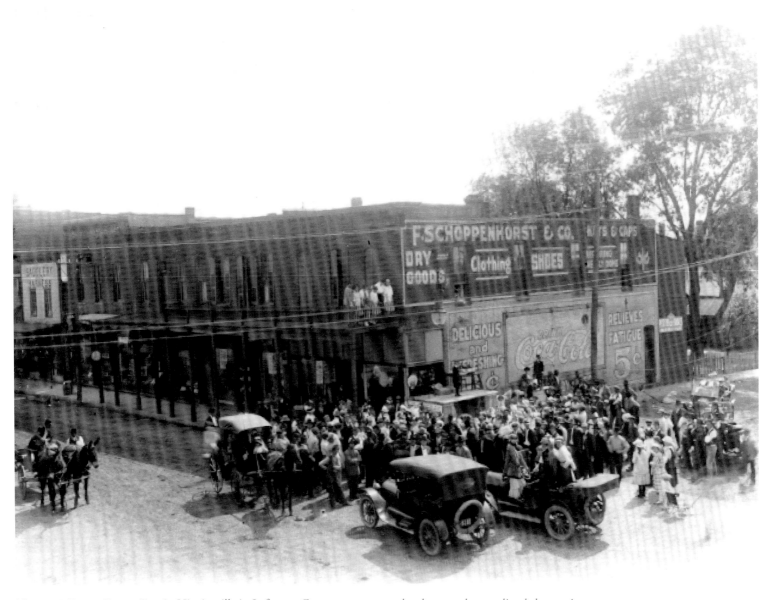

The 1918 Buster Brown Day in Higginsville in Lafayette County was so popular that people even lined the awning above F. Schoppenhorst & Company Dry Goods store. After all the excitement, attendees could unwind with a five-cent glass of Coca-Cola, advertised in hand-lettered signage as able to "relieve fatigue."

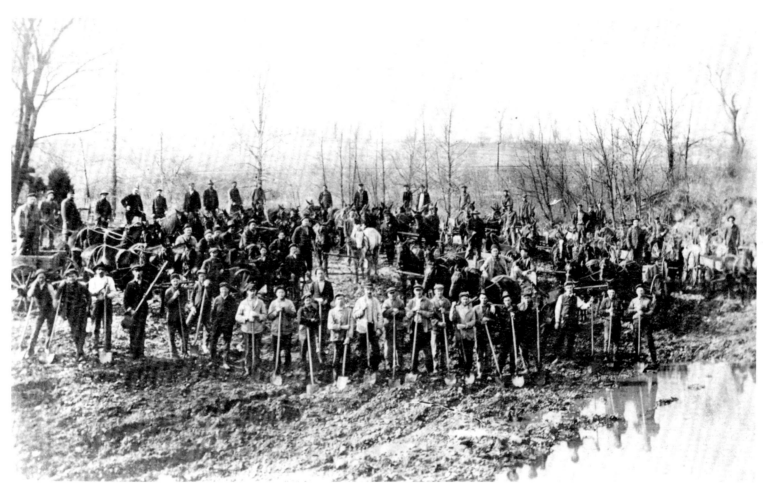

A muddy slough fails to dampen the determined spirits of this road-building crew in Ste. Genevieve in 1918.

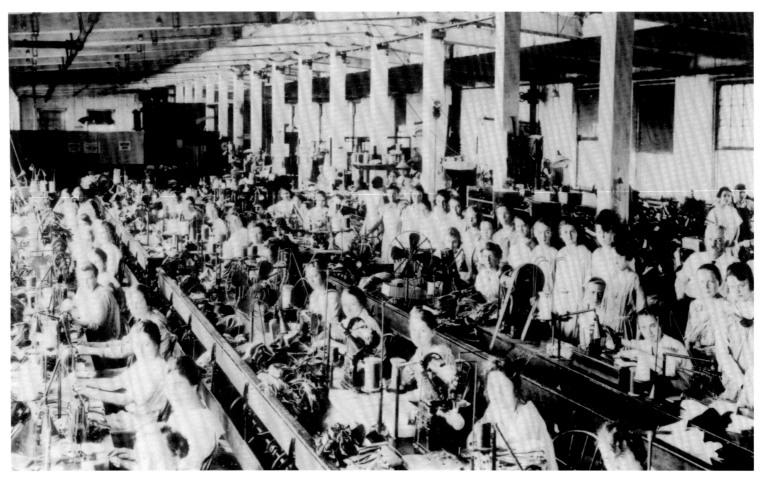

Hundreds of women found jobs in the city as the state moved from a rural to an urban economy. Rows of women put their sewing skills to commercial use in the stitching department of A. Priesmeyer Company in St. Louis in 1918.

Early grocery stores were a lot like today's convenience markets. Patrons of E. B. Rader Grocery Store in Conway, shown here posing for the photographer in 1919, could also purchase candies, ice cream, and cigars. The town is in Laclede County in south-central Missouri.

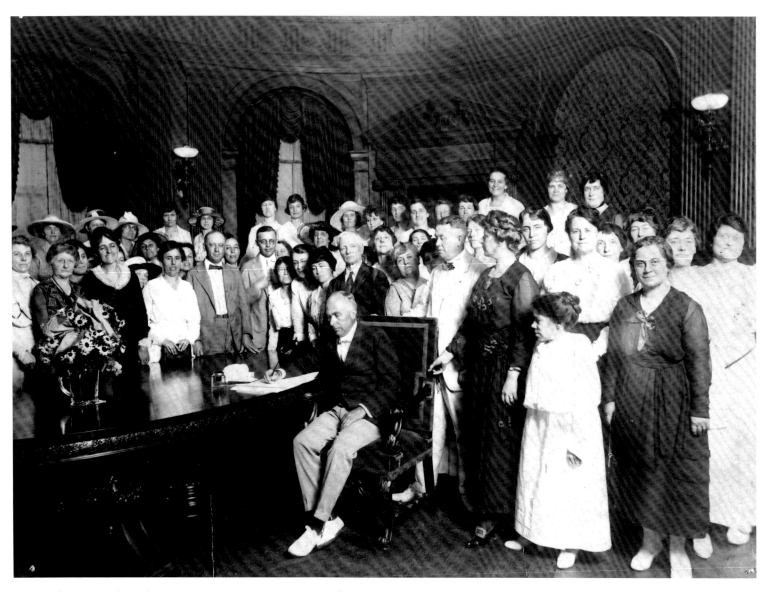

Women from around the Show-Me State surround Governor Frederick Gardner as he signs a resolution ratifying the 19th Amendment, giving women the right to vote. In 1919, Missouri became the eleventh state to ratify the amendment.

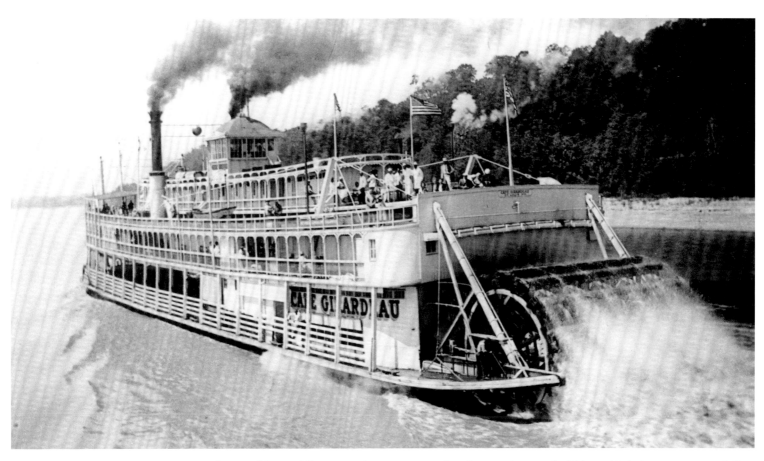

Missouri, with two of the world's greatest rivers, was central to the steamboat trade. This multi-deck steamer, named *Cape Girardeau,* carries passengers on the Mississippi River.

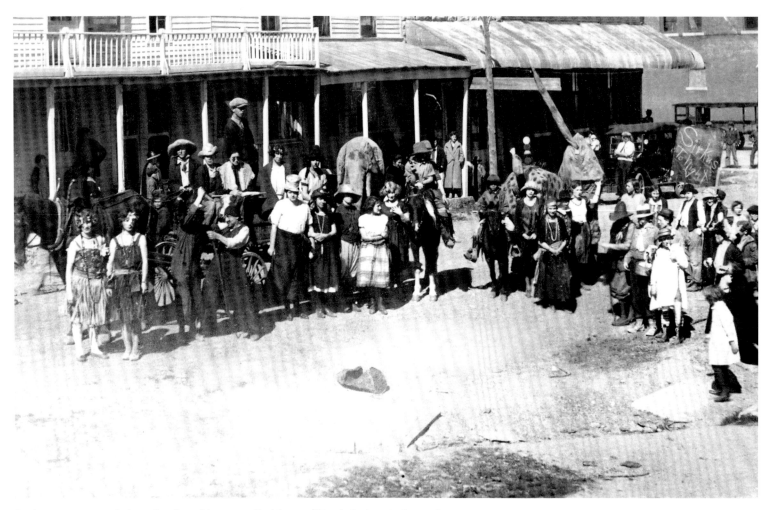

Business comes to a halt as the circus hits town. Residents of Reeds Spring, in Stone County near Branson, turn out in force for this 1920 circus parade.

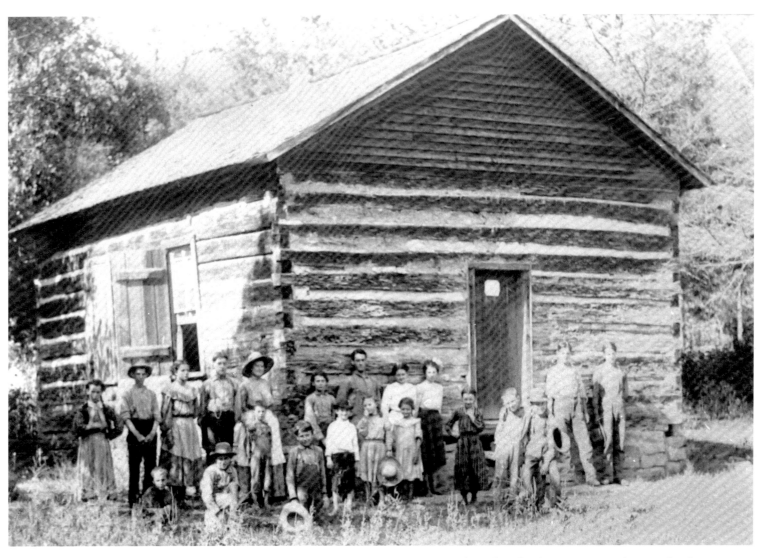

Students at the Old Bee Creek School in Taney County are dressed up for this 1920 group photograph. The one-room schoolhouse was made of hand-hewn square logs from trees felled in the nearby woods.

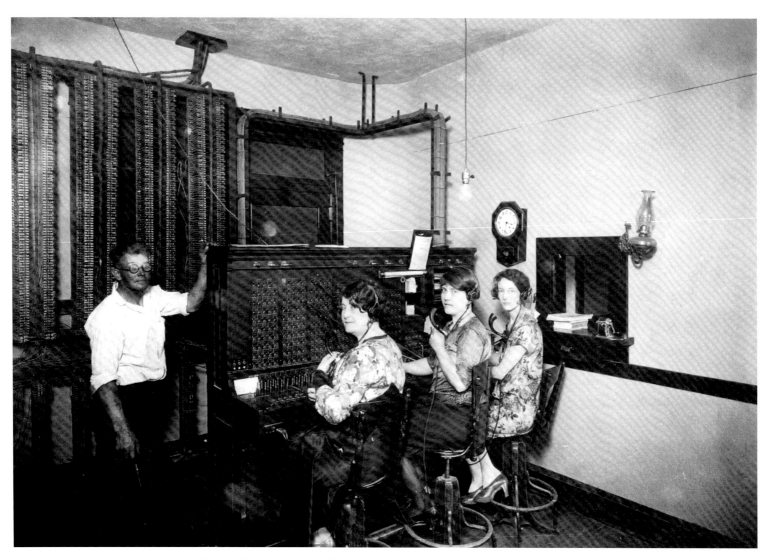

When early phone systems were installed, small-town women often found work as switchboard operators. These women are ready to patch calls through in Lancaster in Schuyler County in 1921.

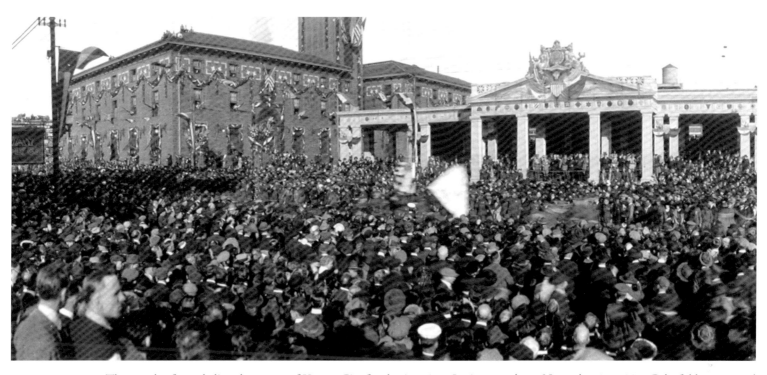

Thousands of people line the streets of Kansas City for the American Legion parade on November 21, 1921. Colorful banners and bunting decorate the Kansas City Star building on the left. A mere three years had elapsed since the armistice was signed ending World War I, and patriotic fervor continued to run high.

The visionary J. C. Nichols developed Kansas City's Country Club Plaza as one of the nation's first shopping districts. This 1920s photograph from the intersection of 47th Street and J. C. Nichols Parkway shows that the Plaza was already a hit with motorists.

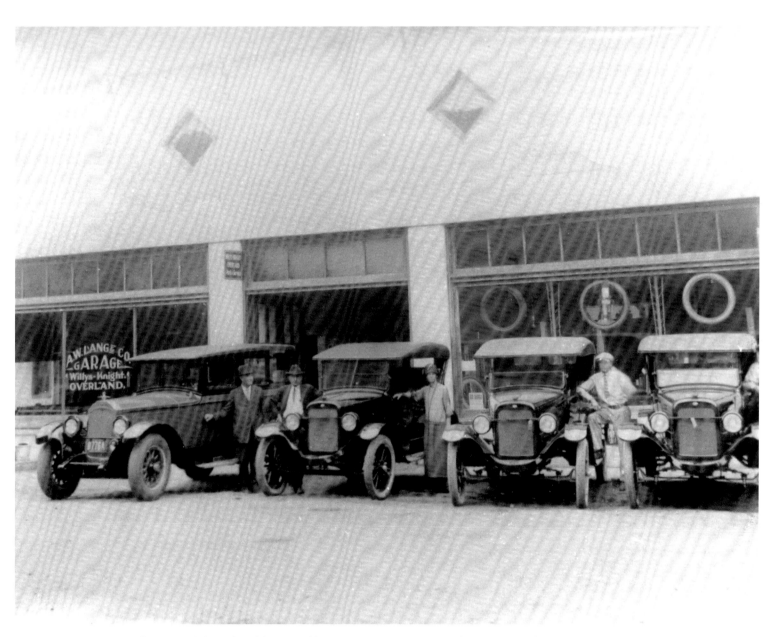

As the automobile replaced horse-and-buggy transportation across the state, a number of garages opened up to provide sales and service. Adam Lang's Garage on West Main Street in Kahoka attracted Clark County car shoppers in the 1920s.

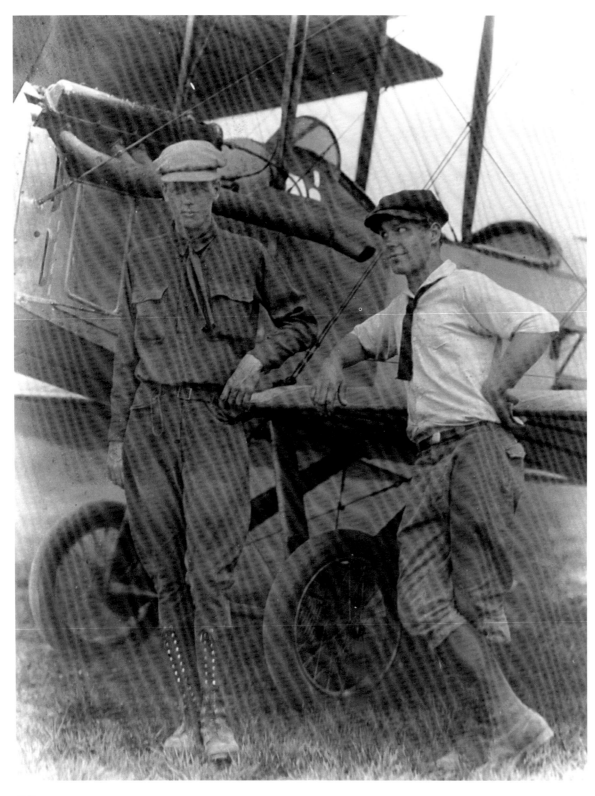

Charles Lindbergh poses in front of a biplane with Harlan "Bud" Gurney at Lambert Field in St. Louis in 1923. The National Air Races at Lambert Field that year set new standards for aeronautical exhibitions. St. Louis and human flight enjoy a long and storied association. The first president to fly in an airplane, Teddy Roosevelt, took that first flight at Lambert, then known as Kinloch airfield.

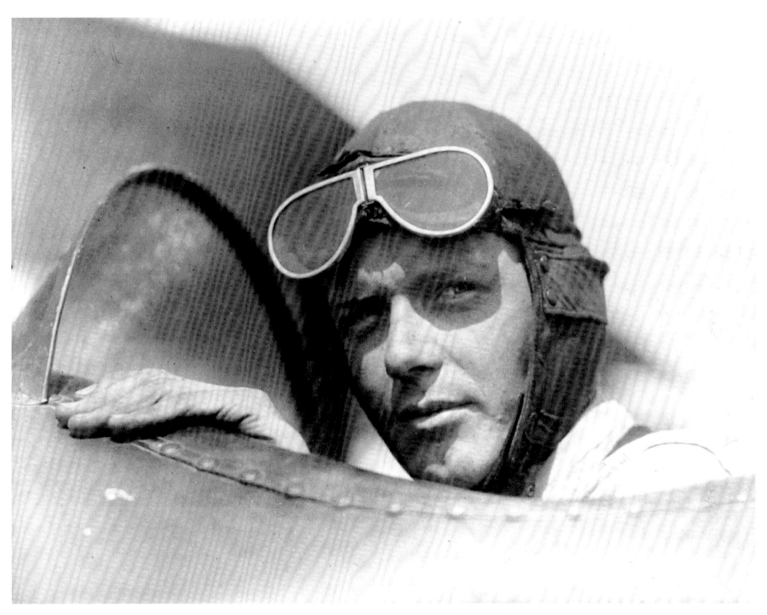

In goggles and flight helmet, Charles Lindbergh sits in the open cockpit of an airplane at Lambert Field in St. Louis in 1923. He had flown to St. Louis to attend the National Air Races being held there, not as a participant, but as a spectator. As a barnstorming wingwalker, test pilot, air mail carrier, and survivor of four emergency bailouts, "Lucky Lindy" would go on to achieve legendary fame for his solo flight across the Atlantic in the *Spirit of St. Louis*.

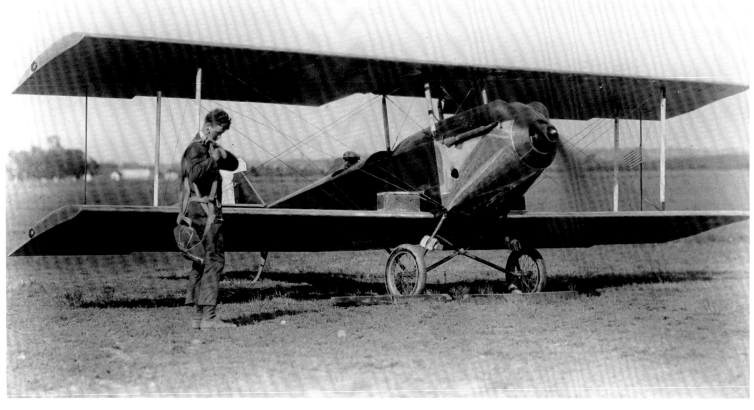

Charles Lindbergh, perhaps the most famous aviator of the twentieth century, adjusts his parachute before testing Sergeant Bell's experimental biplane (Bell is seated in the cockpit). Lindbergh made the flight in 1925 at Lambert Field in St. Louis.

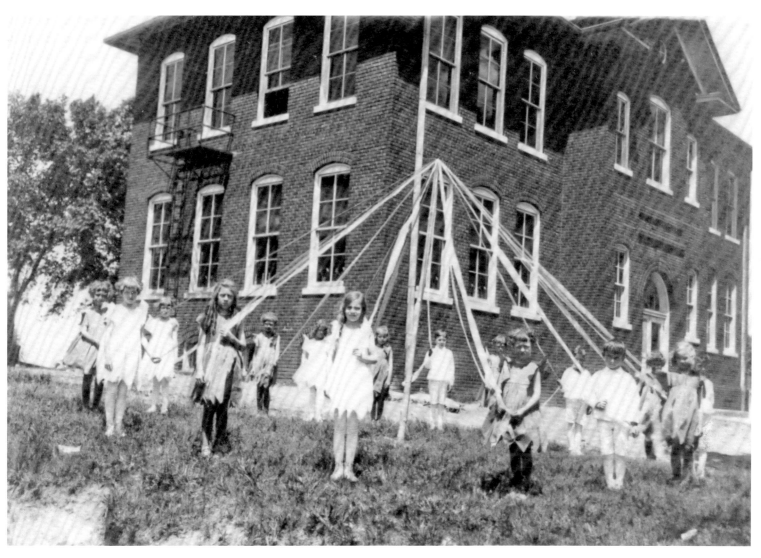

It's hard to keep the kids indoors when the weather turns warm in the spring. Students in the town of Blackburn perform a traditional May Pole dance in 1923.

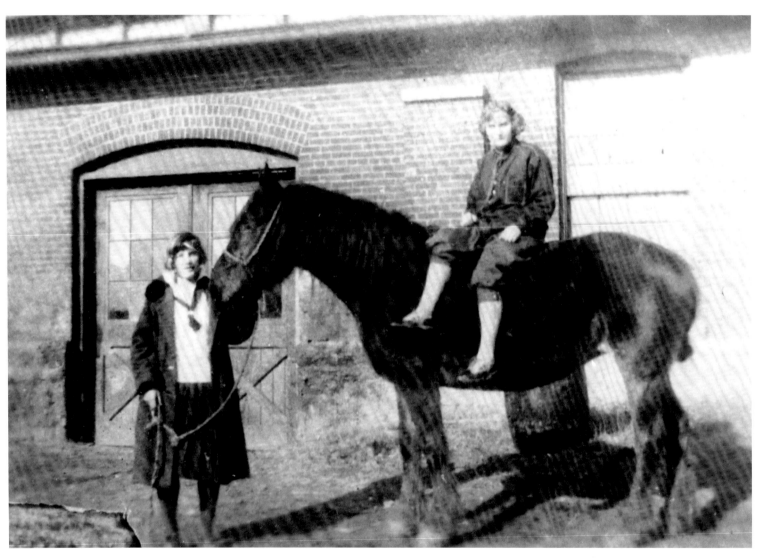

This horse may be blind, but it served its country well during World War I. Mary and Martha Beard of Edina in Knox County pose with their beloved friend in 1923.

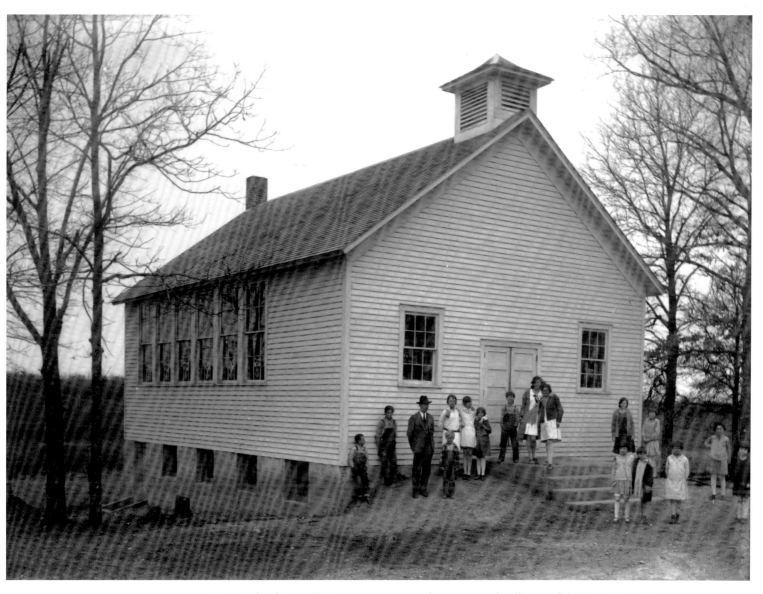

Moser School in rural Missouri was a typical one-room schoolhouse of the late 1920s. The teacher, wearing a jacket, tie, and hat, taught children of all ages.

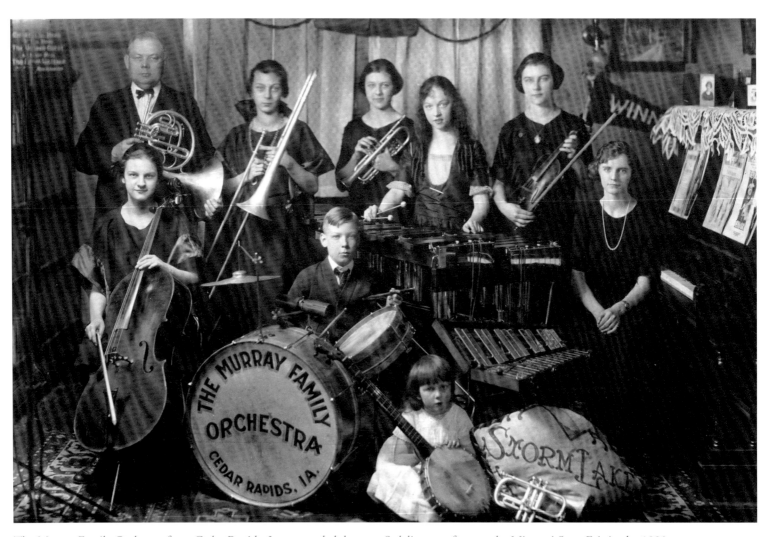

The Murray Family Orchestra from Cedar Rapids, Iowa, traveled down to Sedalia to perform at the Missouri State Fair in the 1920s.

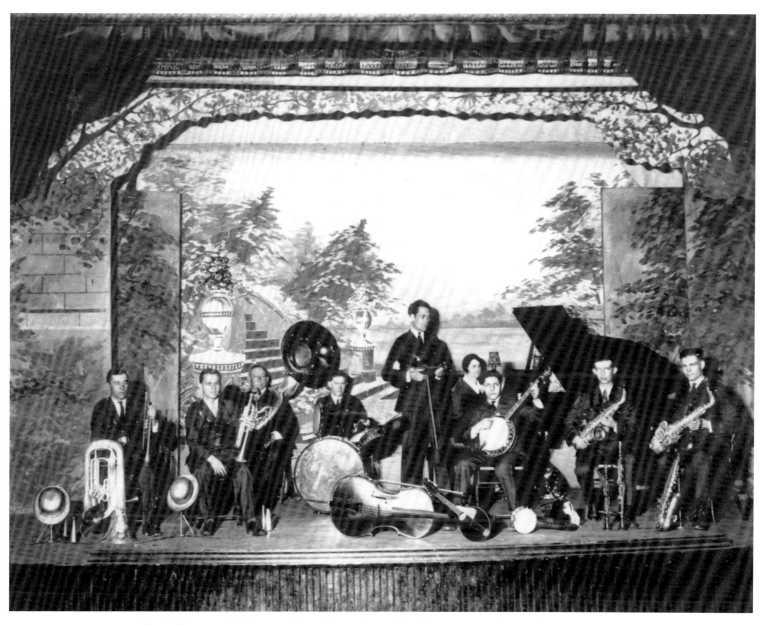

The Bill Barnett Orchestra performs for residents of Butler County, in the Ozark Foothills region of the state, in the 1920s. Residents of the Ozarks may have been poor in material goods, but they left a rich musical heritage that lives on today in the country music mecca of Branson.

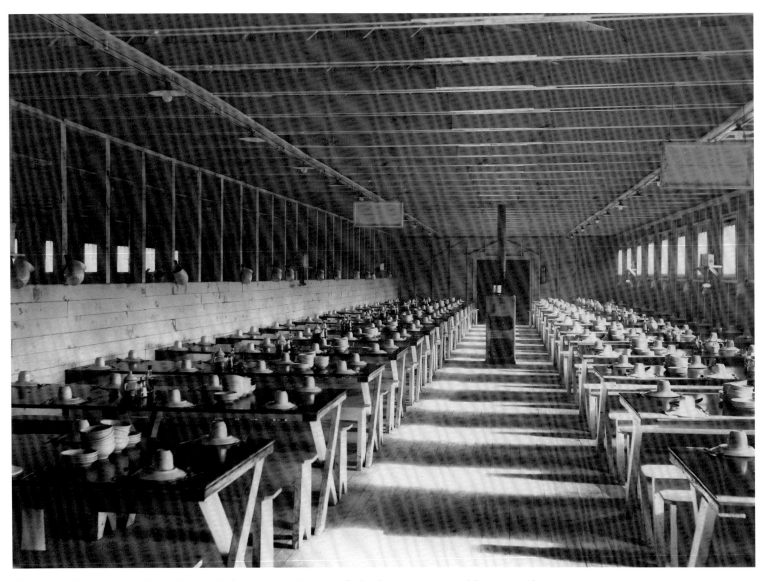

The mess hall of the new Union Electric Light & Power Company hydroelectric station could accommodate a great number of hungry workers in 1929.

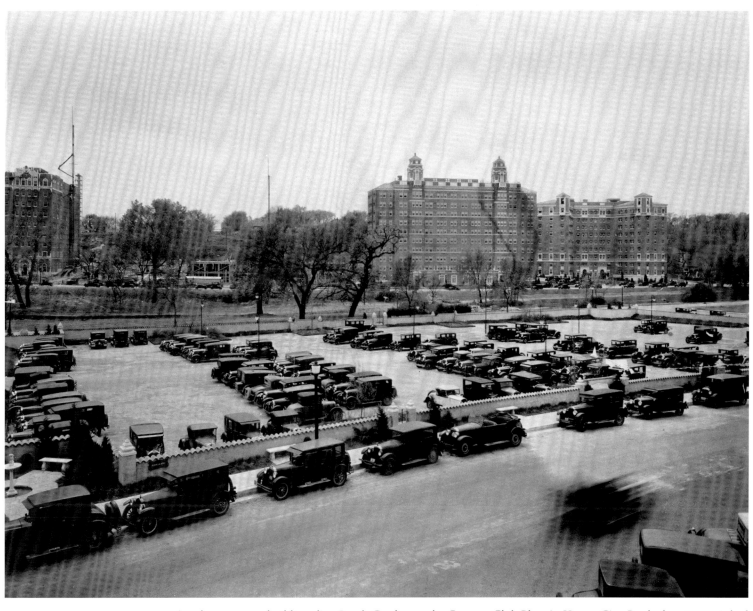

Stately apartment buildings line Brush Creek near the Country Club Plaza in Kansas City. By the late 1920s, it had become evident that the automobile was clearly more than a passing phenomenon.

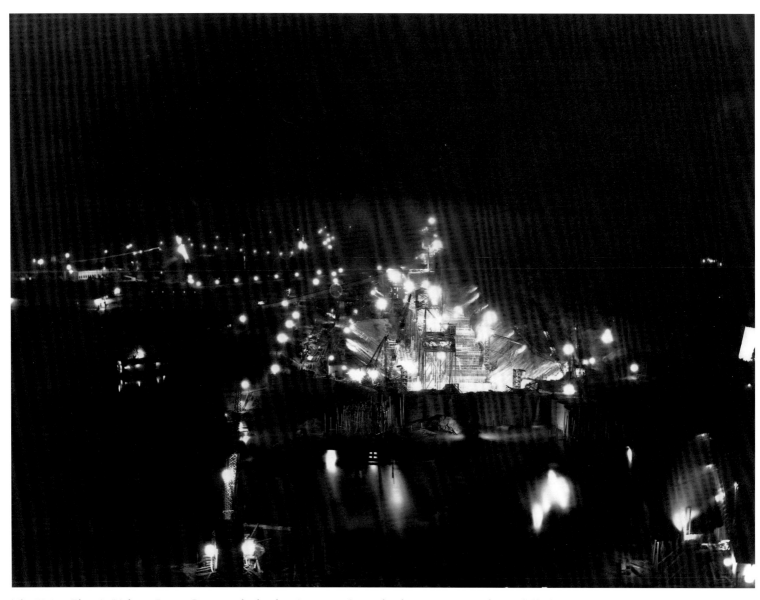

The Union Electric Light & Power Company hydroelectric station Osage development, as seen from a hillside to the east, lights up the night sky.

ECONOMIC DEPRESSION AND A SECOND WORLD WAR

(1930–1945)

The elation that marked the end of World War I was short-lived in Missouri, just as in the rest of the nation. The Great Depression took a heavy toll on urban centers such as St. Louis and Kansas City, but small-town and rural Missourians also were forced to tighten their belts or go off to the cities in search of hard-to-find jobs. Although the Dust Bowl was not as severe as in neighboring Oklahoma, many farm families headed west in search of opportunities.

The depression brought out the best in most Missourians, as families and neighbors pulled together to weather the crisis. But it brought out the worst in others, who turned instead to a life of crime. The infamous Kansas City Massacre in 1933, in which an attempt to free gangster Frank Nash went awry, triggered a nationwide war on crime by J. Edgar Hoover and the FBI.

Not all was gloom and doom, however. In the central part of the state, Union Electric completed the massive Bagnell Dam in 1931. The project provided a new source of hydroelectric power while also creating jobs and a new summer playground that was easily accessible to most Missourians. Up the road in Columbia, a young football coach named Don Faurot was laying the foundation for a team that would garner national attention for the University of Missouri.

Throughout the 1930s "Boss" Tom Pendergast set about changing the Kansas City skyline through the impressive resources of his political connections and the influence generated through his family-owned concrete business.

As the 1930s drew to a close, rumblings of another war in Europe were growing louder. With the bombing of Pearl Harbor by the Japanese in December 1941, Franklin Roosevelt took the nation to war. And once again, thousands of Missourians fought—and many died—to preserve the nation from the ever-present threat of conquest by hostile foreign nations unsympathetic to the ideal of liberty of, by, and for the people. Schoolchildren, veterans, and civic groups added to the resources available for the troops through War Bonds and scrap drives, and mobilization for the war effort created an unprecedented need for women to enter the workforce. The war effort also helped the economy shake off the lingering effects of the depression. Missouri was to play a decisive role in the war and its aftermath when Harry Truman, the man from Independence who became president following the death of Franklin Roosevelt in 1945, succeeded at ending the war by dropping two atomic bombs on Japan.

Missourians take pride in their hometowns. Downtown Brookfield in Linn County is immaculately landscaped and maintained here in 1930. This photograph shows the intersection of West Park Avenue and Main Street, focusing on plots of canna lilies in the foreground.

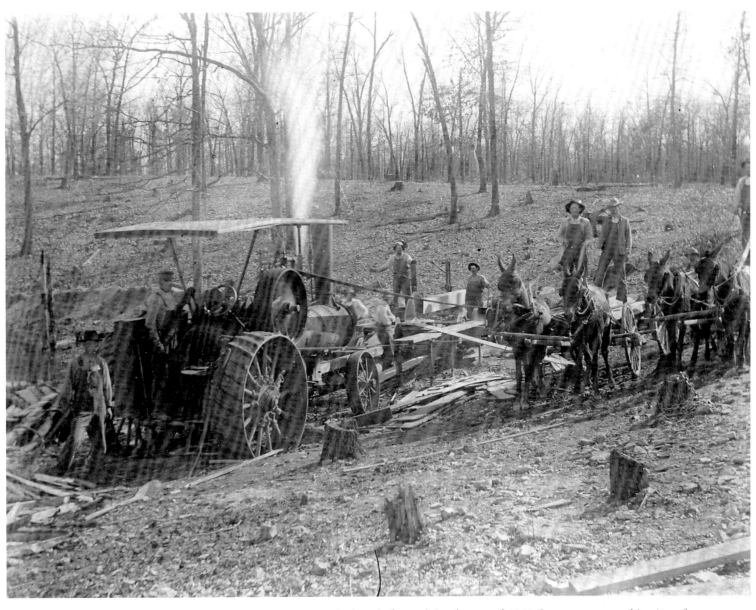

Timber was an important industry in the heavily forested Ozarks around 1930. Loggers use a combination of steam power and mules at this sawmill near Howard Ridge in Ozark County.

Memorial Union at the University of Missouri in Columbia honors the 117 students who lost their lives in service to the nation during World War I. Their names are inscribed inside the walls of the tower archway. The Gothic building still stands guard over campus today.

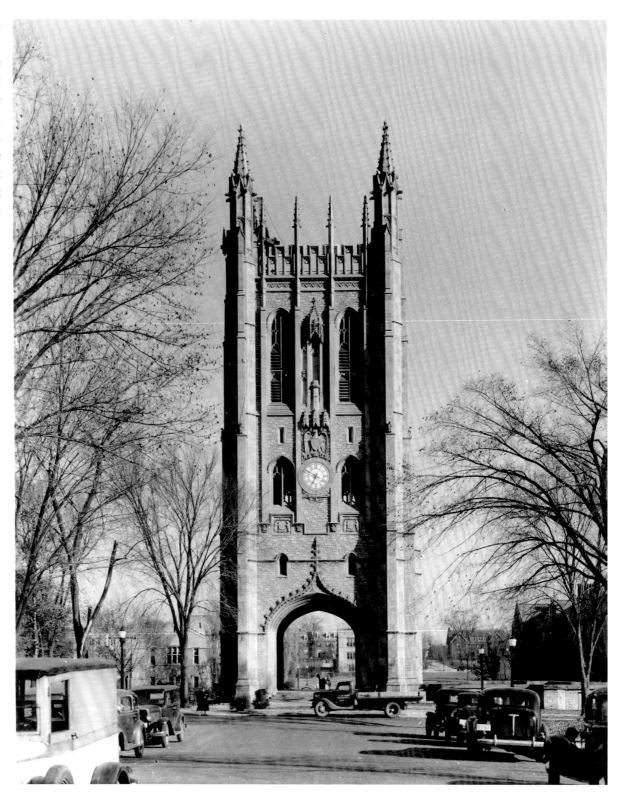

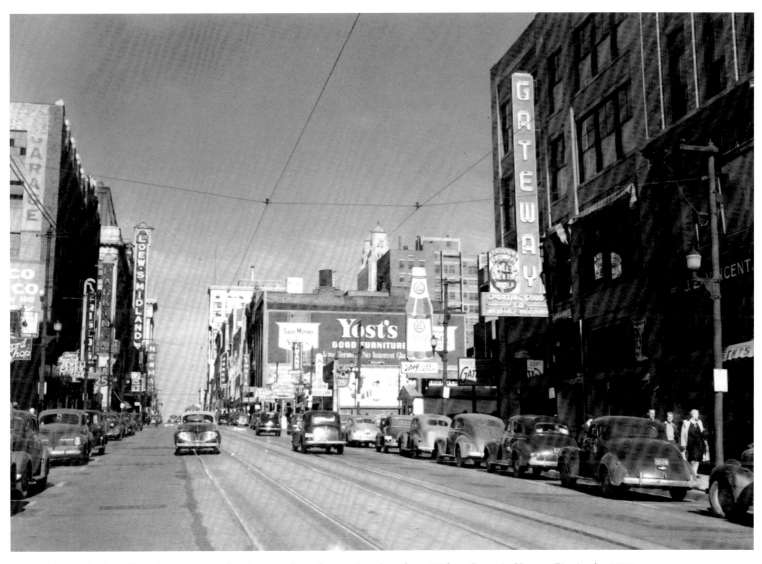

Neon lights and advertising signs compete for the attention of motorists along busy Walnut Street in Kansas City in the 1930s.

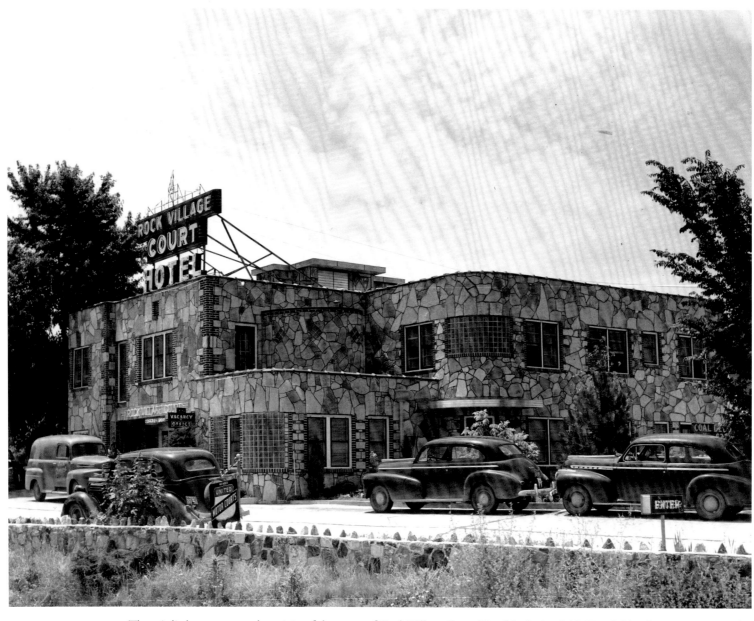

There is little mystery to the origin of the name of Rock Village Court Hotel in Springfield. Hotels like this one were popular throughout the state after American motorists began taking to the open road in the 1920s, a phenomenon that also gave rise to the motor hotel, shortened to "motel."

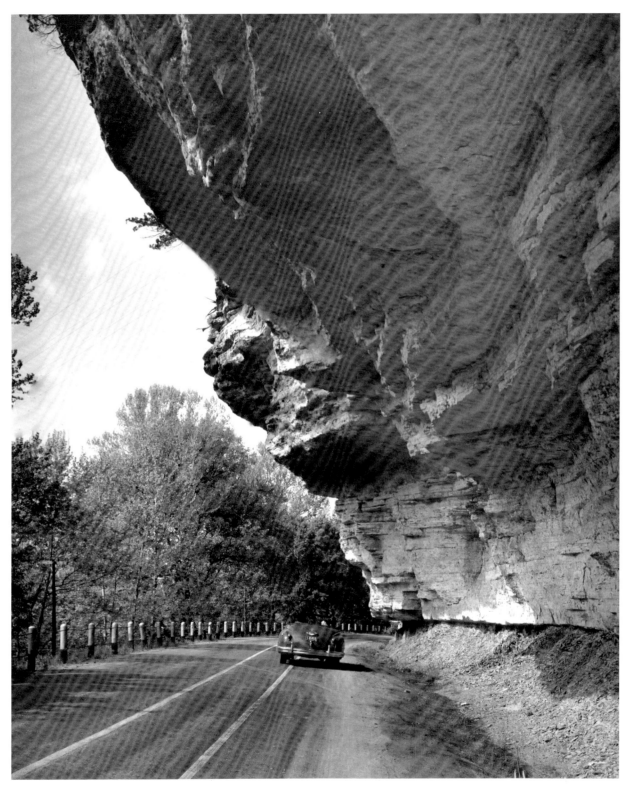

The drive along Highway 21 near Noel in McDonald County is scenic but not for the faint of heart. Each winter, the local post office cancels thousands of stamped pieces of mail with the message, "Noel, Missouri: The Christmas City of the Ozark Vacation Land."

The St. Louis University Cathedral towers above the Jesuit campus in the 1930s. Located in midtown St. Louis, the university was founded in 1818.

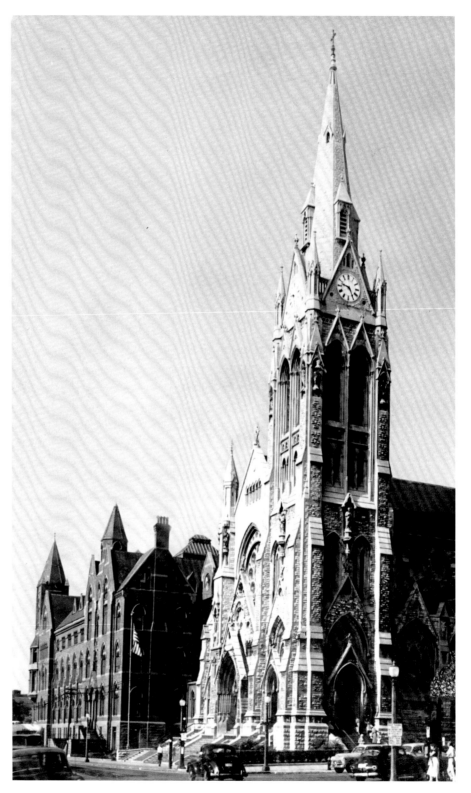

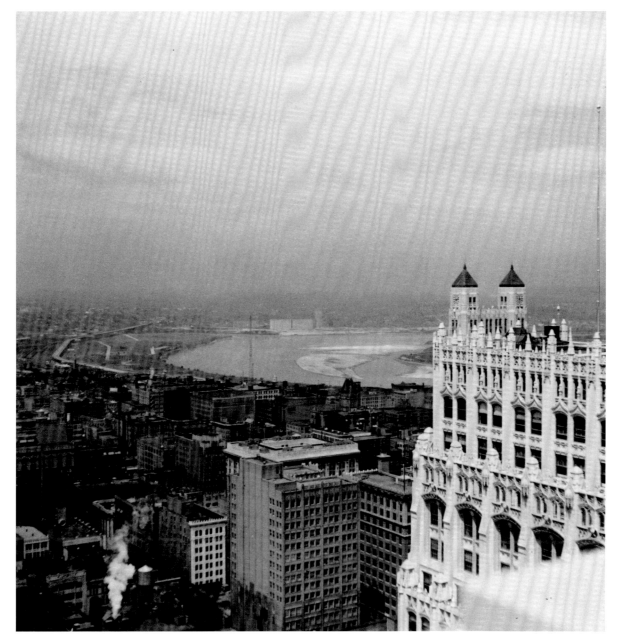

A rooftop view from downtown Kansas City reaches across the Missouri River and west into Kansas in this photograph from the 1930s.

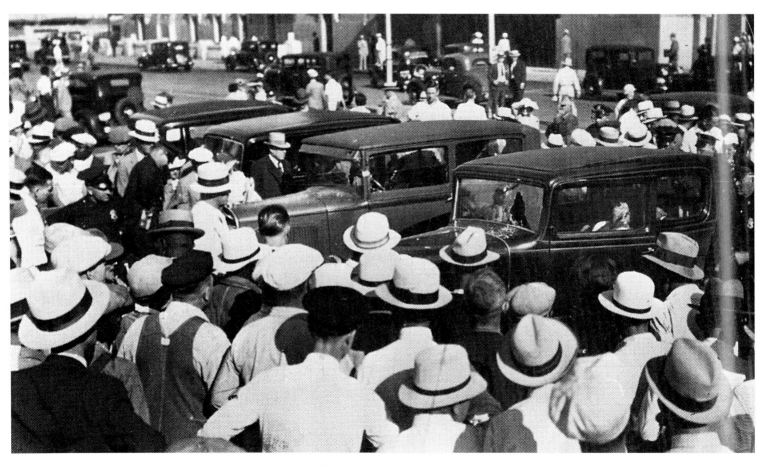

Crowds look on in the aftermath of the "Kansas City Massacre" on June 17, 1933, at Union Station. Four law enforcement officers and one criminal were killed as part of an attempt by Charles Arthur "Pretty Boy" Floyd, Vernon Miller, and Adam Richetti to free Frank Nash, a federal prisoner who was being returned to the U.S. Penitentiary in nearby Leavenworth, Kansas.

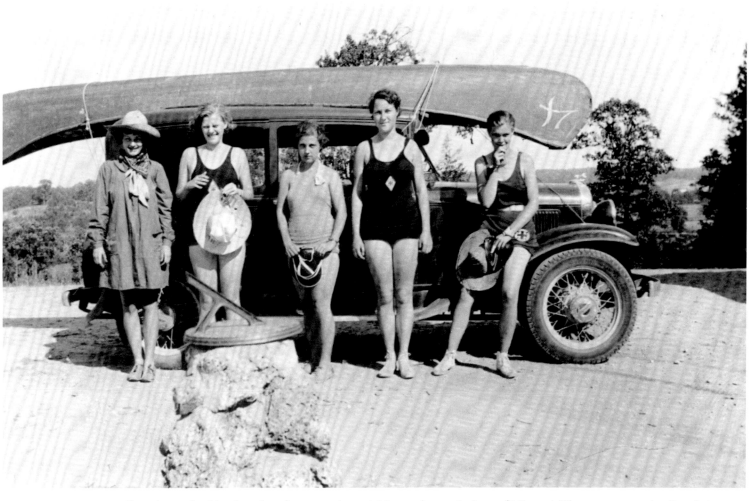

Canoeing and rafting have long been popular activities on the scenic rivers of Missouri. These women are hauling their canoe on the roof of their automobile before hitting the water at Camp Maries in Maries County in 1934.

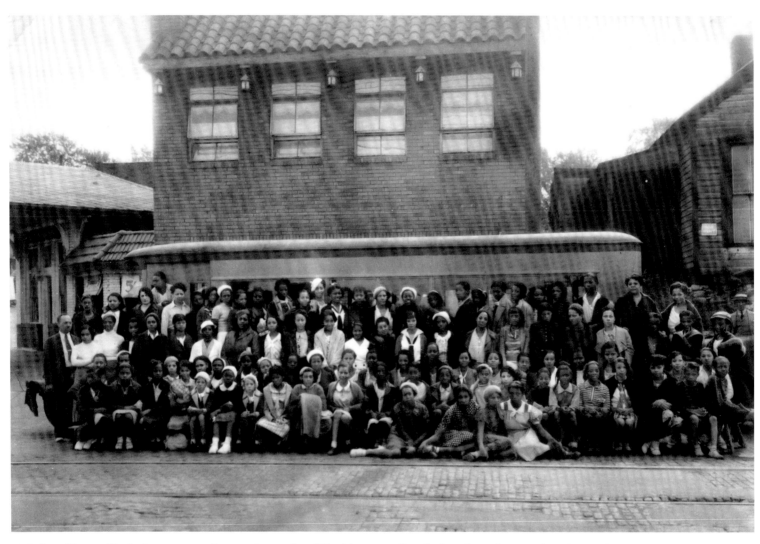

Girls from Kansas City had an opportunity to enjoy outdoor life without traveling far from home by attending the 1934 Urban League Girls Camp, which was held at the Rotary Club Camp near Lee's Summit.

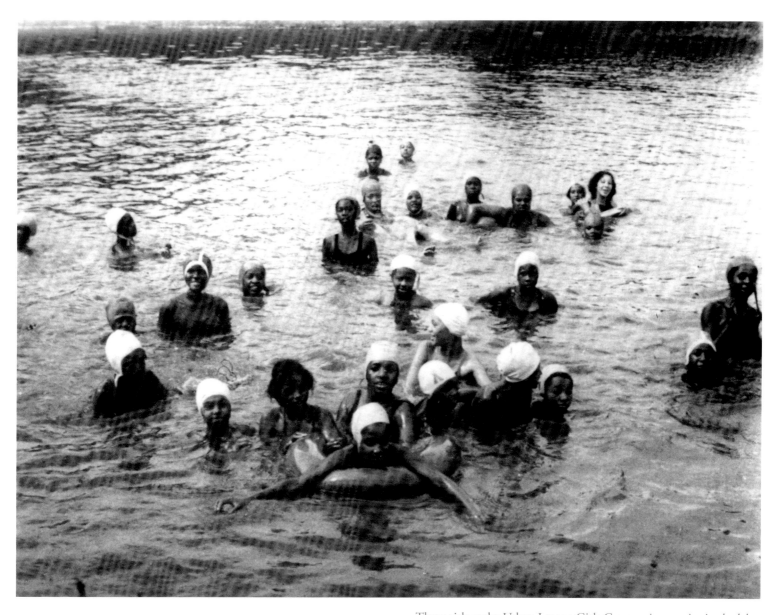

These girls at the Urban League Girls Camp enjoy a swim in the lake.

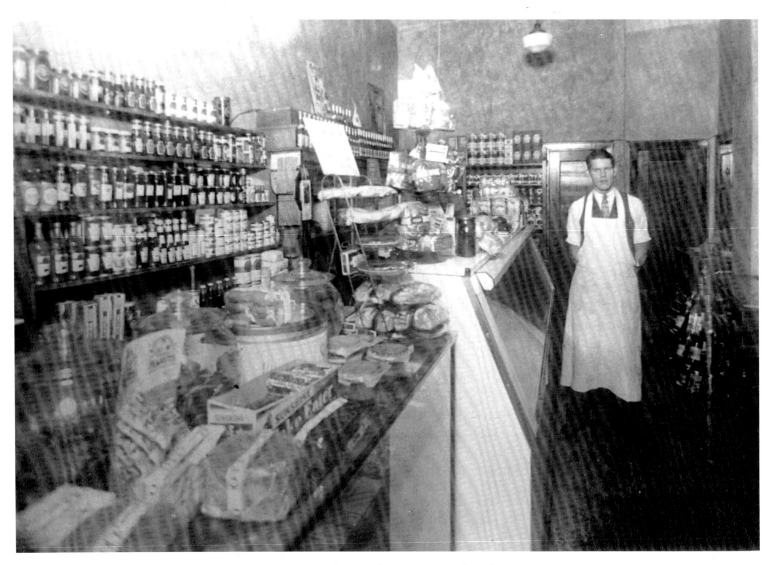

A well-stocked delicatessen was one of the amenities at the Cavalier Hotel on Armour Boulevard in Kansas City during the mid-1930s.

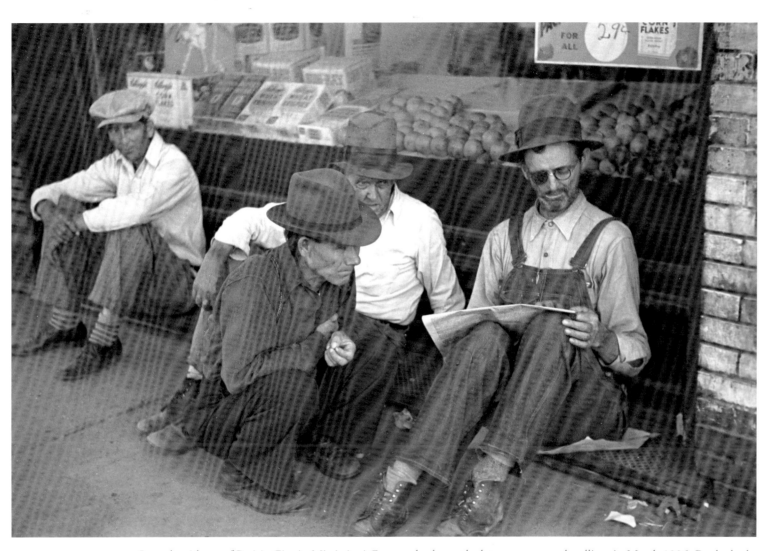

Several residents of Prairie City in Mississippi County check out the latest newspaper headlines in March 1936. By the looks on their faces and the idle time on their hands, one can surmise they were also searching the Classifieds looking for work.

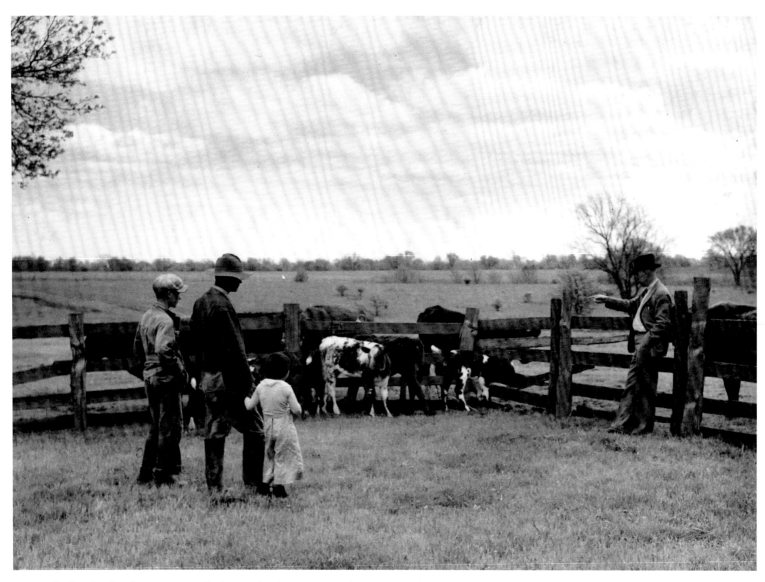

The Wilks family of Callaway County looks at calves born to cows that were purchased with a loan from the Rehabilitation Administration in 1936. Under President Roosevelt's New Deal administration, federal programs aimed at the stalled economy provided temporary relief to many Americans in cities and on the farm.

Canning time is coming, which means it's time to wash and dry the jars. This woman in the Lake of the Ozarks region prepares for the job in May 1936. In the not-so-distant past, most Americans relied on home-grown food and the canning method as a means of preserving fruits and vegetables raised in the home garden.

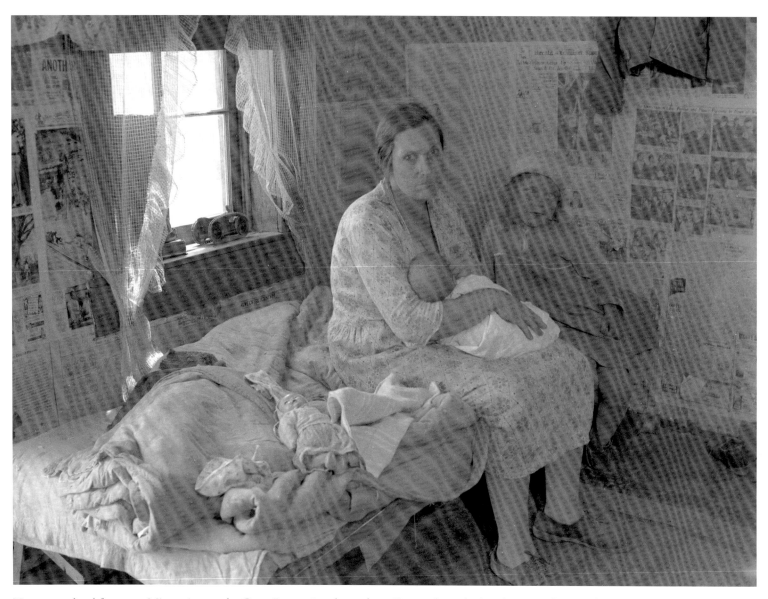

Times were hard for many Missourians as the Great Depression dragged on. Six people made their home in this Ozarks cabin in the mid-1930s.

The Drover's Inn in Moscow Mills in Lincoln County provided simple accommodations during the mid-1930s.

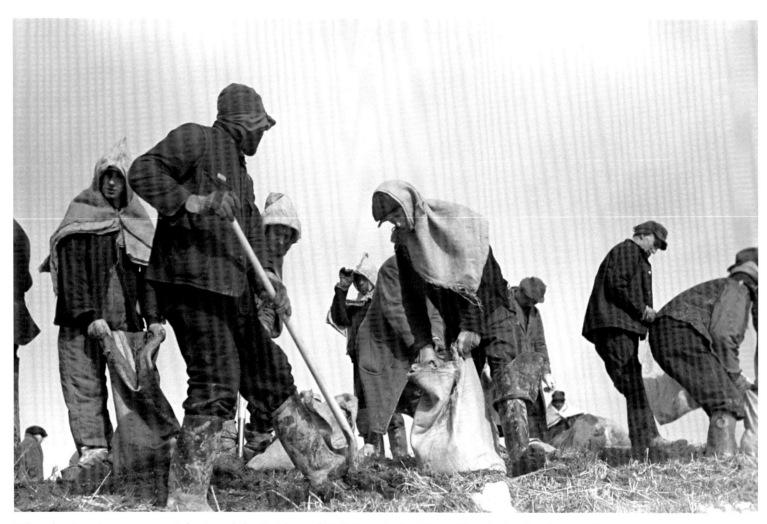

When the river rises, everyone pitches in to help. Residents of Bird's Point in the Missouri Bootheel region shore up the levee to protect the town from the Mississippi River in January 1937.

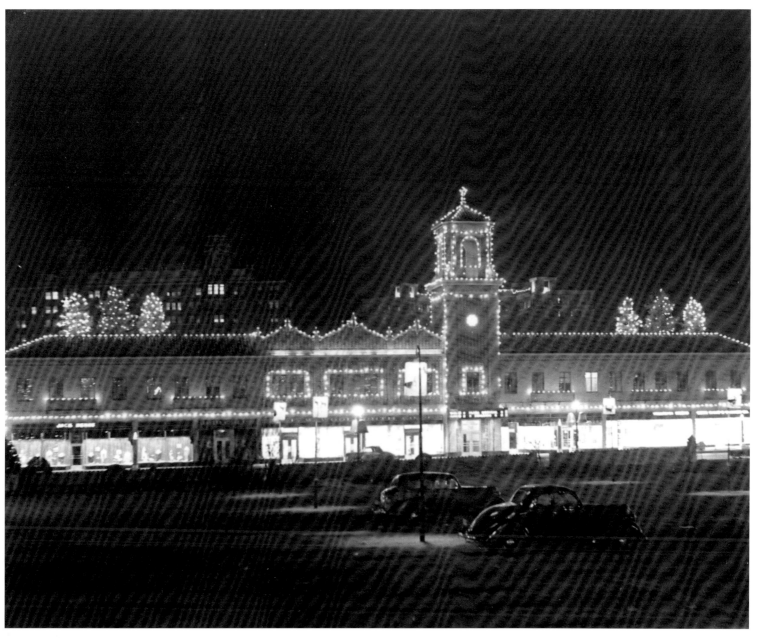

In good times and bad, the lighting of the Country Club Plaza has made the Christmas season brighter for generations of Kansas Citians. Cars drive by slowly as motorists check out the decorations in 1937.

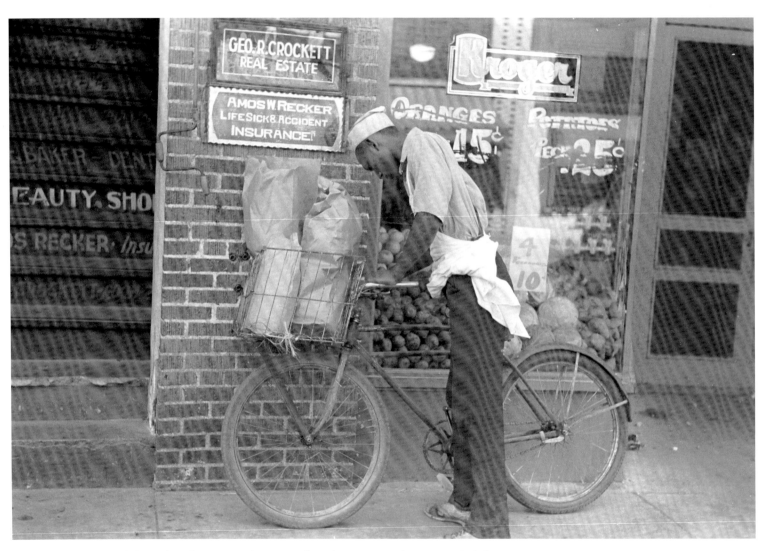

Missourians considered themselves fortunate to have any job in the 1930s. In this view, a clerk for a Kroger store in New Madrid County loads bags of groceries for delivery by bicycle. The price of potatoes? Twenty-five cents a peck.

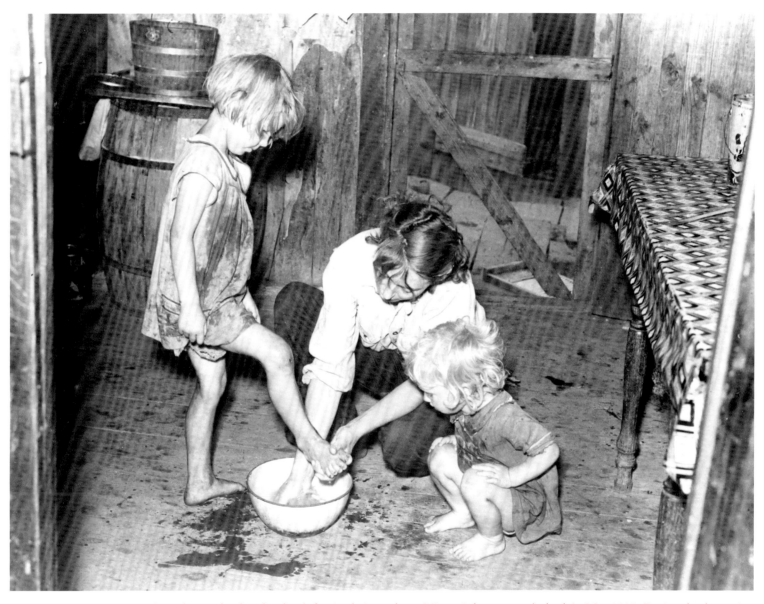

A mother washes her daughter's feet in their southeast Missouri sharecropper's shack in May 1938. During the depression some families were hard put to it to keep their children in clothing and shoes.

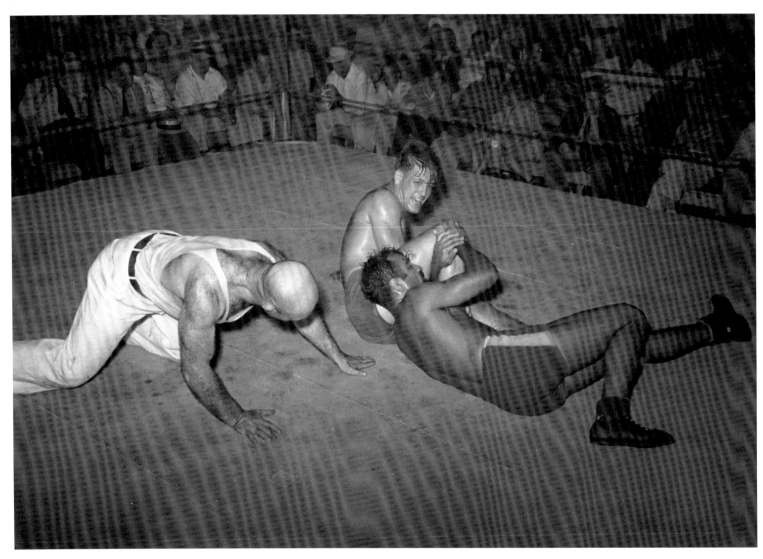

There is nothing fake about this 1938 wrestling match sponsored by the American Legion in Sikeston. A referee keeps a close eye on the action as fans look on.

Cotton growing was still a labor-intensive job in the Bootheel of the 1930s. In this view, workers hoe the weeds from emerging cotton plants in the New Madrid County fields in May 1936. Broad-brimmed hats to keep the sun off were once considered essential gear for farmers and farm workers working the fields from sunrise to sunset.

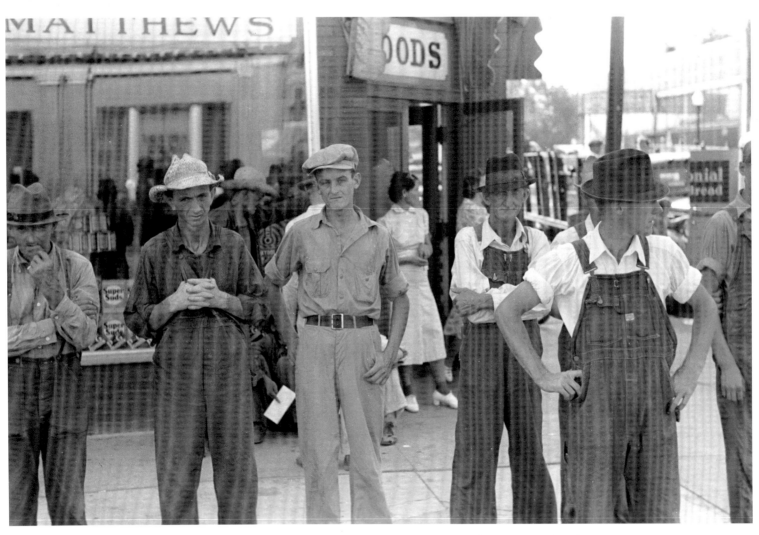

Farmers and Americans everywhere once wore only their best clothes when they went to town for supplies and to shop. Visits to town also provided an opportunity for Americans living on farms to trade the news with their friends and neighbors. These men in the Bootheel town of Caruthersville pause briefly for the photographer in the late 1930s.

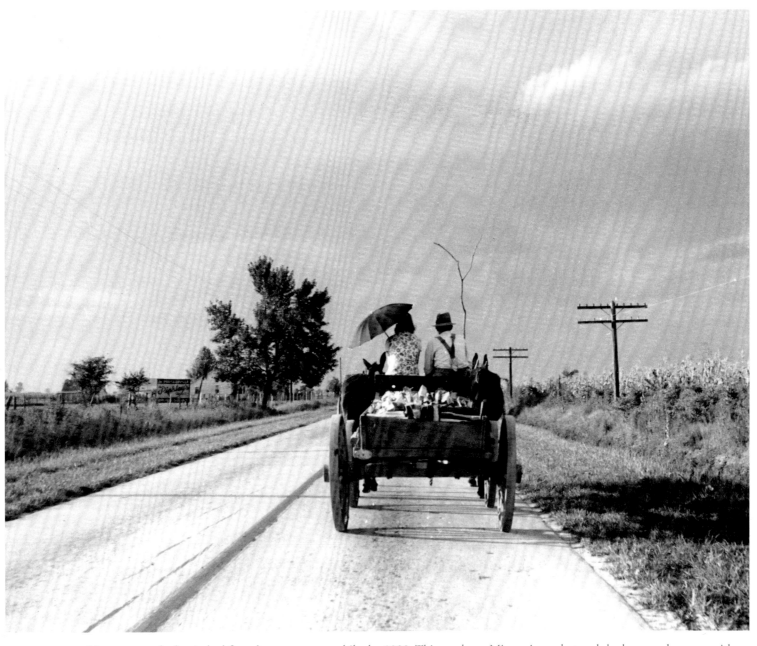

Not everyone had switched from horses to automobiles by 1938. This southeast Missouri couple travels by horse and wagon, with an umbrella providing shade against the late summer sun. A cornfield at right has matured and is ripening for harvest.

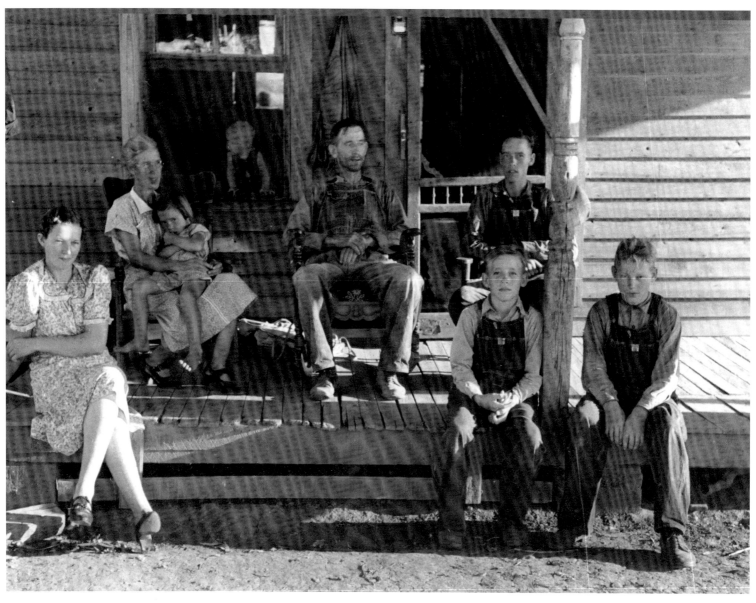

A number of government programs helped Missourians weather the hard times of the 1930s. The Farm Security Administration enabled this family to become owner-operators of their farm near Caruthersville in Pemiscot County. Nationwide, however, unemployment was still running at 17 percent by 1939 despite an unprecedented number of federal programs aimed at the crisis.

It's back-to-school time at this country school in southeast Missouri. Girls square off against the boys in a game of tug-of-war during recess in 1938. It appears that two boys have switched sides to give the opposing team an edge.

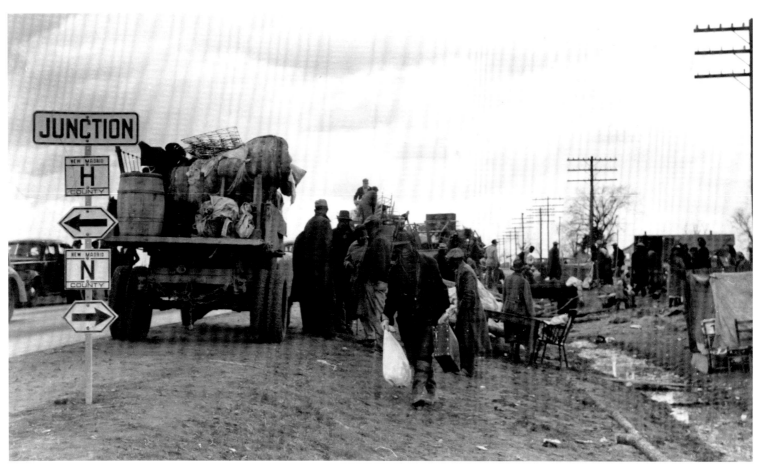

Flooding has been all too common along the Mississippi River Delta in the Bootheel. In this image, state highway officials move sharecroppers away from the danger zone in New Madrid County in January 1939.

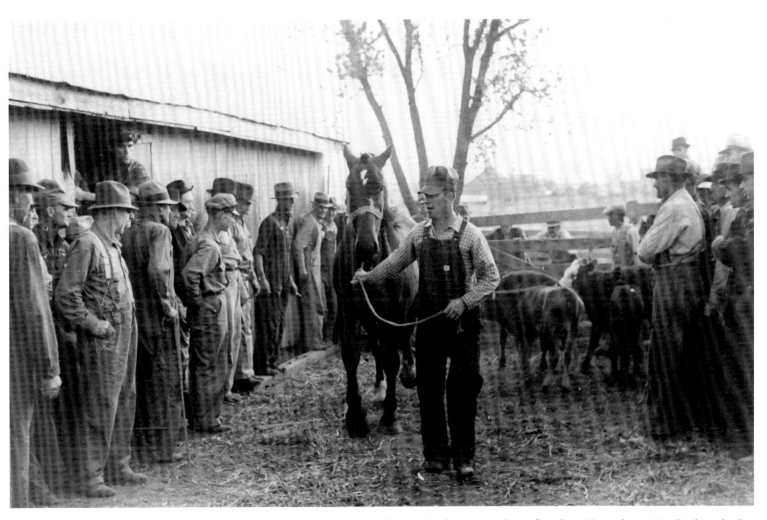

Bargain-hunting farmers in Pettis County closely inspect a horse for sale in November 1939. Cattle and other livestock are also in line to be sold.

Even people in humble surroundings can enjoy the quiet beauty of a Missouri evening. This woman near Clever in southern Missouri takes in the view from her front porch in 1939.

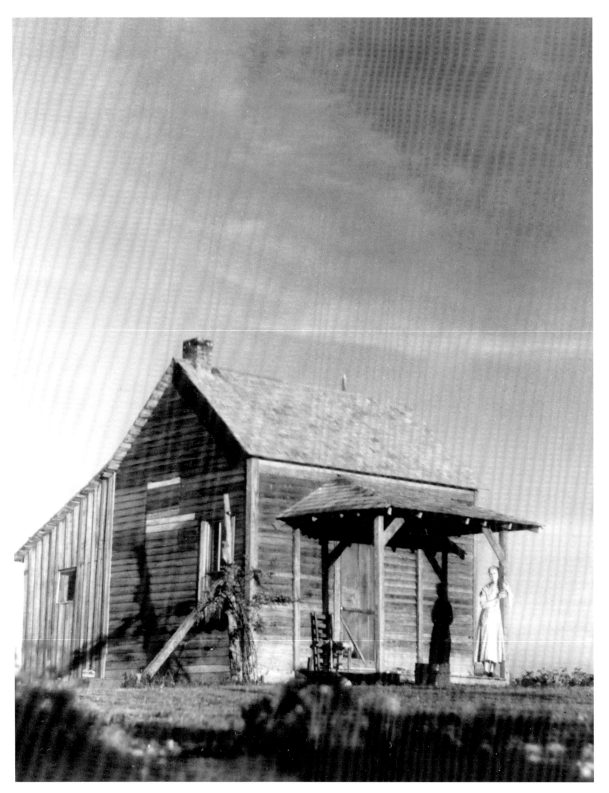

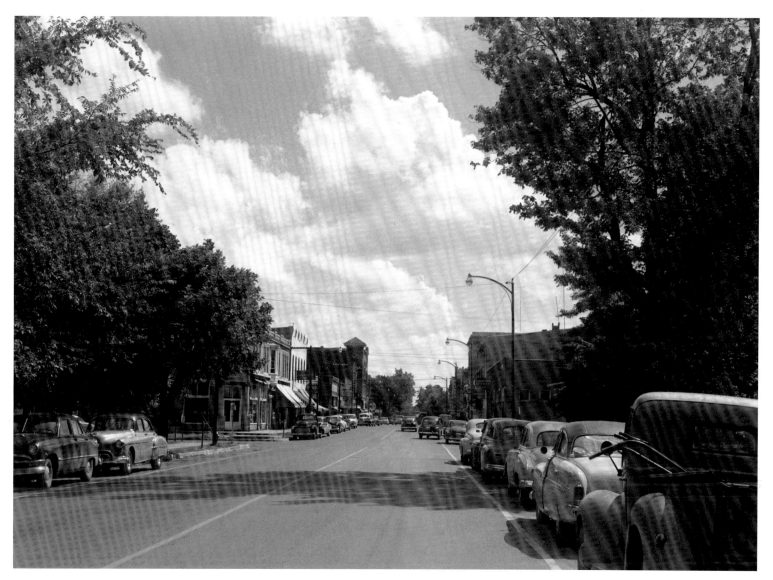

Traffic snarls are nonexistent in this view of Charleston, although a number of cars and trucks are parked along this street. Former governor Warren Hearnes grew up in this Mississippi County town. In 1895, Charleston became the epicenter of a 6.6 magnitude earthquake which, although far less massive than the 1812 New Madrid temblor, toppled chimneys as far away as Evansville, Indiana.

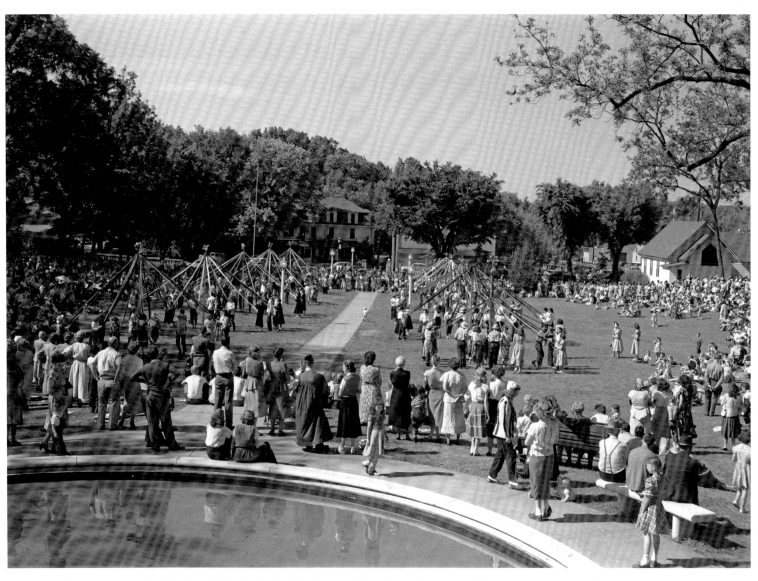

Featuring at least 10 maypoles, the city of Neosho in the Ozarks goes all out for a May Day celebration here in the 1940s.

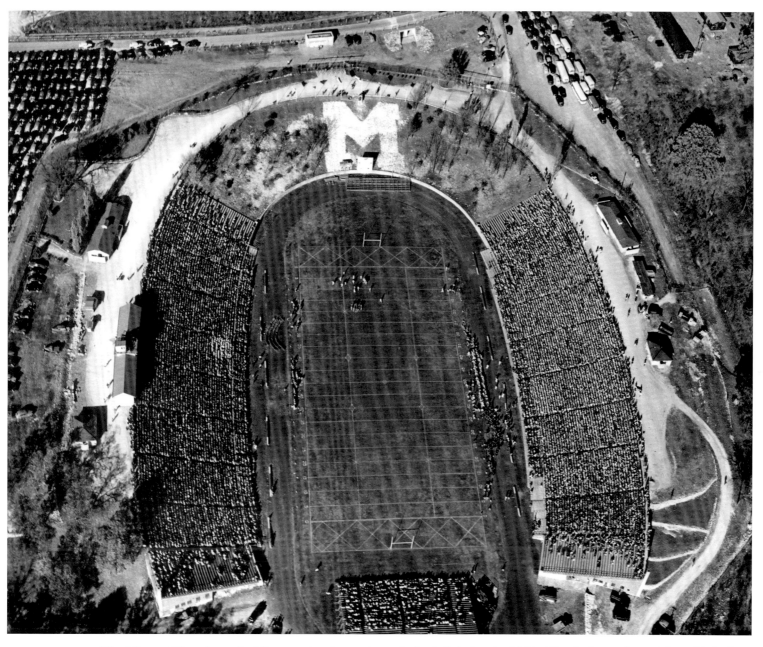

The Missouri Tigers began building a national powerhouse in football during the 1940s. The playing surface at Memorial Stadium would later be named in honor of legendary Coach Don Faurot. The giant "M" made of rocks remains a prominent stadium feature.

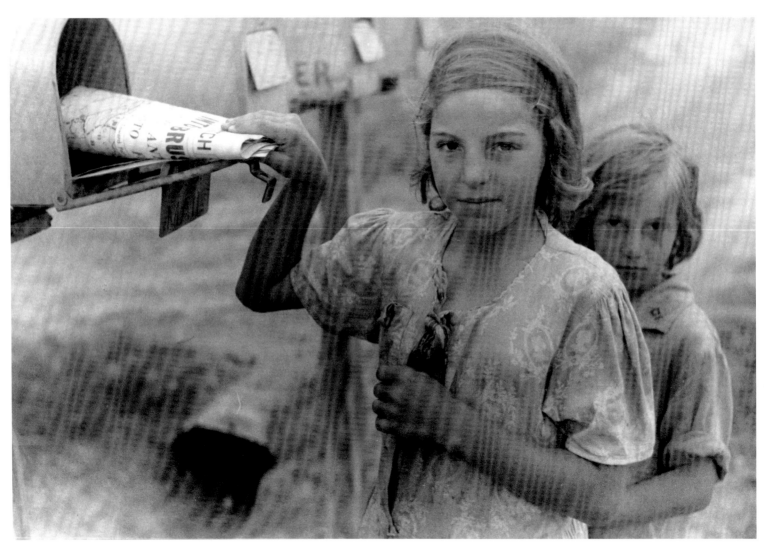

Everyone was excited to see what the mail would bring when Rural Free Delivery service came to the Ozarks. These girls pick up the daily newspaper from their family's mailbox in 1940.

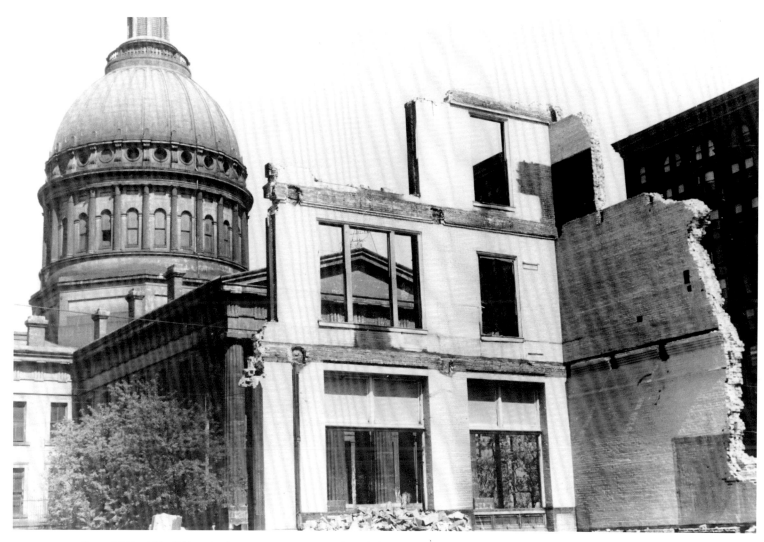

One of 500 old buildings in downtown St. Louis is demolished in May 1940 to clear the way for the new Luther Ely Smith Square, part of the Jefferson National Expansion Memorial begun before the war but halted as Americans focused the nation's resources on defeating the Nazis in World War II. The memorial would be completed in the 1960s and is known today as the St. Louis Gateway Arch.

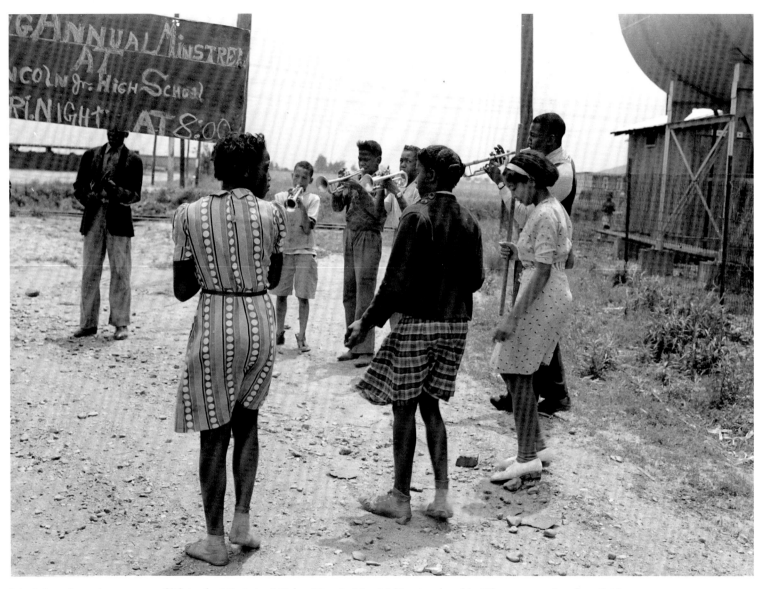

Music has always been a part of life in the Mississippi Delta. Here in May 1940, a jazz band in Sikeston practices for a Friday night performance at Lincoln Junior High School.

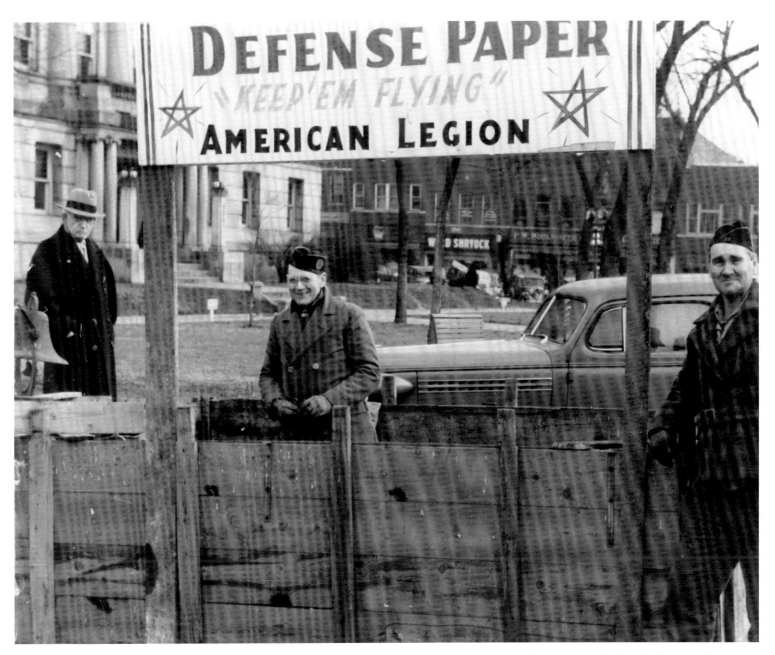

During World War II, Missourians across the state tightened their belts and pitched in to help with the war effort. Many planted Victory gardens to increase the supply of foodstuffs. Others organized rubber and scrap metal drives. Members of the American Legion shown here collect scrap paper at a booth in downtown Chillicothe in January 1942.

With so many men at war overseas, Americans still at home were needed to fill vacancies in defense plants. These Missourians work side-by-side on the production lines of the Airplane Division of the Curtiss-Wright Corporation in St. Louis.

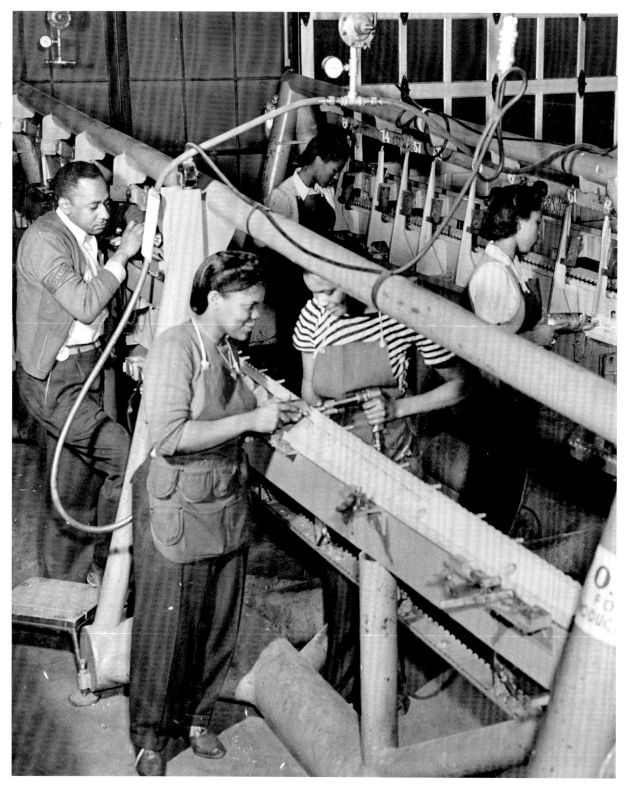

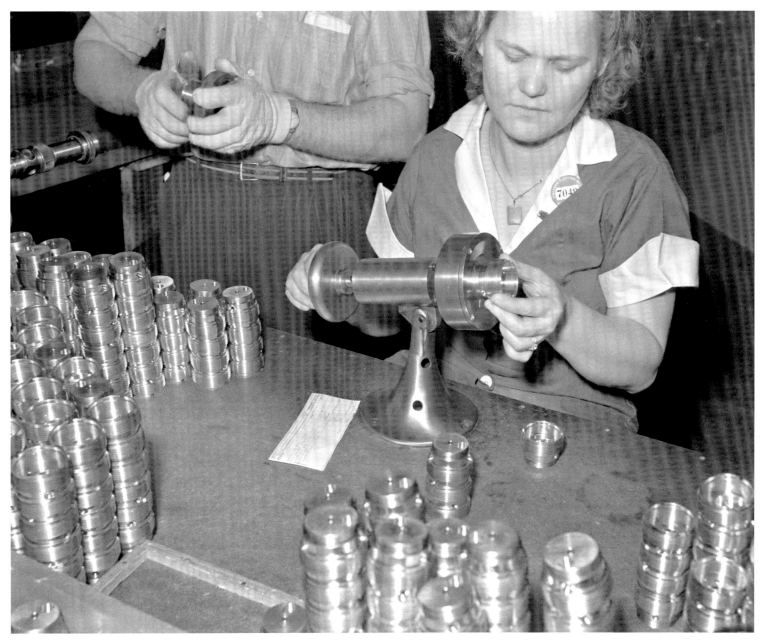

Necessity is the mother of invention. A woman inspects threads on a 20mm shell booster using a machine designed and built by a plant superintendent. The machine saved the company the months it would have taken to purchase and obtain a similar machine made elsewhere.

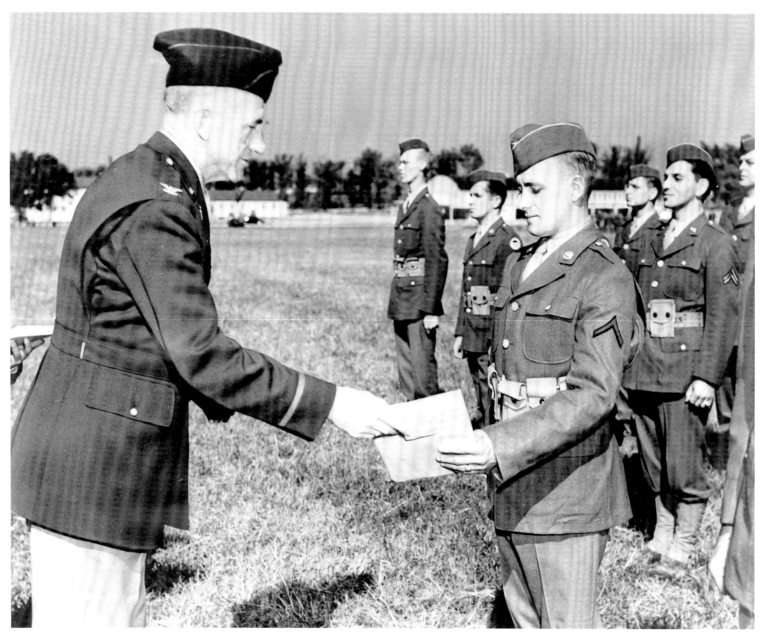

Colonel Sylvester Nortner presents Private William J. De Groot $364 in war bonds and stamps at Camp Crowder in southwest Missouri in the early 1940s. A Detroit auto parts manufacturer rewarded De Groot for an idea he suggested that would accelerate war materiel production at the plant.

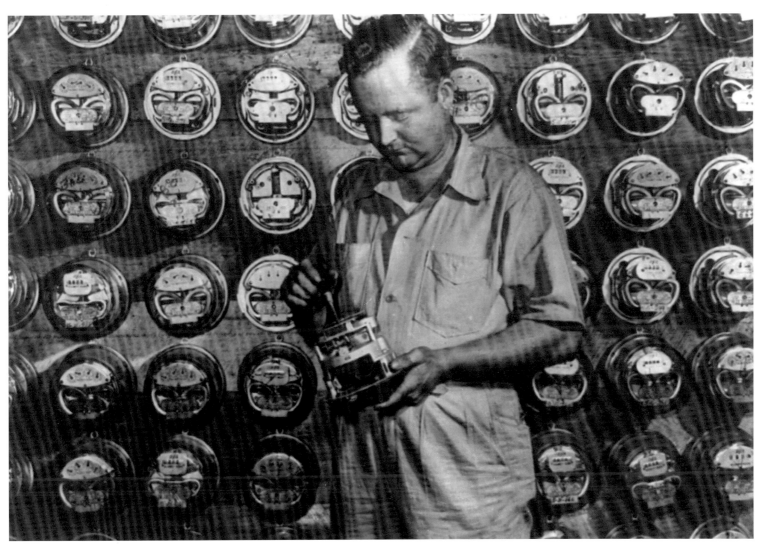

Rural electrification came to Missouri in the 1940s. A worker gives an electric meter a final adjustment before it is installed on a farm. Local electric cooperatives often trusted members to read their own meters and sometimes calculate their own bills.

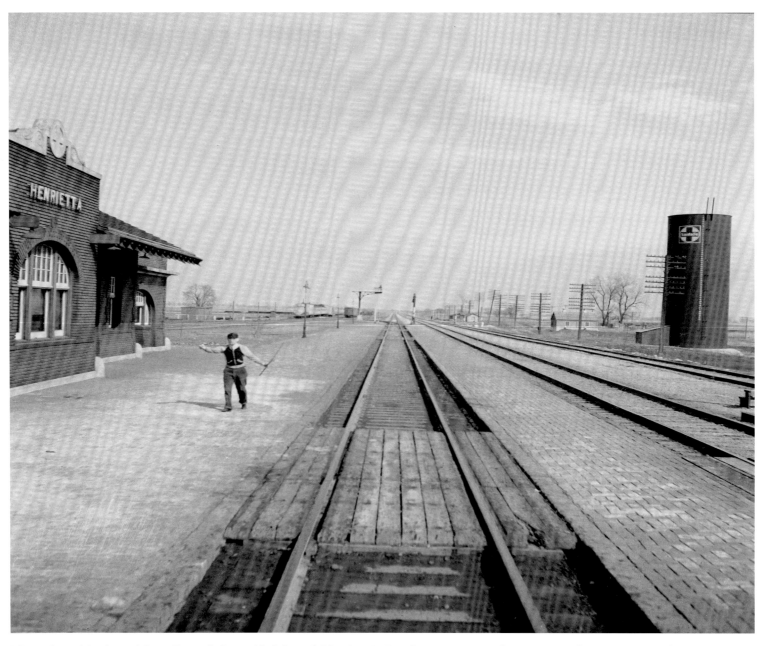

The Atchison Topeka and Santa Fe regularly rumbled through Henrietta in Ray County on its run between Marceline, Missouri, and Argentine, Kansas. The arrival of a train was often the highlight of the day for many small-town residents. The Henrietta depot is visible at left.

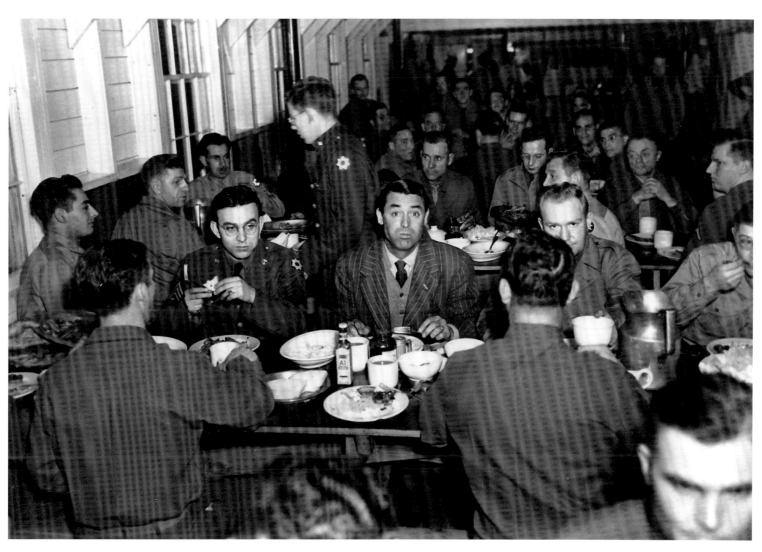

World War II brought men together from all racial and socioeconomic backgrounds. Enlisted men and civilians, including the ever popular Hollywood actor Cary Grant, dine side-by-side at Camp Crowder in this war era photograph. Grant was on hand to boost the morale of servicemen as part of his contribution to the war effort.

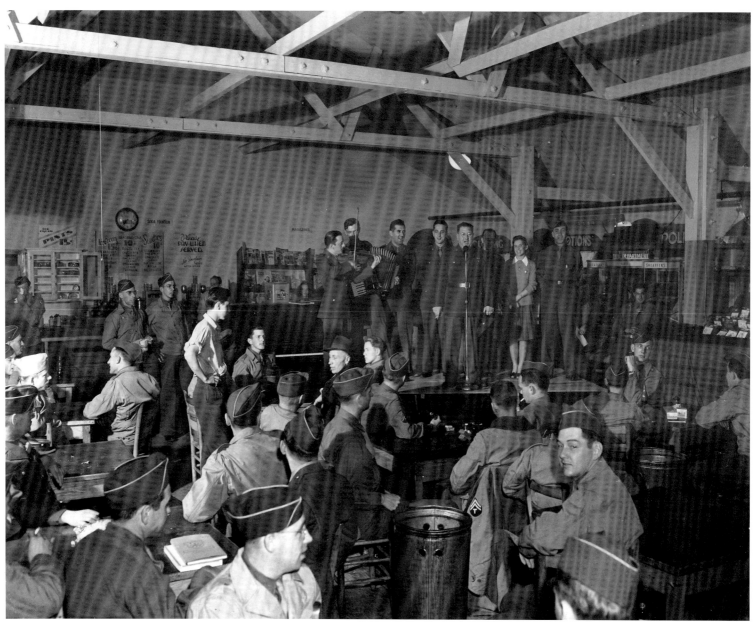

A band featuring a violin, piano, accordion, and vocalists entertains Missouri soldiers at PX No. 2 during World War II.
Sergeant Marty Bahn, director of the Ninth Regiment Music Hall, leads the performance.

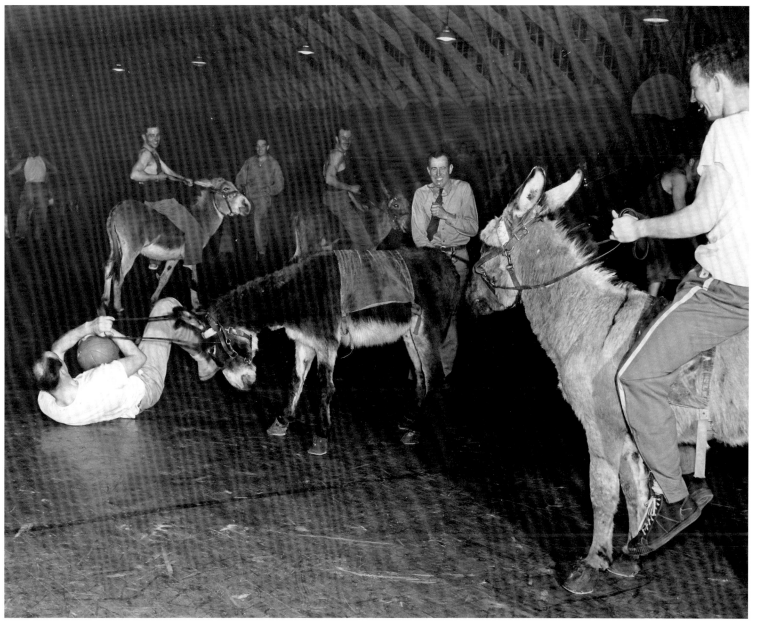

Mules may be synonymous with Missouri, but that doesn't make them any easier to ride. Donkey and mule basketball games have long been popular entertainment in many small-town gymnasiums. This game is under way in the 1940s.

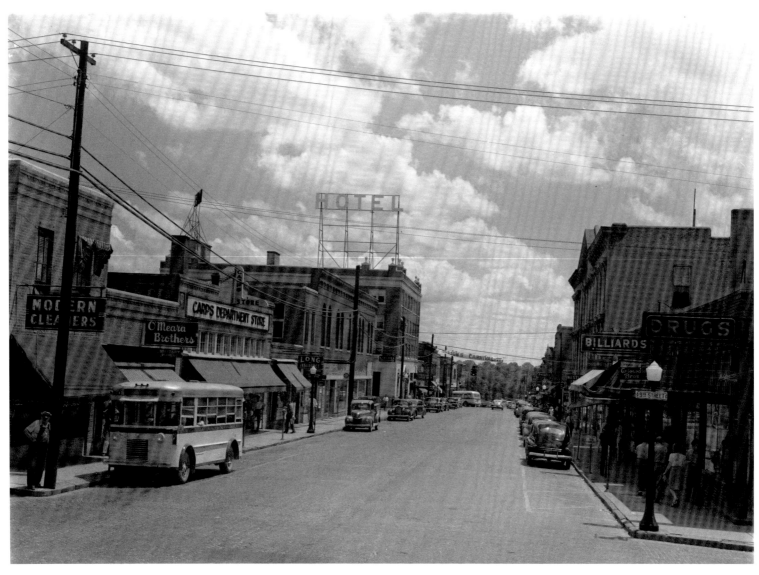

With the end of World War II in sight, downtown Rolla in 1945 was bustling with plenty of foot and automobile traffic. The city has long been a transportation crossroads, both as a rail center and as a stop on historic Route 66.

MISSOURI IN THE POSTWAR ERA

(1946–1974)

V-J Day marked the formal end of World War II in August 1945, but a new threat was already taking its place. Winston Churchill joined President Truman in Fulton in 1946 to announce that an "iron curtain" had descended on Europe. Although the ensuing cold war would define the postwar era, returning soldiers had already survived a shooting war. They quickly resumed their lives, getting married, starting families, and kicking off what came to be known as the Baby Boom. Enrollment swelled at colleges across the state as veterans took advantage of the G.I. Bill.

Factories quickly retooled from war to civilian production. Missouri soon became the second-largest automobile-producing state in the nation. Many manufacturers expanded into smaller communities to take advantage of lower costs and ample acreage. As residents followed the jobs, St. Louis lost 50 percent of its population in the second half of the century.

Spectator sports continued to be popular as the Cardinals played championship baseball at Busch Memorial Stadium. The Kansas City Royals began play in 1969, replacing the former team, the Athletics. Outdoor concerts, small-town festivals, and water sports at the Lake of the Ozarks also grew in popularity. Television changed the leisure habits of millions of Missourians, and some found opportunities to share their talents with the rest of the state by way of the new medium. Many people rediscovered the rivers, caves, and other scenic wonders of Missouri. In sleepy Branson, entrepreneur Pete Herschend built Silver Dollar City above his family's Marvel Cave, which continues to attract millions of visitors to the Ozarks town every year for music and theater, including acts by the legendary singer Andy Williams at Moon River Theatre and performances of *Shepherd of the Hills,* the million-seller novel by Harold Bell Wright. The Gateway Arch on the St. Louis riverfront opened to the public in 1967. As a civic icon, it continues to draw countless visitors to the city.

The postwar years brought social changes, including racial integration and migration to the suburbs. Missouri's greatest statesman Harry Truman retired to Independence, becoming a fixture on the local scene, with walks to the nearby Truman Library and Museum nearly every morning. Through good times and bad, residents of the Show-Me State proved that the same spirit that had brought them through the Civil War, the Great Depression, and two world wars would keep their state strong and vibrant into the late twentieth century.

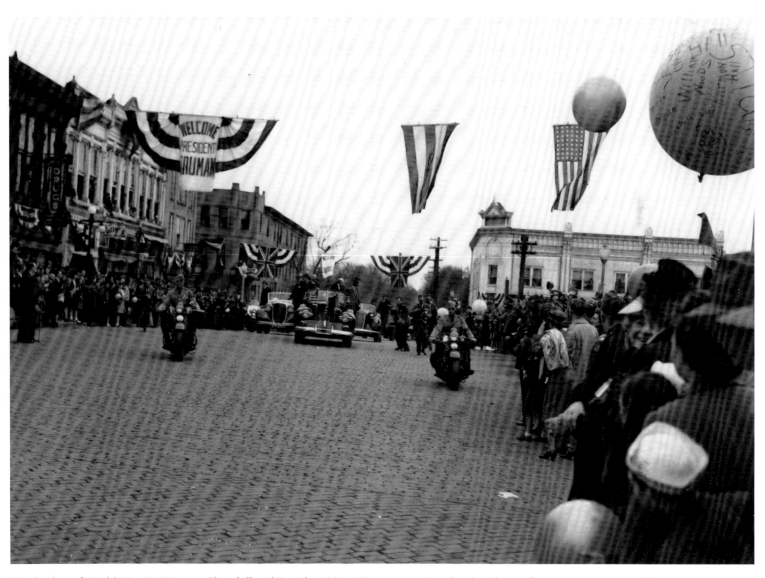

Two leaders of World War II, Winston Churchill and President Harry Truman, receive a hero's welcome for an appearance in Fulton on March 5, 1946. The British prime minister delivered his famous "Sinews of Peace" speech at Westminster College there less than a year after the war ended, in which he made the world aware of the "iron curtain" being raised across central and eastern Europe by the Soviet Empire in Russia. The cold war was on.

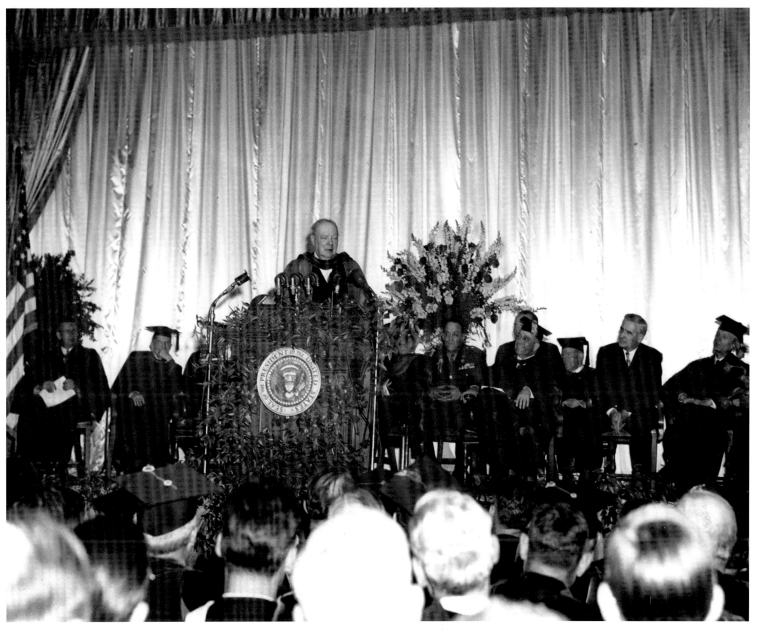

Introduced by President Harry Truman, Winston Churchill addresses an audience at Westminster College in Fulton. "An iron curtain has descended across the continent," Churchill declared.

Catcher Joe Garagiola, a hometown kid from the Hill, was a favorite among Cardinals fans during the 1946 season. Garagiola went on to become a well-known baseball broadcaster after his playing career ended.

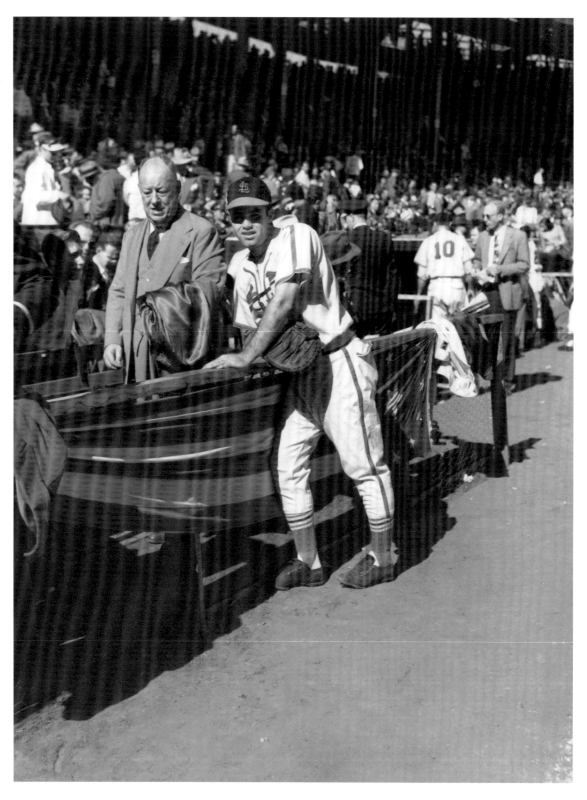

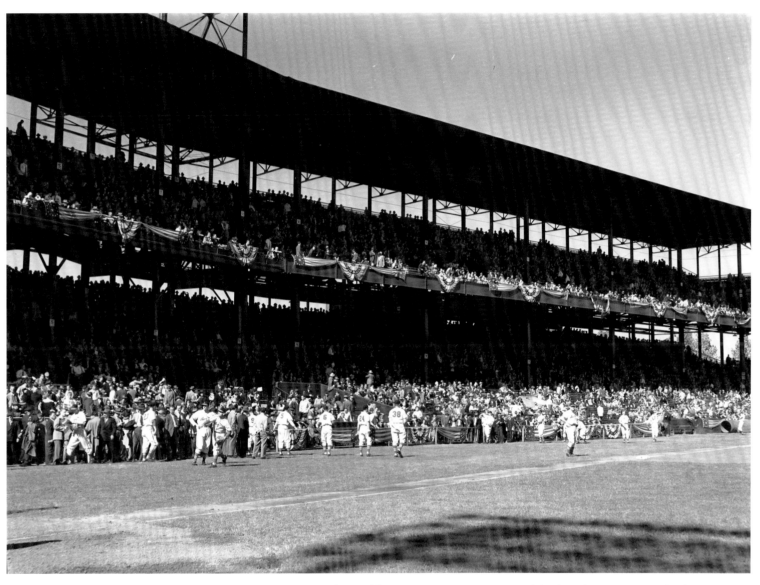

Baseball has a long and storied tradition in the Show-Me State. The World Series came to Missouri in 1946, when the St. Louis Cardinals defeated the Boston Red Sox in seven games, giving them their sixth world championship.

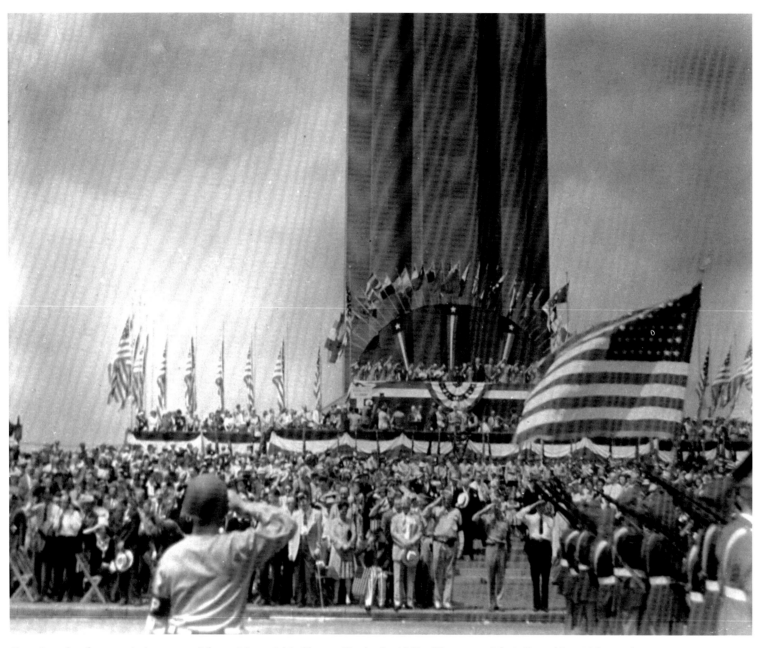

Crowds gather for a patriotic event at Liberty Memorial in Kansas City in the 1940s. The memorial, dedicated in 1926, now is home to the National World War I Museum.

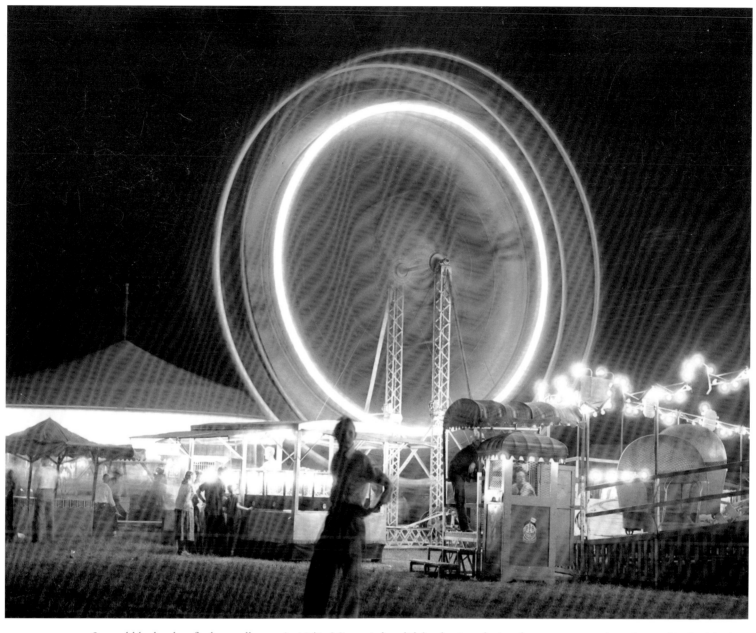

It would be hard to find a small town in 1940s Missouri that didn't take time during the summer months to host a fair. In this view, a Ferris wheel thrills riders while lighting up the night sky.

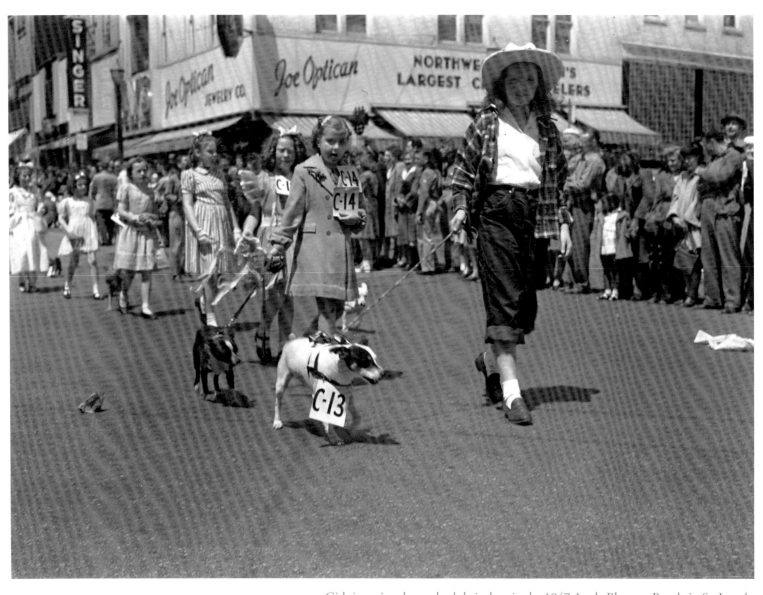

Girls in spring dresses lead their dogs in the 1947 Apple Blossom Parade in St. Joseph.

The queen and her attendants make an appearance at the 1947 Apple Blossom Parade in St. Joseph. The city has held the annual parade and festival since 1924.

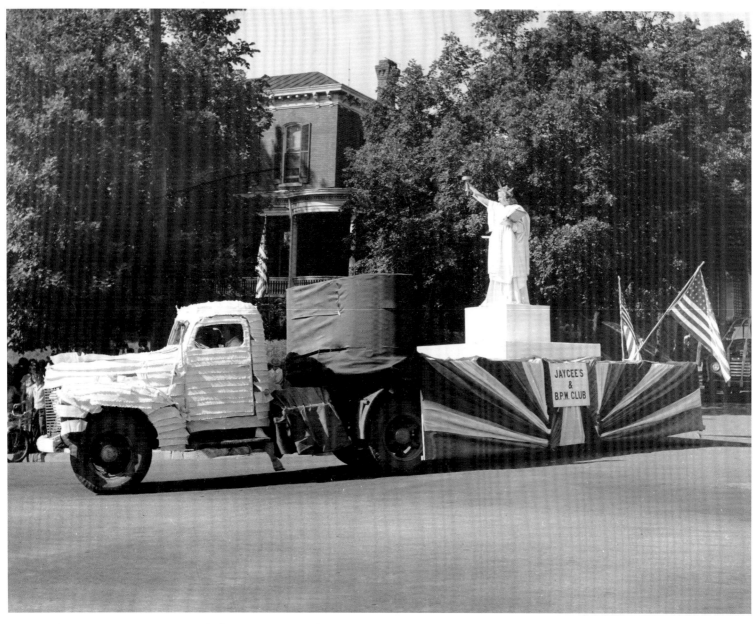

Patriotic themes were common on parade floats. The Statue of Liberty makes an appearance on a float sponsored by the Jaycees and the Business and Professional Women's Club in a 1947 parade.

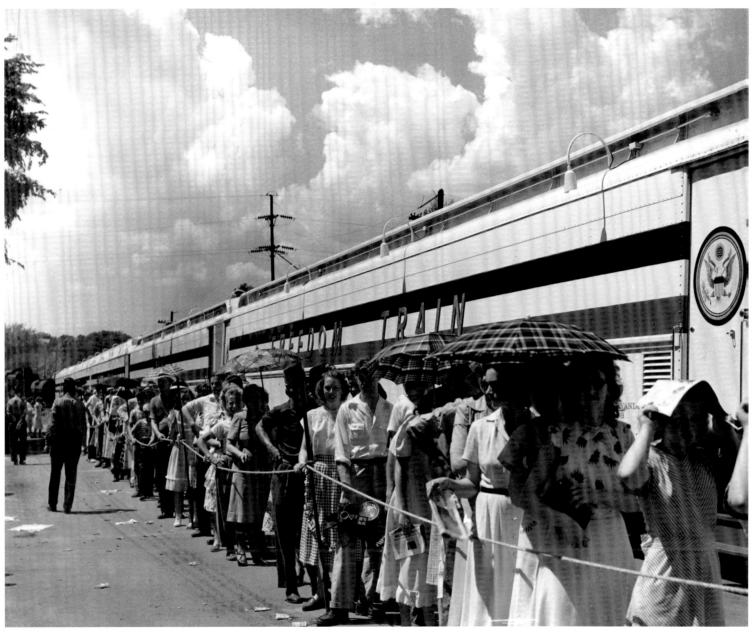

The Freedom Train toured Missouri and the nation from 1947 to 1949, giving Americans an opportunity to reflect on the meaning of citizenship after the hardships of the Great Depression and World War II.

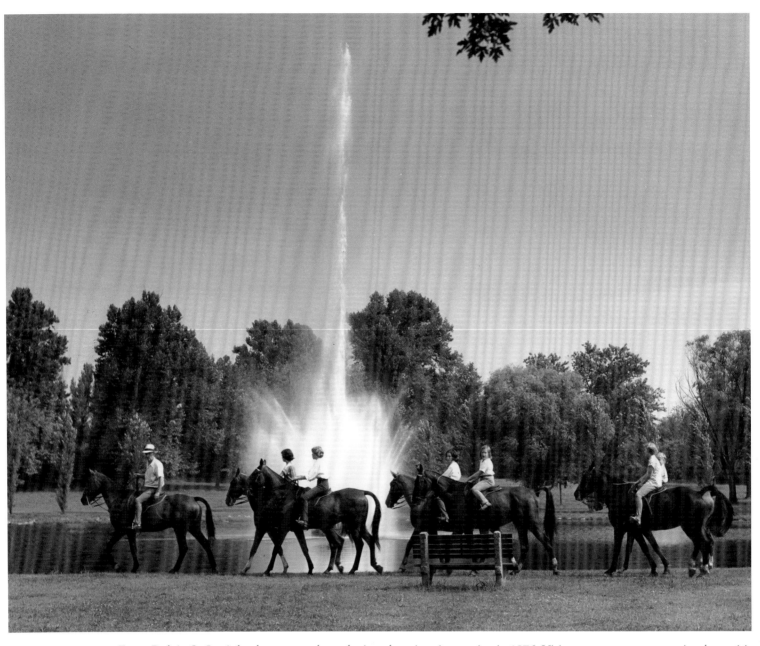

Forest Park in St. Louis has been a popular gathering place since its opening in 1876. Visitors can tour museums, ice skate, visit the zoo—or ride horses, as this group is doing in the 1940s.

Unity Village near Lee's Summit is home to the Unity School of Christianity, founded by Charles and Myrtle Fillmore in 1889. The incorporated village attracts guests from around the world, who enjoy its Spanish architecture and inspirational teachings.

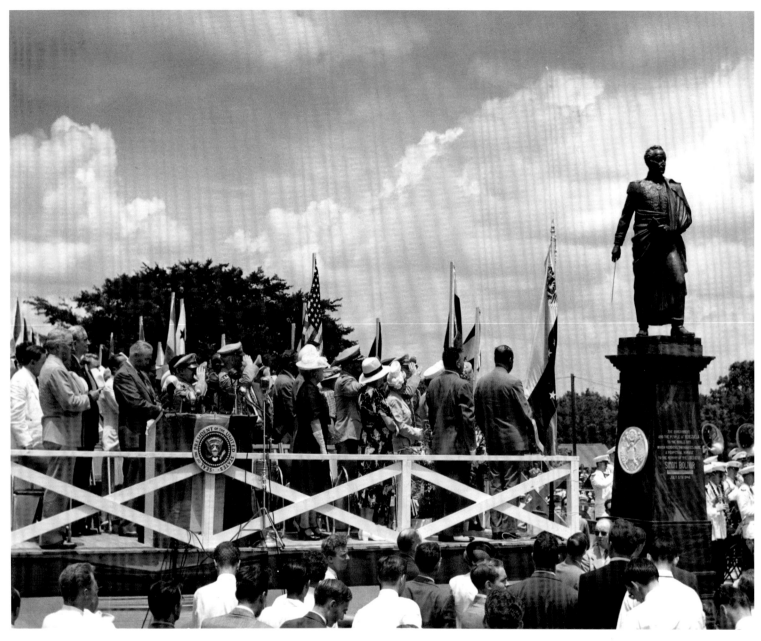

Citizens of Bolivar in Polk County gather in 1948 for the dedication of a statue of Latin American leader Simon Bolivar. The statue was presented by President Romulo Gallegos of Venezuela and dedicated by President Harry Truman, who stands at far left.

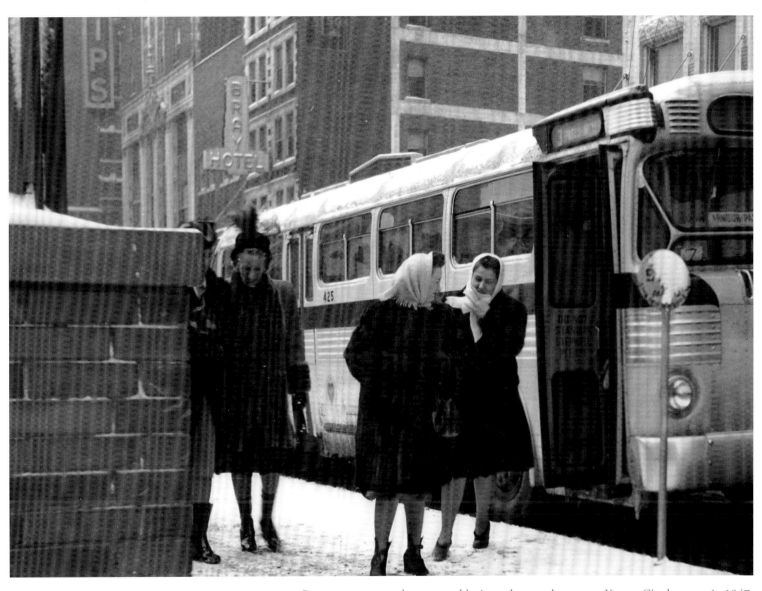

Passengers come and go on a cold winter day at a downtown Kansas City bus stop in 1947.

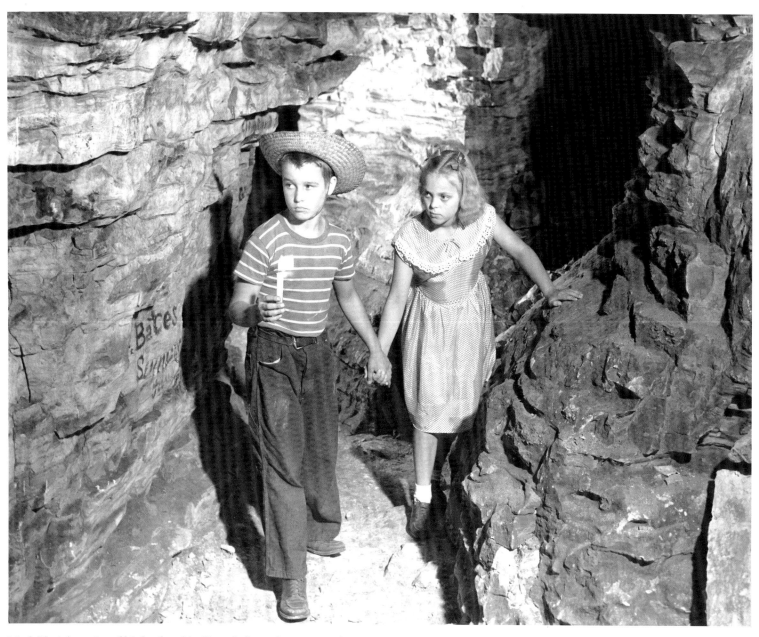

Mark Twain's stories of his boyhood in Hannibal put the town on the map as a popular tourist destination. A local boy and girl dress as Tom Sawyer and Becky Thatcher, from *The Adventures of Tom Sawyer,* in the Mark Twain Cave on the outskirts of town. Twain was born in Florida, Missouri, in 1835 and grew up in Hannibal in a house that can still be visited today.

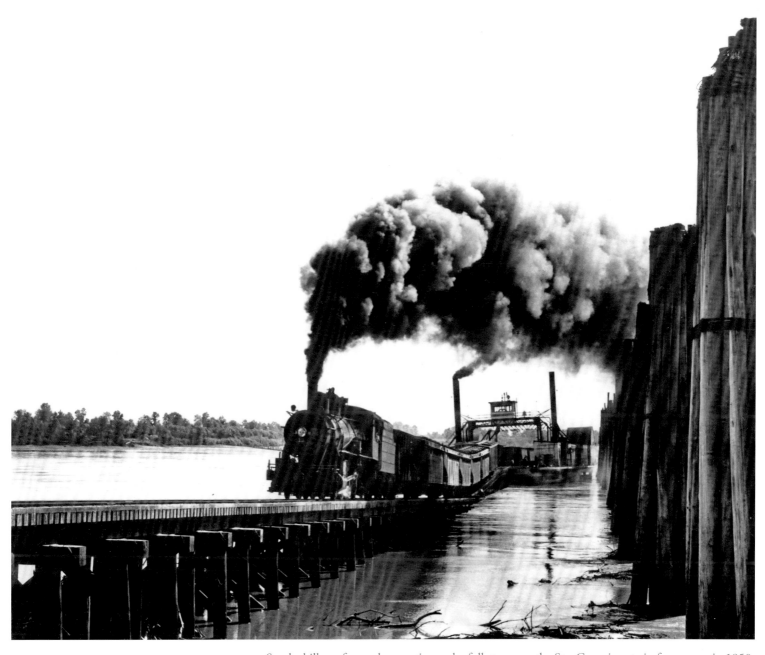

Smoke billows from a locomotive under full steam on the Ste. Genevieve train ferry ramp in 1950.

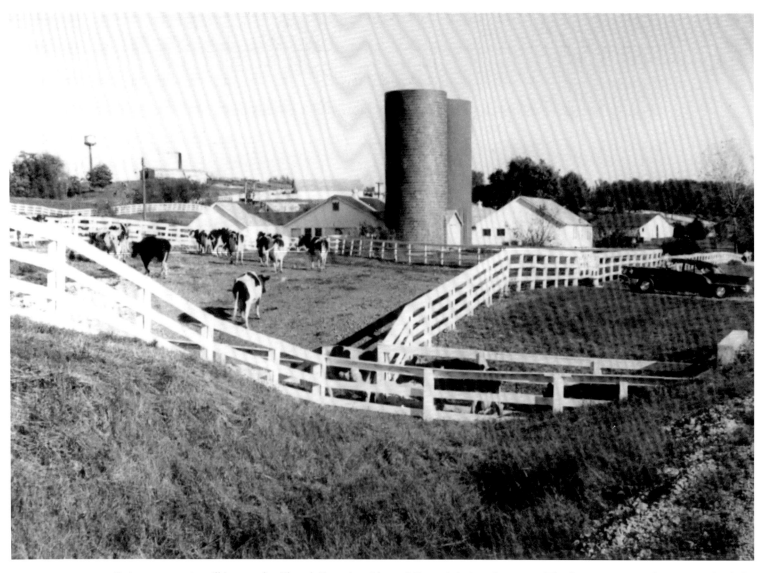

Dairy cows await milking on the Church Farm in midstate Missouri during the 1950s. The farm was an auxiliary prison built for prisoners nearing the end of their sentences. Inmates also grew wheat, alfalfa, and vegetables.

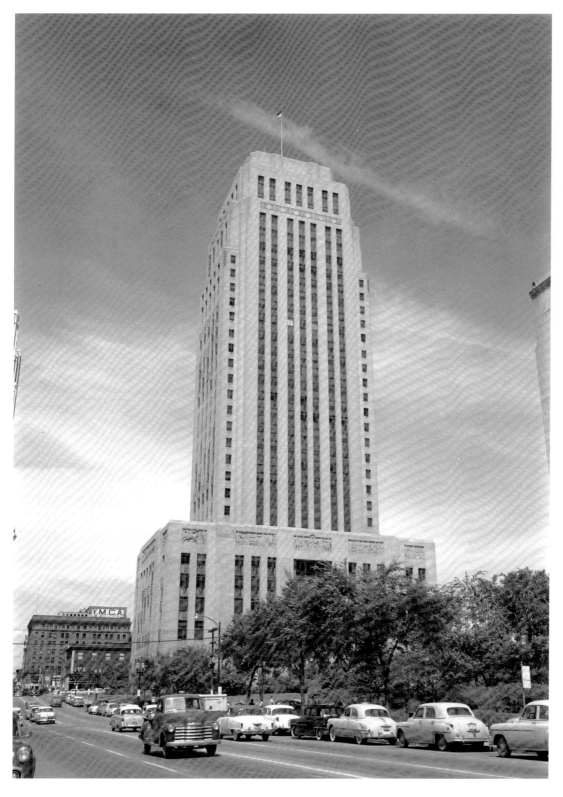

At 29 stories, City Hall towered over downtown Kansas City in the 1950s. The building was constructed in the 1930s under the influence of political "Boss" Tom Pendergast, who coincidentally owned a cement company. Pendergast's legacy of ill repute involves control of local elections during the era of Prohibition and the Great Depression.

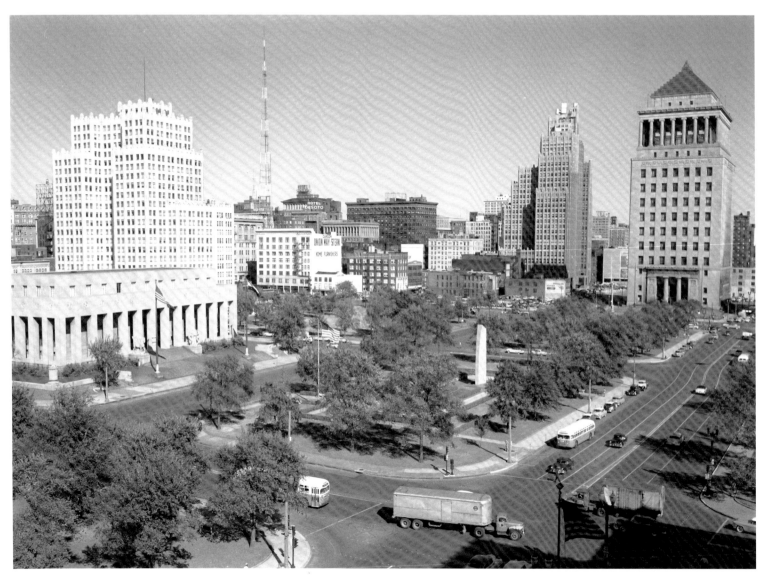

Downtown St. Louis preserved trees and parks around the concrete streets and buildings, even as many residents began moving to the suburbs at midcentury. This view is along Market Street on the south edge of downtown.

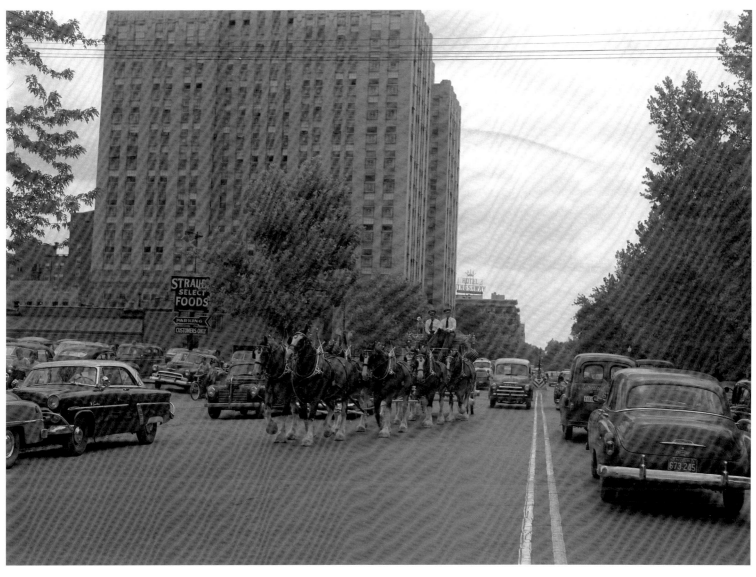

Massive Clydesdale horses have long been associated with Budweiser and the city of St. Louis. They continue to perform at parades today, just as they did at this event in downtown St. Louis in the 1950s.

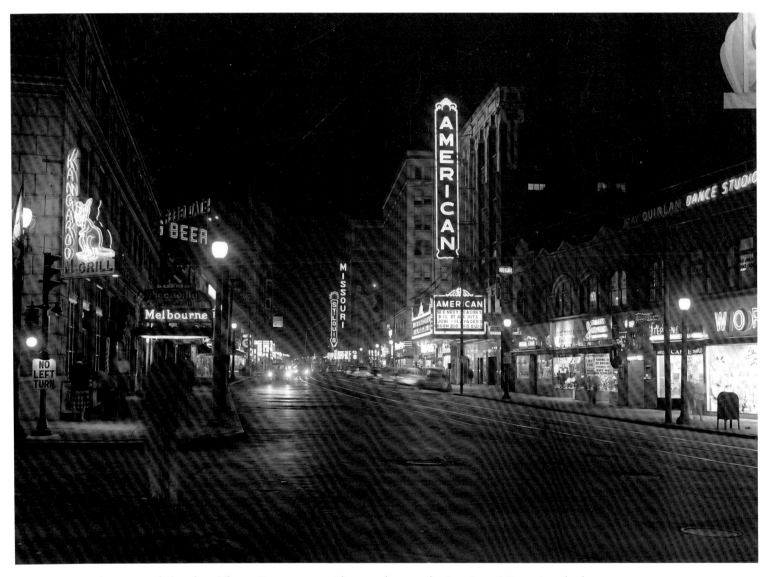

Move over, Broadway. Neon lights along Theatre Row attract residents to shows at the American, Missouri, and other downtown St. Louis theaters in the 1950s.

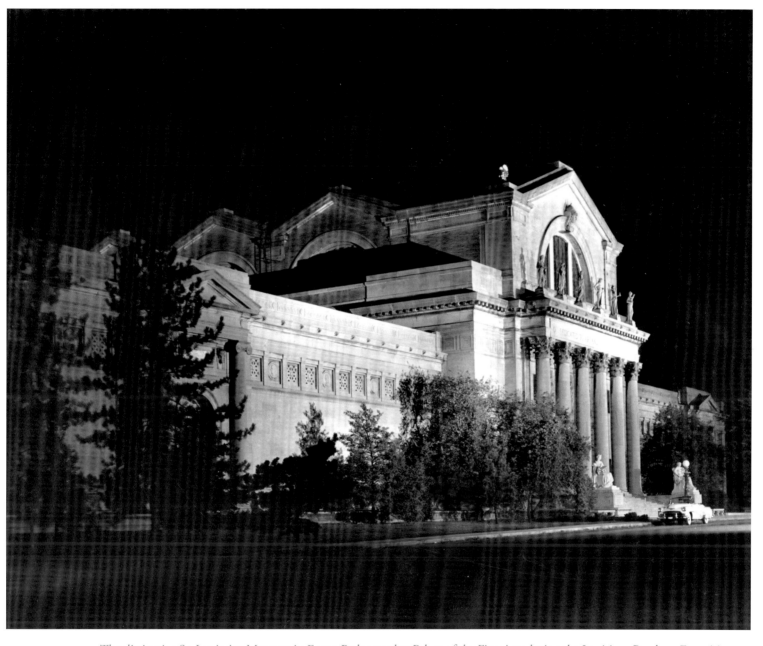

The distinctive St. Louis Art Museum in Forest Park served as Palace of the Fine Arts during the Louisiana Purchase Exposition, or World's Fair, of 1904. Admission is free to the museum, which attracts half a million visitors each year.

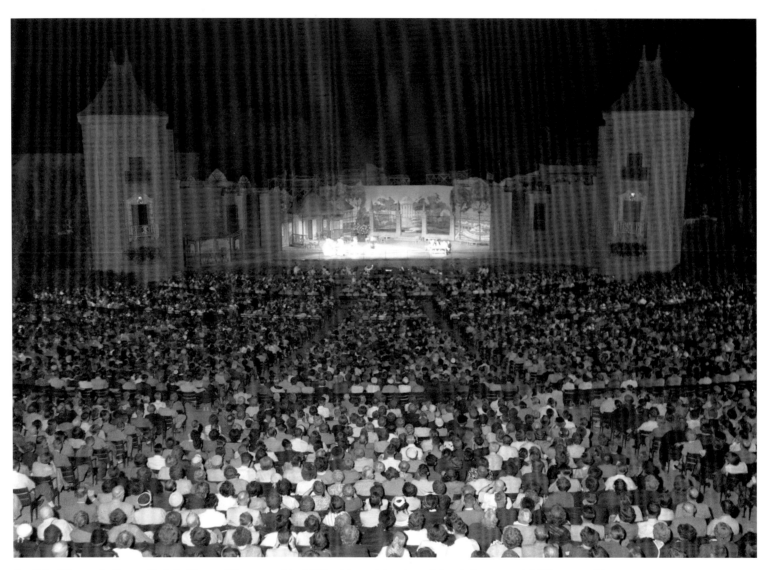

Starlight Theatre in Swope Park in Kansas City opened in 1950 with a celebration of the city's centennial. The venerable theater has undergone several renovations since then and continues to pack in audiences for Broadway shows and musical performances each summer.

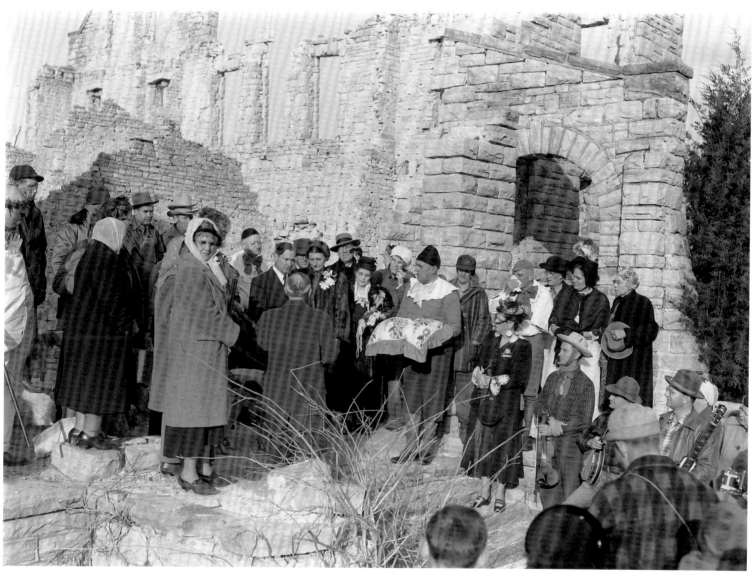

Ha Ha Tonka is a popular attraction near Camdenton. The area, now a state park, features the ruins of this mansion, which burned in 1942. A wedding ceremony on the grounds seems to be under way in this view.

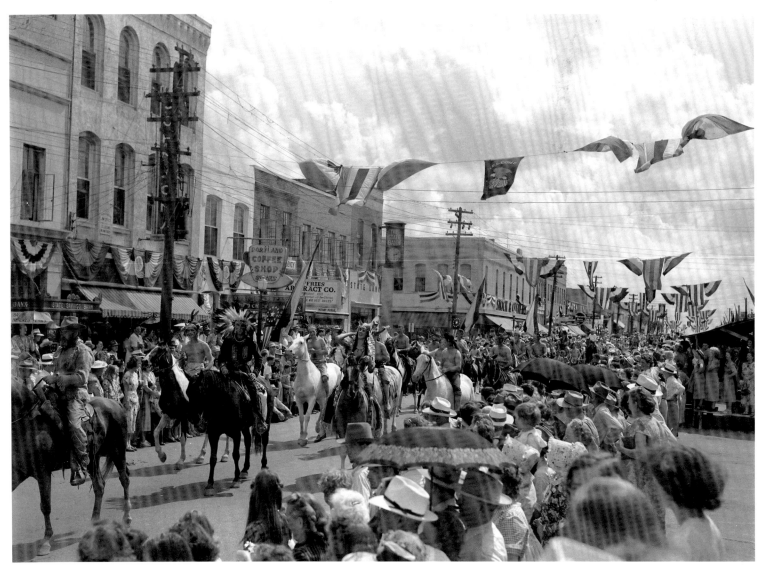

Cowboys and Indians lead the way as the city of Lebanon celebrates its centennial in 1951. Lebanon once attracted thousands of visitors to its mysterious "magnetic waters," which were thought to have healing powers.

The town of Dexter is in Stoddard County, where cotton is an important cash crop. That's why these mechanized cotton pickers are a big part of the parade during a 1950s Dexter Fall Festival.

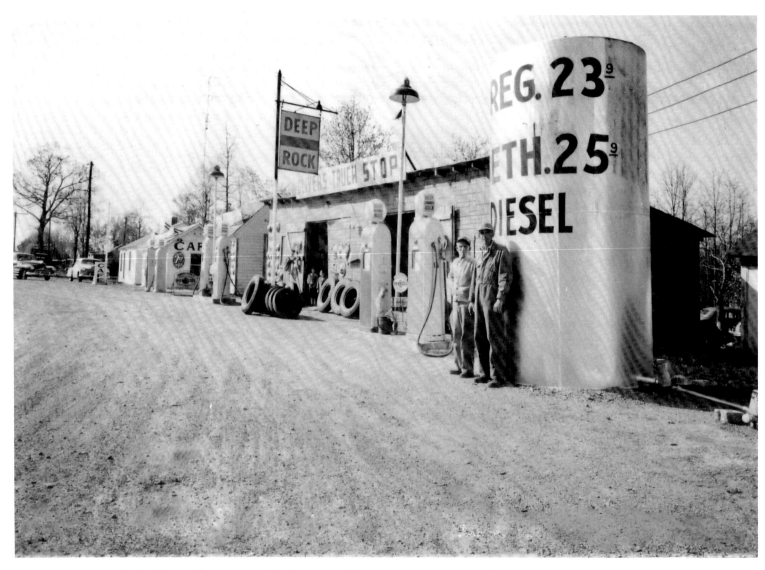

Gasoline prices were hard to beat in the 1950s at Oliver's Deep Rock service station in the Ozarks town of Willow Springs. That's right—the signage advertises gas at 23.9 cents a gallon and ethyl for two pennies more.

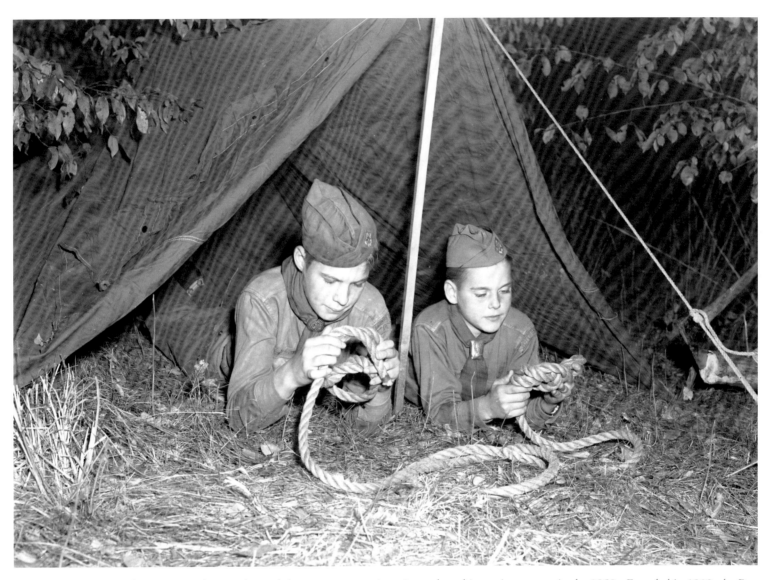

Boy Scouts across the state learned the ropes on camping trips such as this one in progress in the 1950s. Founded in 1910, the Boy Scouts of America seeks to train youth in responsible citizenship, character development, and self-reliance and instill wholesome values such as honesty, good citizenship, and outdoor skills.

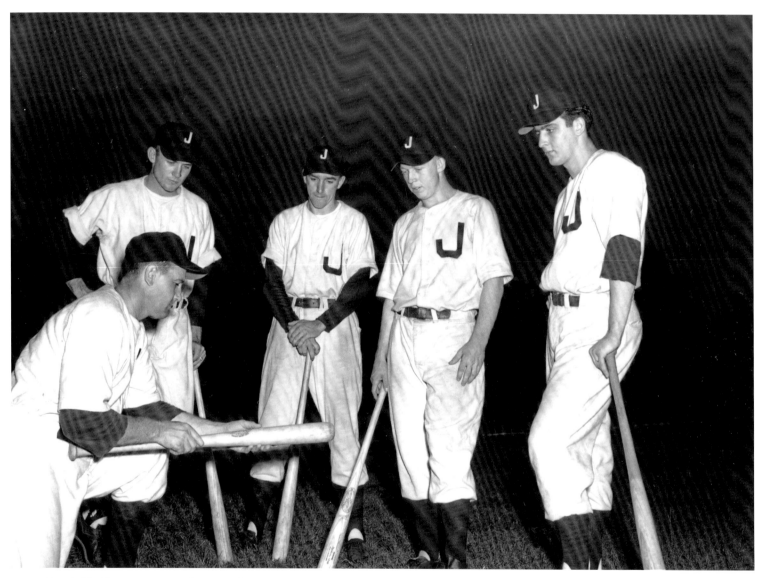

One of baseball's all-time greats got his start playing semi-pro ball in Missouri. Mickey Mantle (second from right) prepares for batting practice with the Joplin Miners.

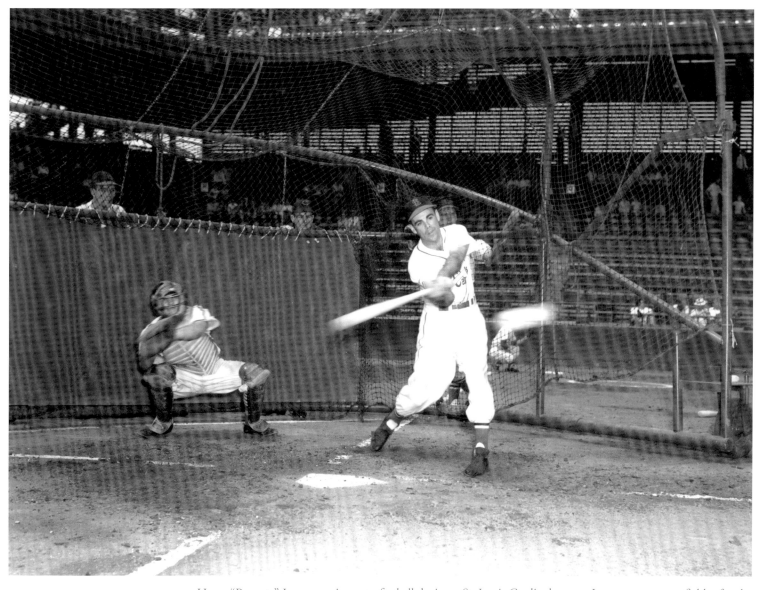

Harry "Peanuts" Lowery swings at a fastball during a St. Louis Cardinals game. Lowery was an outfielder for the team from 1950 through 1954.

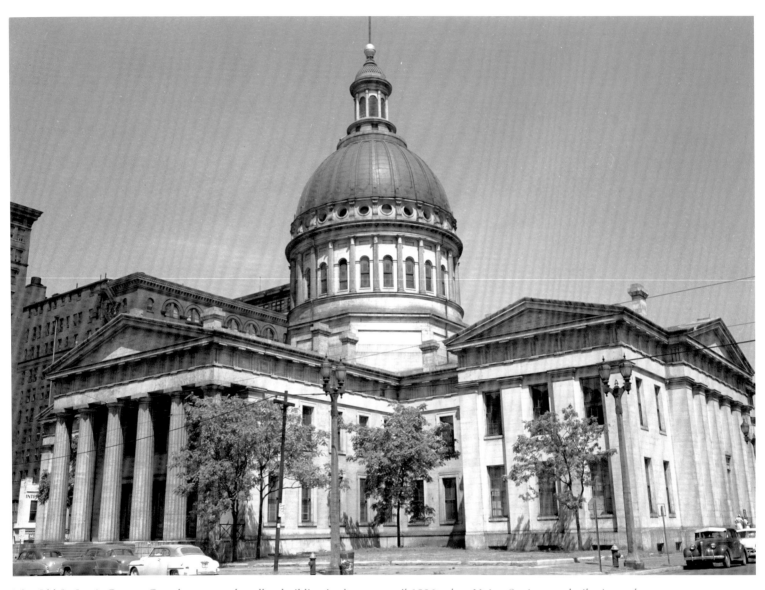

The Old St. Louis County Courthouse was the tallest building in the state until 1896, when Union Station was built. A number of famous cases were decided here, including the Dred Scott hearings from 1855 to 1858. The building now is part of the Jefferson National Expansion Memorial, which includes the Gateway Arch.

The square in Springfield is busy with shoppers just before the Thanksgiving holiday in 1955.

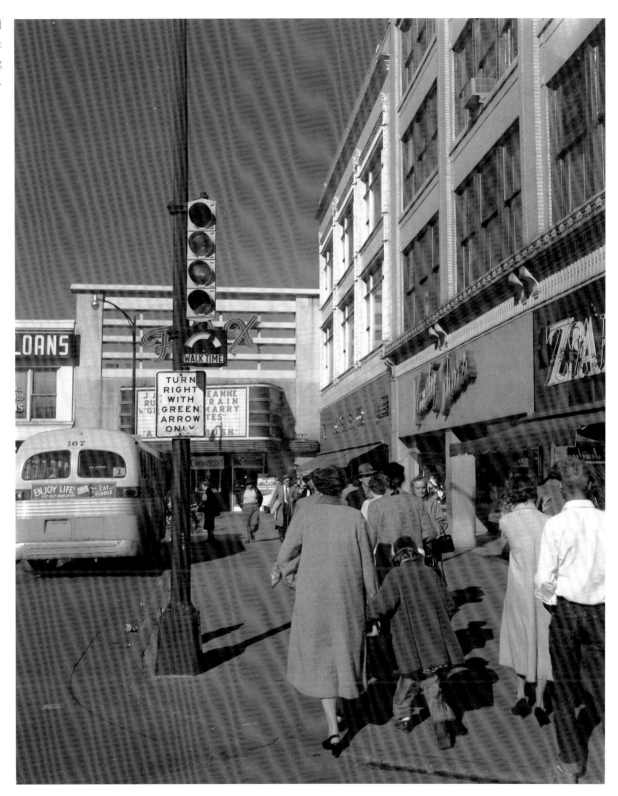

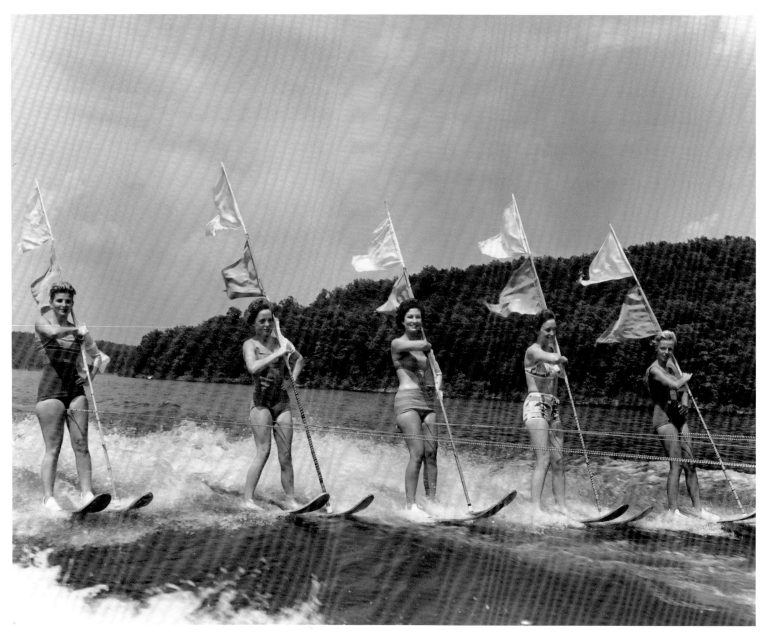

Created by the construction of Bagnell Dam in 1931, the Lake of the Ozarks extends 92 miles and encompasses 54,000 acres. In addition to generating hydroelectric power, the lake quickly became a summer playground for all Missourians. Shown here in the 1950s, these women display their skills during the lake's Water Ski Pageant.

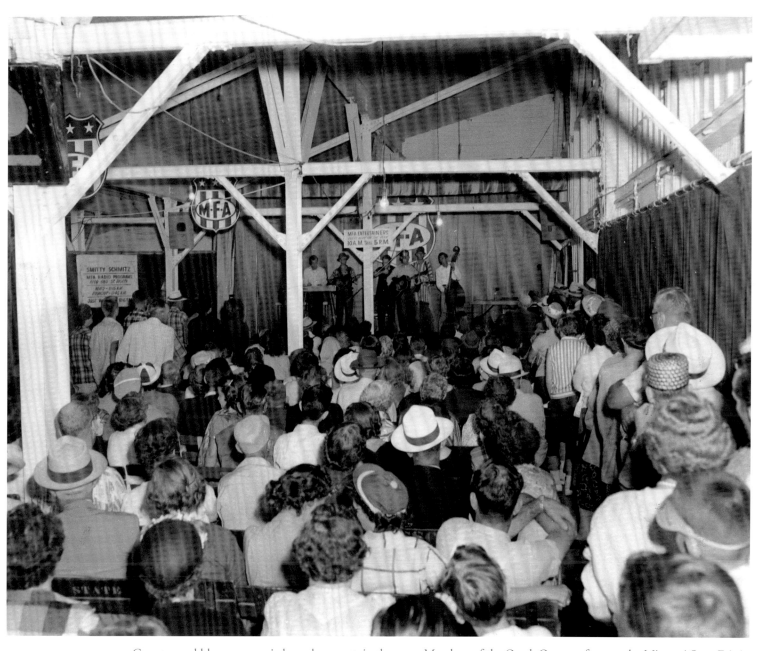

Country and bluegrass music have deep roots in the state. Members of the Ozark Opry perform at the Missouri State Fair in Sedalia. The Missouri Farmers Association sponsored this concert.

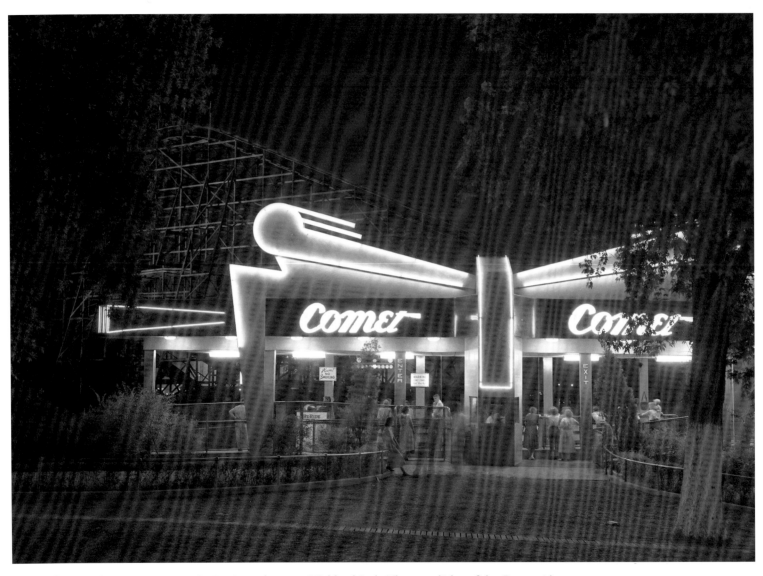

Long before Six Flags came to town, St. Louis was home to Highland Park. The neon lights of the Comet ride beckon to thrill-seekers in this 1950s view.

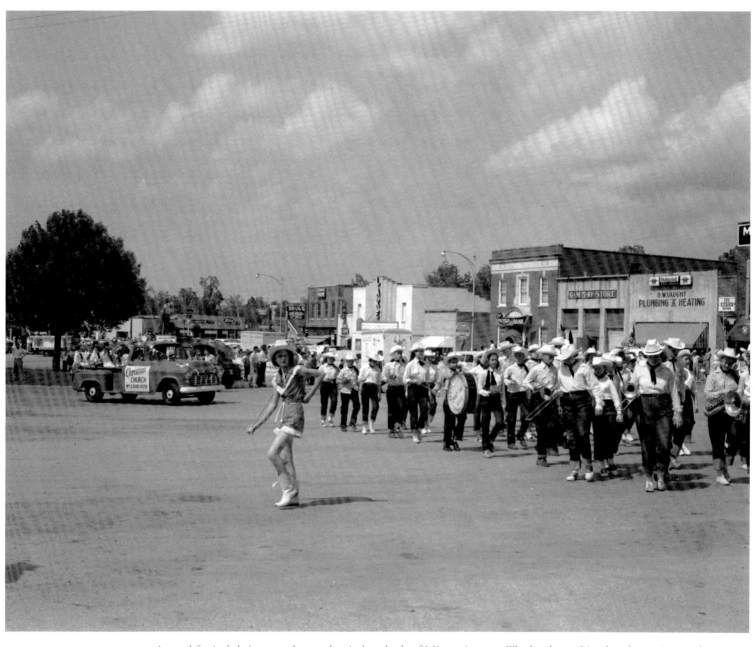

Annual festivals bring people together in hundreds of Missouri towns. The local marching band, wearing cowboy attire, prepares to perform at the Camdenton Dogwood Festival in 1956.

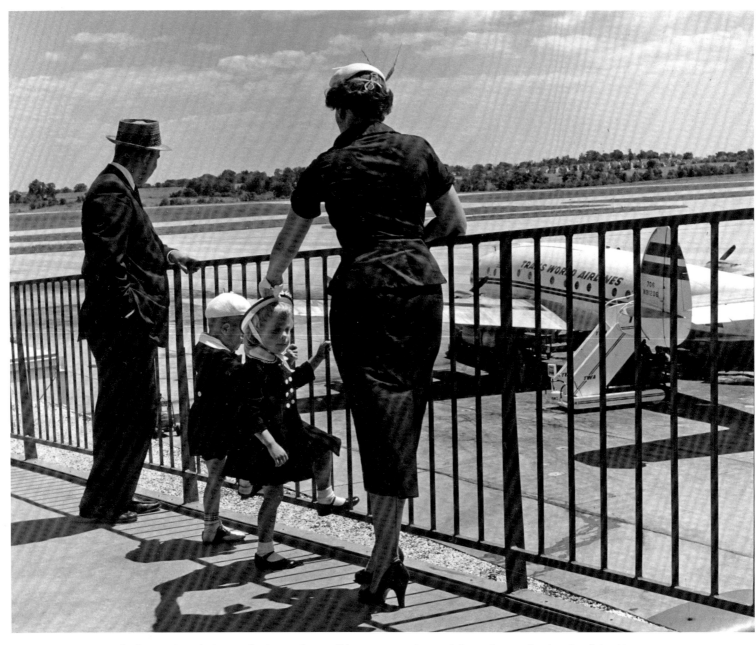

Postwar prosperity and advances in aviation made air travel accessible to more and more Missourians as the decade of the 50s progressed. This fashionable family looks at a Trans World Airlines airplane on the tarmac at Lambert Airport in St. Louis.

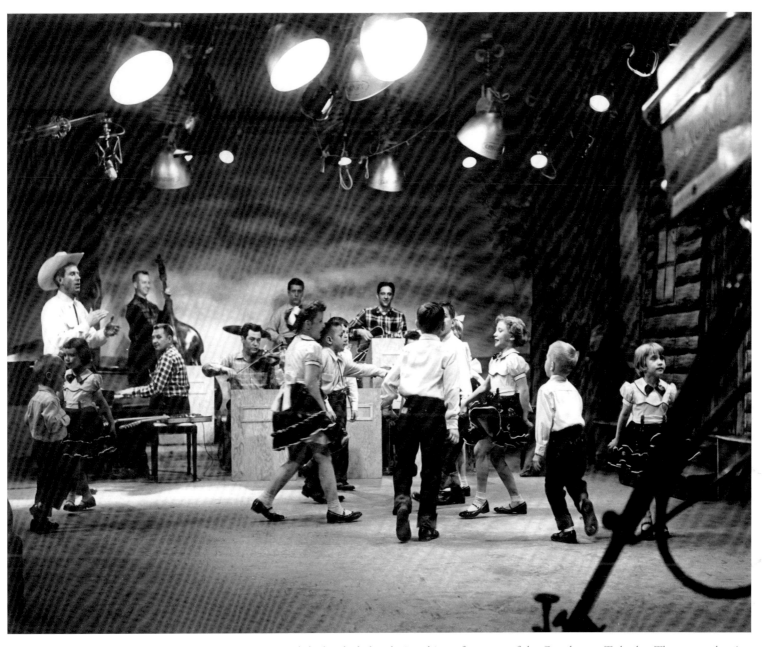

Young dancers don't seem to mind the bright lights during this performance of the Camdenton Tadpoles. The square dancing group performed regularly on the popular *Ozark Jubilee* television show in Springfield.

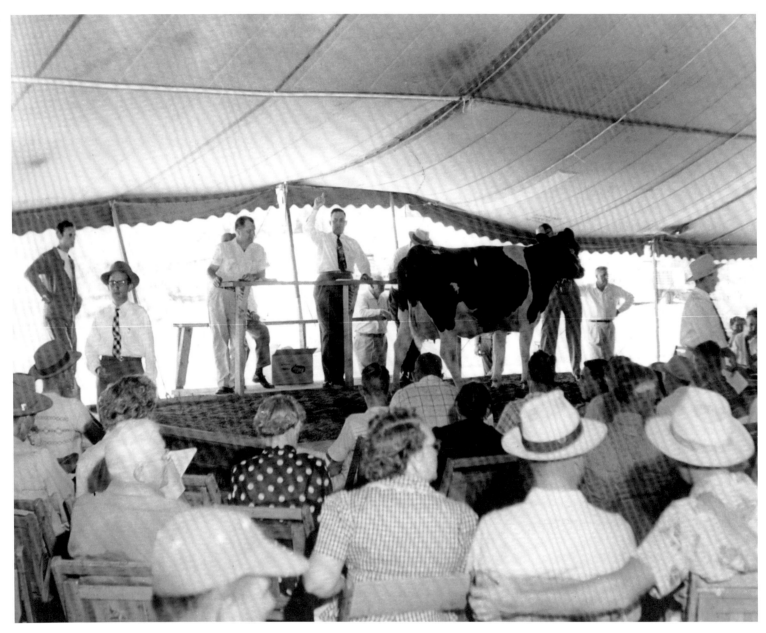

A prize Holstein is being auctioned at Church Farm in midstate Missouri in 1963. The prison farm won three national honor certificates for excellence in milk production.

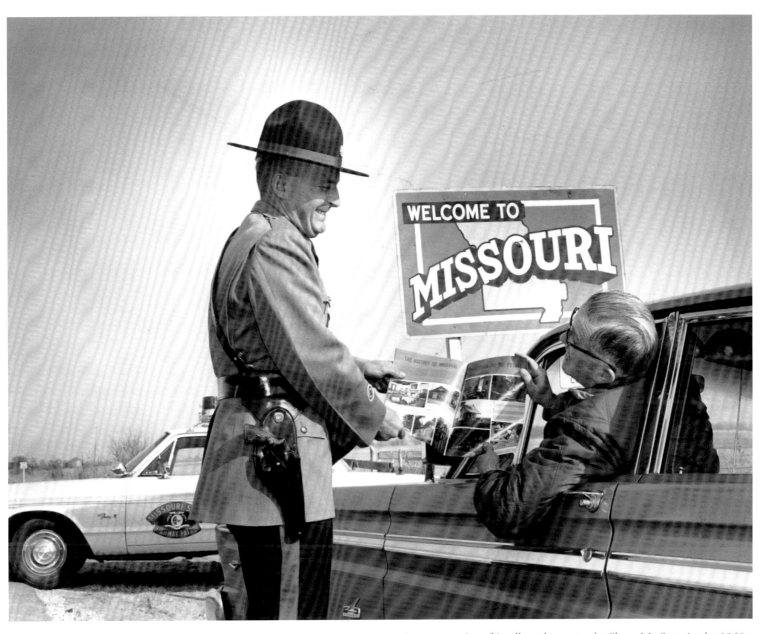

A state trooper gives a motorist a friendly welcome to the Show-Me State in the 1960s.

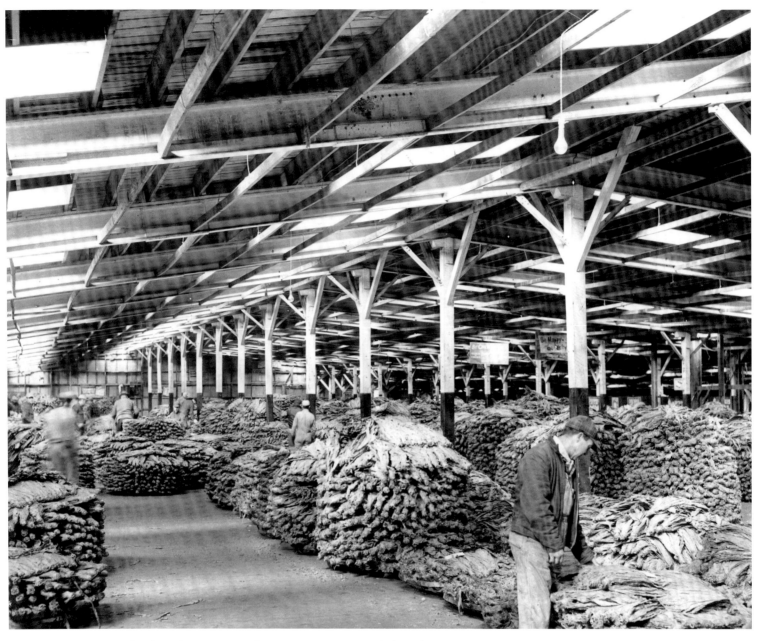

Buyers examine stacks of burley tobacco in a warehouse in Weston, situated along the Missouri River in Platte County. Each fall, the town is home to the only tobacco auction west of the Mississippi.

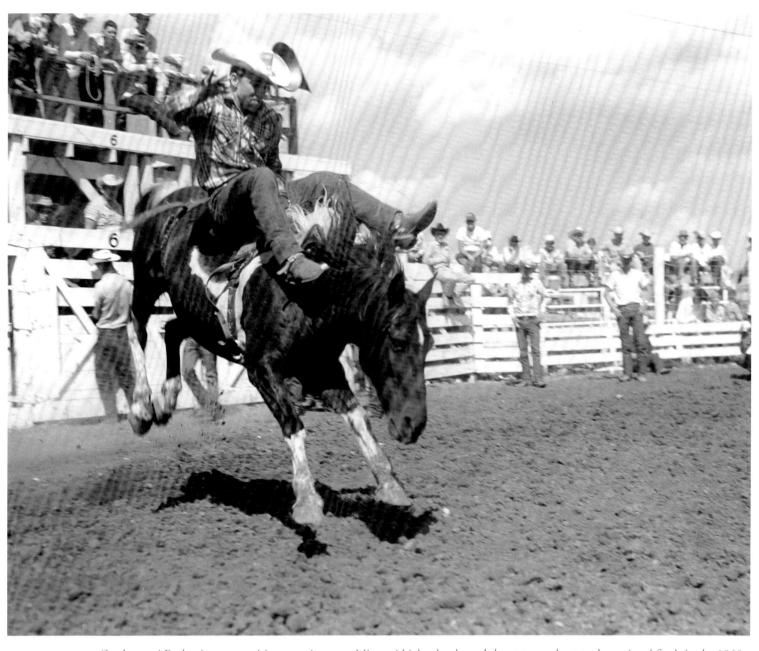

Cowboy up! Rodeo is a competitive sport in many Missouri high schools, and the state was host to the national finals in the 1960s.

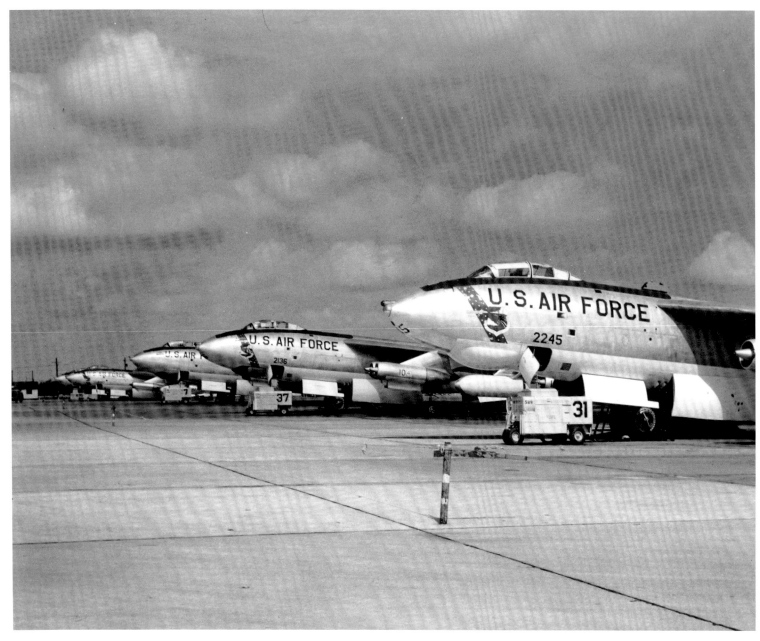

Air Force jets are lined up at Whiteman Air Force Base near Knob Noster in Johnson County in 1960. Minuteman missiles were installed at the base four years later, and today the base is home to the B-2 stealth bomber.

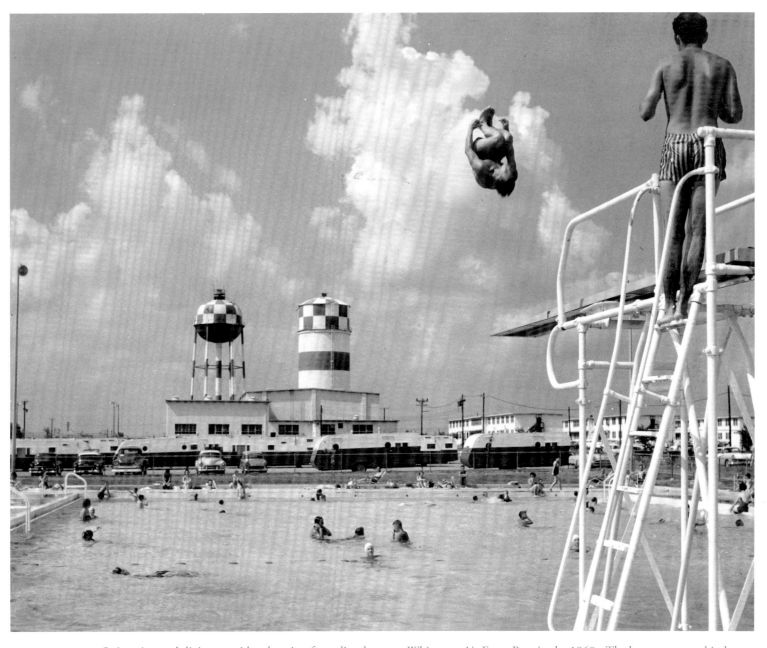

Swimming and diving provide relaxation for enlisted men at Whiteman Air Force Base in the 1960s. The base was named in honor of George Whiteman of nearby Sedalia, one of the first American airmen killed during the attack on Pearl Harbor.

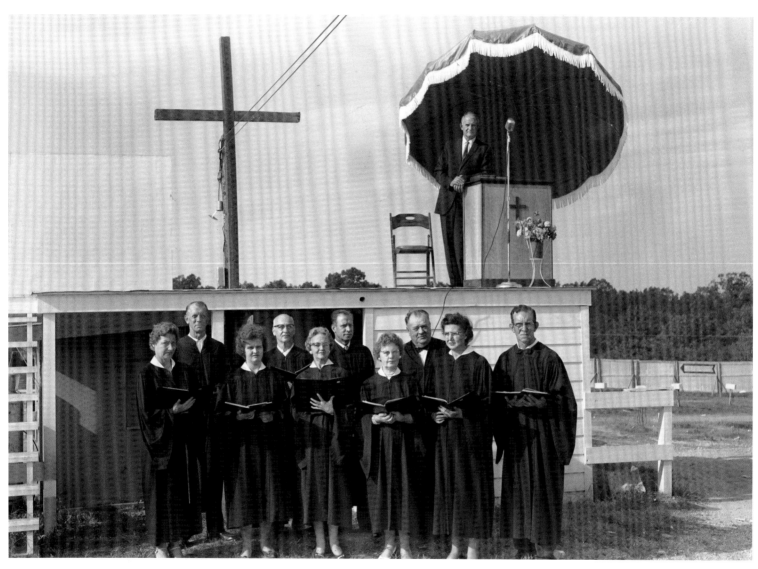

If you can't beat 'em, join 'em. A pastor and choir minister to a mobile flock in 1961 at Glaize Drive-in Church. Here in 1961, Missourians could see a movie, eat dinner, and even hear a sermon without ever leaving their cars.

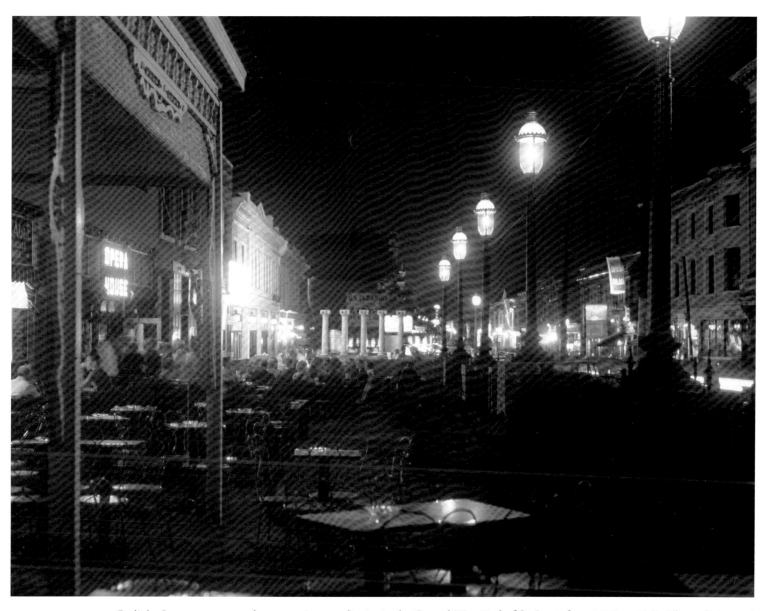

Gaslight Square was a popular entertainment district in the Central West End of St. Louis from 1953 to 1972. The gaslights and ornate Victorian architecture recalled the days gone by when the city was a bustling riverboat port.

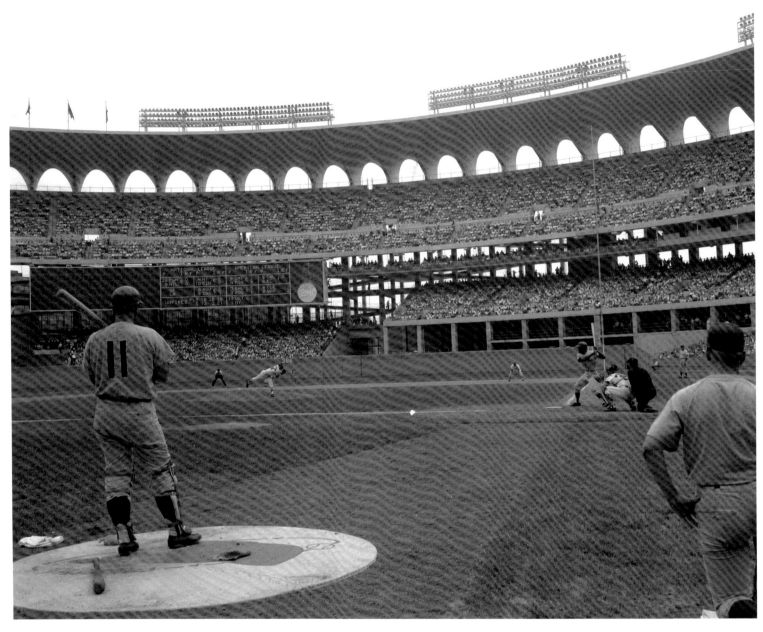

The St. Louis Cardinals played at Busch Memorial Stadium downtown from 1966 until 2005, when a new ballpark with the same name was built nearby. The old Cardinals team of the National Football League also played in the multipurpose stadium. The open, arched areas in the roof of Busch Memorial Stadium were designed to complement the shape of the nearby Gateway Arch.

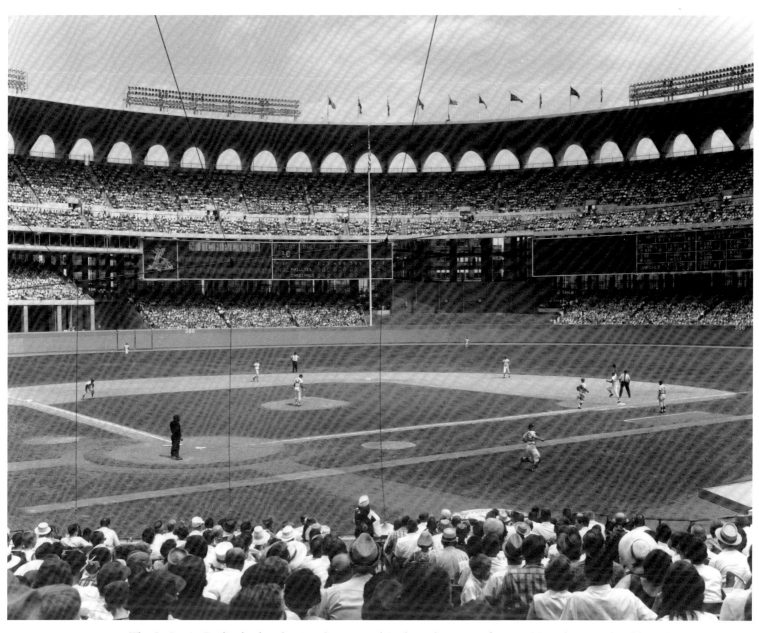

The St. Louis Cardinals played at Busch Memorial Stadium downtown from 1966 until 2005. The old Cardinals team of the National Football League also played in the multipurpose stadium.

Ellis Library at the University of Missouri in Columbia is the second-largest research library in the state and the 47th-largest in the nation. The building is also home to the State Historical Society of Missouri.

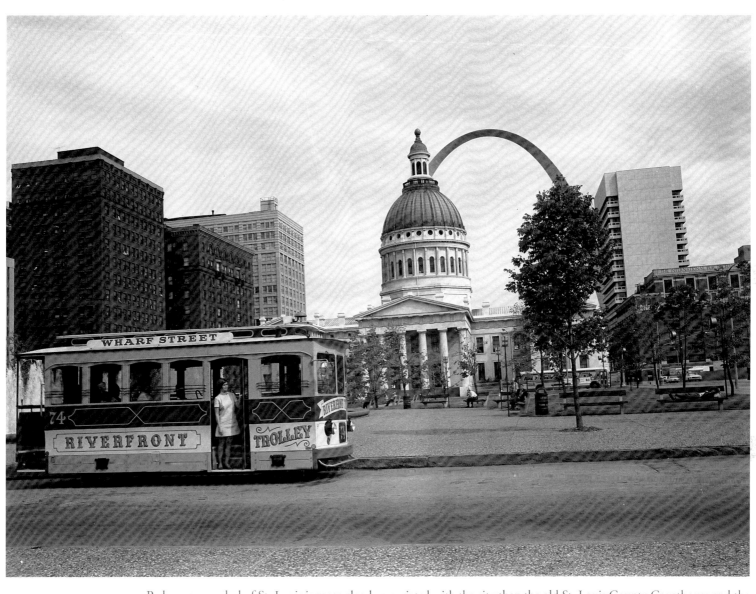

Perhaps no symbol of St. Louis is more closely associated with the city than the old St. Louis County Courthouse and the Gateway Arch. In this image, a riverfront trolley bus transports tourists to attractions along the Mississippi River.

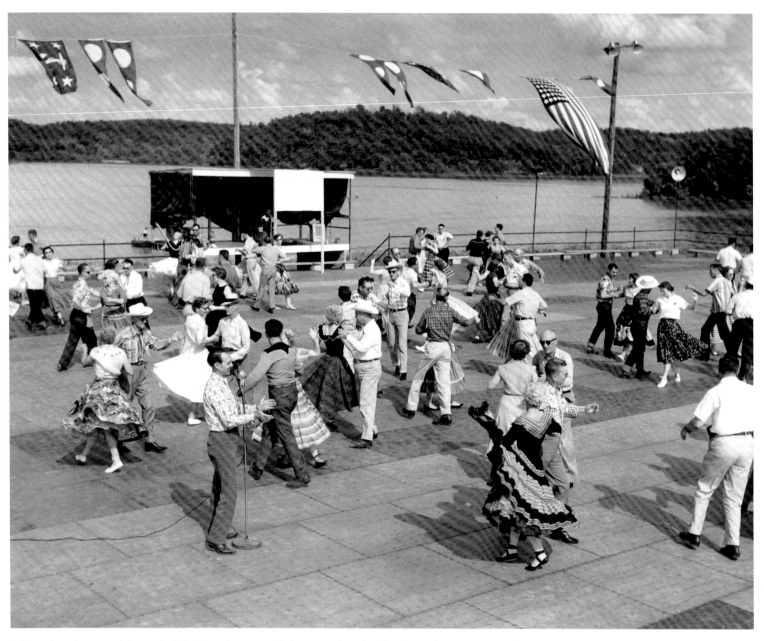

Missourians love to celebrate their heritage in song and dance, such as this display at the International Square Dance Festival at the Lake of the Ozarks in the 1960s.

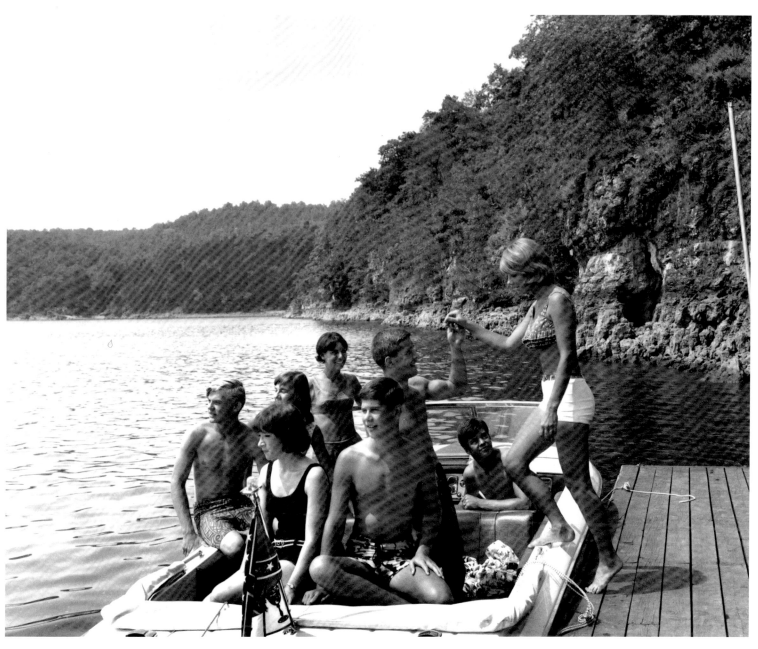

A speedboat is the best way to see the lake around Bridal Cave near Camdenton. More than 2,000 couples have tied the knot in the cave since the early nineteenth century.

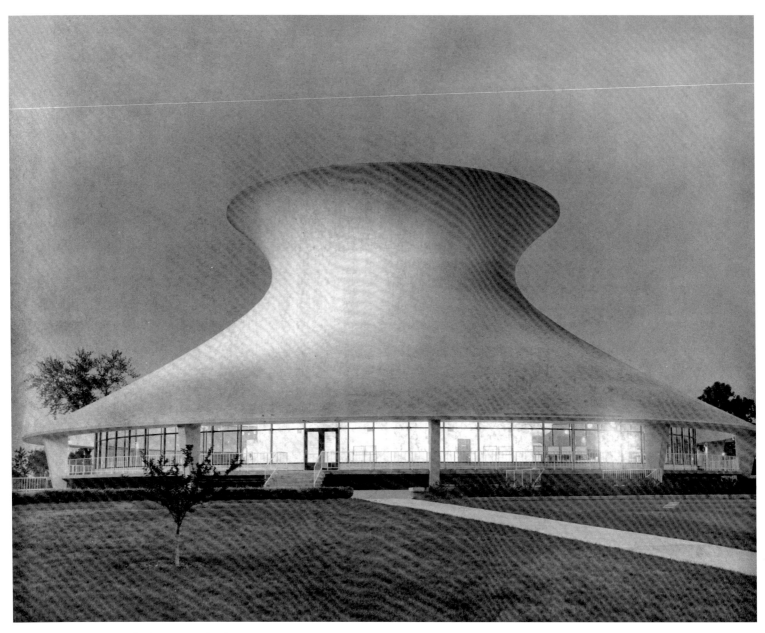

The James S. McDonnell Planetarium has been an icon at the St. Louis Science Center since 1963. The building was named for the co-founder of the city's McDonnell-Douglas aerospace company. Students from nearby Washington University often wrap the building with a red bow at Christmas.

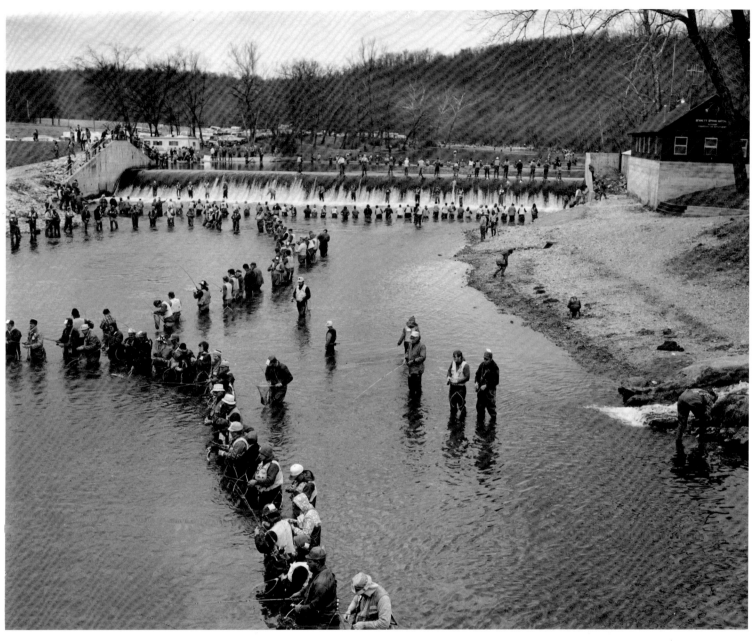

The opening of trout season at Bennett Spring State Park each spring is almost like a state holiday. In this image, hundreds of anglers jostle for position on opening day in 1974.

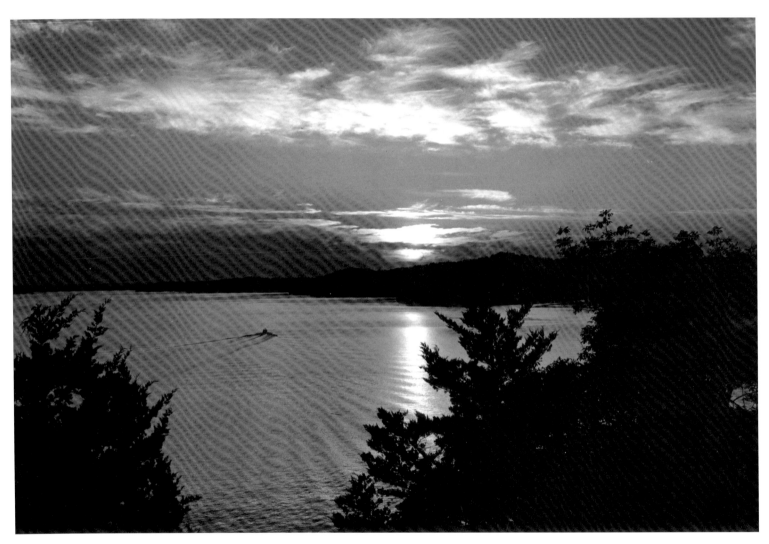

Throughout centuries of progress, Missouri has never lost its natural beauty. There is no better way to end a lazy summer day than by watching the sun set over the Lake of the Ozarks.

NOTES ON THE PHOTOGRAPHS

These notes, listed by page number, attempt to include all aspects known of the photographs. Each of the photographs is identified by the page number, photograph's title or description, photographer and collection, archive, and call or box number when applicable. Although every attempt was made to collect all data, in some cases complete data may have been unavailable due to the age and condition of some of the photographs and records.